Mary Shannon
888-1193

W9-AUV-660

How to
Make Money in
ADVERTISING
PHOTOGRAPHY

How to Make Money in
ADVERTISING PHOTOGRAPHY

Bill Hammond

AMPHOTO

American Photographic Book Publishing Co., Inc.

Garden City, New York

I am deeply indebted to those exceptionally creative photographers who so kindly provided me with samples of their inspired artistry. To single out any one individual would be totally unfair. Each work speaks for itself.

I would also like to express my great appreciation to Pat and Louise who made sense of my scribbles, clarified them, and typed the text, and to my wife, Rose, who provided the patient understanding every writer needs.

Third printing, 1979

Copyright © 1976 by American Photographic Book Publishing Co., Inc.

Published in Garden City, New York, by American Photographic Book Publishing Co., Inc. All rights reserved. No part of this book may be reproduced in any form without the written consent of the publisher.

Library of Congress Catalog Card No. 74-79950

ISBN 0-8174-0581-X

Manufactured in the United States of America

Contents

PREFACE

CHAPTER 1
page 9

HOW TO—GET STARTED IN ADVERTISING PHOTOGRAPHY
The Big Money Potential
Choosing the Correct Time
Profit from Self-Evaluation
How to Exploit Personal Preferences

CHAPTER 2
page 19

HOW TO—HIT THE TOP MONEY MARKETS
The Big Three—Fashion, Industry, and Commerce
The Ready Picture Market
Book Illustration
The Power of Pictures in Politics

CHAPTER 3
page 33

HOW TO—SELECT THE CORRECT EQUIPMENT
Cameras and Lenses
Studios and Darkrooms
Choosing Special Equipment
Props That Work Miracles

CHAPTER 4
page 47

HOW TO—GET MONEY-MAKING ASSIGNMENTS
Samples That Hit the Jackpot
Professional Presentations
Dealing with Manufacturers
Getting the Work
The Presentation
Selling Your Services
The Tie-in Technique
The Requirements of Printers and Publishers
How to Approach Advertising Agencies
Your Personal Interests Pay Off
Applying the Personal Touch
Estimates and Quotations

CHAPTER 5
page 65

HOW TO—UNLEASH YOUR IMAGINATIVE POWERS
Originality Pays Top Dividends
The Dream Session
Find Time for Experiments
Direct Stimulation

CHAPTER 6

page 77 HOW TO—PRODUCE PICTURES THAT SELL
Putting Punch into the Picture
How to Capture Mood and Atmosphere
Techniques That Please the Client
Subtleties of Showmanship

CHAPTER 7

page 87 HOW TO—INCREASE YOUR PROFITS BY
SHREWD ORGANIZATION
Artists and Layouts
Backgrounds and Locations
Preshooting Approval
Meeting Deadlines

CHAPTER 8

page 97 HOW TO—GET THE BEST FROM YOUR MODELS
Professional Models and Enthusiastic Amateurs
Scales of Payment
The Accidental Model
Models and the Law

CHAPTER 9

page 107 HOW TO—ESTABLISH A NATIONWIDE REPUTATION
AS A SPECIALIST
Ten Thousand Golden Opportunities
Self-Advertisement
The Importance of Research
Style Is Like an Autograph

CHAPTER 10

page 117 HOW TO—PERFORM DARKROOM MAGIC
Combination Printing
Screens and Grids
Solarization
Tone Separation
Reticulation
Photo Patterns Made Without a Camera
The Trick with Proofs
Reproduction in Color
The World of Fantasy

CHAPTER 11

page 129 HOW TO—FIND GOLD WITH OFF-BEAT SUBJECTS
Public Services
Illustrated Articles
Building a Transparency Library
Unusual Photographic Material

CHAPTER 12

page 143 HOW TO—BUILD A SUBSTANTIAL BUSINESS IN
ADVERTISING PHOTOGRAPHY
Correct Costing
Simple Accounting
The Economic Way to Buy Materials
Foolproof Record Keeping Saves Money
The Way to Success

Preface

We live in a world of advertising. Everywhere we go, we see advertising photographs: They demand our attention as we travel along the freeways; they surround us in every store; they appear on every long-playing record we buy; and they brighten the sides of public transport vehicles. Advertising photographs are used for product packaging, to entice us to visit foreign countries, to make us think, and to make us buy. They are the lifeblood of magazines and newspapers, and they cost a great deal of money. One major oil company alone budgets nearly $20,000,000 for advertising every year, most of it allocated to photographic applications.

Taking photographs for advertising purposes is a business of the present and of the future. It is ever expanding. It is one of the world's highest paying professions; the fee for just one photograph could pay the rent for several months. Moreover, advertising photography is a profession you can enter now.

How to Make Money in Advertising Photography is a powerful and forthright book that covers the big How-To omitted by most schools of photography. It does not set out to teach sensitometry or chemistry; instead it assumes a basic knowledge of photography and proceeds to put first things first.

In precise, no-nonsense language, **How to Make Money in Advertising Photography** tells you how to start earning money now—immediately. It is obvious that unless you are already wealthy, you need money in order to learn more about photography and to make possible the purchase of better equipment which, in turn, will enable you to earn more money. This book puts the cart where it should be—firmly behind the horse. It shows you how to start making money with the knowledge you already possess; the scientific principles, the tricks of the trade, the luxurious studios and equipment will inevitably follow.

How to Make Money in Advertising Photography is a completely practical book, one which has long been needed. Many established studios will object to seeing in print the methods and procedures they have successfully and profitably followed for some time, and which, in many instances, are the very foundation of the business. It is a book that could only have been written by a photographer with many years of experience in the profession.

Although you, the reader, are expected to provide the enthusiasm and drive that make for success in any form of business, **How to Make Money in Advertising Photography** will provide the essential know-how. It will become the accepted manual for anyone wishing to be an advertising photographer. One thing is certain: This book will encourage more people to enter this lucrative field than anything before ever has.

How to
Get Started
In Advertising Photography

The Big Money Potential
Choosing the Correct Time
Profit from Self-Evaluation
How to Exploit Personal
Preferences

Advertising is big business—very big business. Every year, billions of dollars are spent to introduce a new product, to tempt the public to try a new food, or to convince it that one detergent is better than another. There is a continuous stream of inducements—an avalanche of persuasion.

Day after day, newspapers, magazines, billboards, posters, radio, and television pay their way by means of advertising, most of it in the form of a photograph supported by some very shrewdly written copy. The copy may be slanted to inform or amuse, its message strident or subtle. But the illustrations have one, and only one, vital objective: to catch and hold the jaundiced eye of a lukewarm public.

The men and women who produce these illustrations are experts. They combine a very high degree of technical competence with an extraordinary ability to create pictures charged with enormous visual impact.

The number of top-rank photographers in the field of commercial advertising is surprisingly small. The services of these people are exclusive and very expensive, yet there's more work available than they can handle. They enjoy the enviable privilege of being able to choose the work they prefer.

If you enjoy photography and are technically proficient, there are abundant opportunities for you to join this very elite group. You can enter a profession that offers outstanding opportunities for the person who wants to start earning more money than he ever dreamed possible.

Skill with a camera is not the exclusive domain of either sex. Photography is an art form that allows for a maximum of individual expression by both men and women, and the male gender used throughout the remainder of the book is simply a convenient way of avoiding the clumsy "his or her" references.

One bond that ties all advertising photographers together is their enjoyment of their work. The ever-changing scenes before their cameras are passports to living, and each new assignment is as stimulating as a fresh sea breeze.

To many advertising photographers, their profession is really an extension of their hobby. And the fact that advertising photography embraces so many other hobbies and recreational interests is probably one of its greatest attractions. If you enjoy mountain climb-

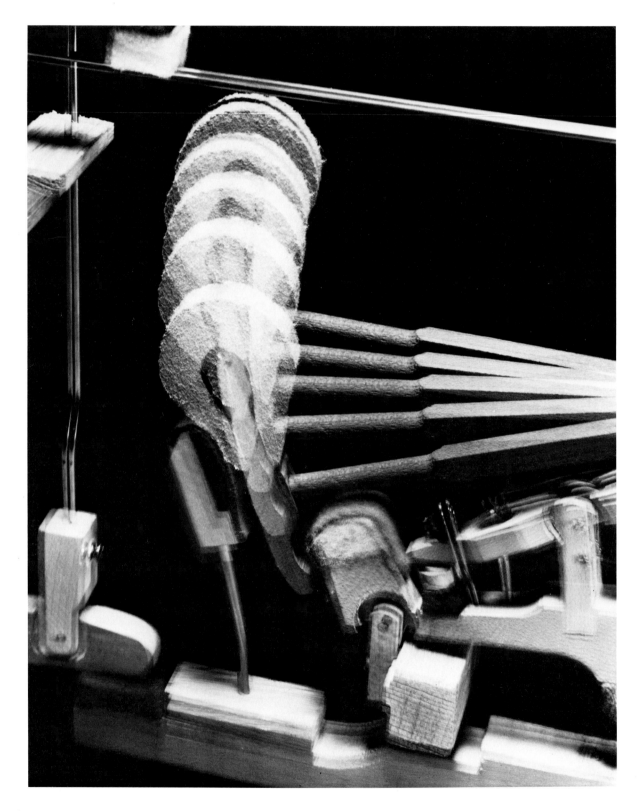

Imagination and skillful technical trickery combine to produce a picture with tremendous visual impact. Photo by courtesy of Gerald William Hoos, International Photo-Art Service.

ing, your knowledge and ability can be profitably incorporated in your business. If your hobby is collecting antiques, that too has a place in advertising photography. Any personal interests or specialized knowledge is of immense value and can be frequently used to your advantage.

When you are employed at something you really enjoy, you produce top-quality work. Your mind is more alert, and you are capable of making a great deal more money than a person employed at a task he finds boring and irksome. As your business grows and you become more secure and more experienced, your entire way of life becomes completely satisfying. A well-run photographic advertising studio is not only gratifying, it is also capable of providing you with a truly congenial lifestyle.

If you like the idea of working every day in a profession that gives you extreme pleasure, brings you into contact with interesting, attractive people, and pays you very highly into the bargain, advertising photography could be your future.

The Big Money Potential

The opportunities for making money with your camera are more extensive in advertising than in any other branch of the photographic profession. Although the cost of equipping a studio and darkroom is the largest initial expense, even this can be kept to a minimum in the beginning, as you can add equipment as you grow. Most of your clients will be satisfied to receive a set of photographs that advances their image or sells their product. They will not be too concerned about the type of equipment you use; they are interested only in results.

While you are becoming established, most of your clients will be manufacturers. Later, when your work is recognized as having that special, hard-to-define quality

A good attachment to the lens will add drama to almost any photograph when lights are in the picture area. Photo by courtesy of Gerald William Hoos, International Photo-Art Service.

and your services are in constant demand, advertising agencies will begin providing a major portion of your business.

Although many manufacturers and industrialists are quite competent amateur photographers, they turn to the photographer who specializes in advertising photography when they require photographs of their products for publicity purposes. These businessmen are aware that they need photographs sparkling with flair and inspiration to give their products maximum appeal, and they are prepared to pay top dollar for that type of picture.

Advertising agencies go for top quality every time, usually sending their work to two or three studios that have proven their ability to produce high-quality photography consistently. The agencies may provide the idea and an outline of the photographs required, but they know that their own reputation rests on the quality of the work they supply to the client. Copy, layout, and art illustration can be handled within the advertising agency, but photography is almost invariably commissioned from outside studios.

As an advertising photographer, your work will be a vivid kaleidoscope of the world around you. It will change with the seasons and be as varied as the whims of fashion. It will hold a mirror to the lifestyles of today and offer a seductive promise for tomorrow.

Clinton Bryant has spent the greater part of his life photographing roses for nurseries on the West Coast. Easy work? Far from easy. Every rose he photographs is a wonderful specimen unfolding from the bud to the exact form, with every petal gently curving to perfection. Fascinating work? Definitely. Clint knows precisely how much each rose will unfold under the studio lights. He also knows which varieties can

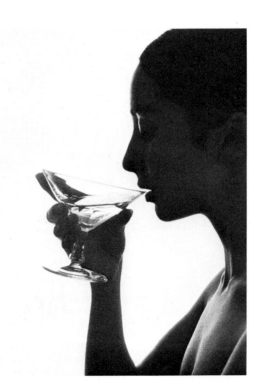

Pictures that seem so simple are usually the result of hours of careful, painstaking work. Note the exact spacing between the lips and the rim of the glass, the spill of light touching the eyelid, and the luminous quality of the glass. Photo by courtesy of Studio Guy Marché.

be teased into an attractive setting and which ones will fade if overhandled. The experience gained through years of painstaking photography and a deep understanding of rose culture has enabled Clinton Bryant to acquire a reputation as one of the finest photographers of roses in California.

As Clinton Bryant knows roses, so other photographers have become well known in their fields: Peter Engels and architecture, Hans Georg Isenberg and motor racing, Kishin Shinoyama and Andre De Dienes for their photography of the nude. These photographers, and others who have become specialists in their chosen fields, have developed the supreme skill of producing photographs that look completely natural. The rose looks as though it could be plucked from the page, and you can almost here the crackling roar of that sports car.

It is this rare ability of being able to give a photograph complete authenticity that rockets an advertising photographer to the top of his profession. Such photographers have taken the trouble to discover the secret of naturalness. They know when a photograph looks false, and they know why.

There are, of course, times when authenticity is not required. Sometimes the photographs have to transport the viewers into a strange land of fantasy or project them into an imagined world of the future. But it is this power of authenticity, of apparent truthfulness, that gives photography the edge over an artist's renderings.

Although the public is well aware that a photograph can be faked and that photography is capable of considerable distortion, it is still inclined to believe that a photograph presented as a true image of the original is, in fact, a completely true and honest representation. People know that when they receive a bedspread or lawn mower, which they have ordered from a mail-order catalog, it will be exactly as it appeared in the illustration. If it isn't exactly as they expected, they'll return it.

You may be one of the photographers who possesses the technical ability to produce photographs that project authenticity, yet you are unable to find your way into those high-paying fields which will allow you to demonstrate that skill. There is a route that will allow you to make the most of your special talent. It's a route that's not too difficult to follow, and you begin by selecting the appropriate moment to take those first, exhilarating steps.

Choosing the Correct Time

This can be one of the most important decisions in your life. It can mean the beginning of an entirely new way of life, and it's essential that you launch yourself into the mainstream at the right time and in a way that puts the odds of success firmly in your favor.

It could be that you're already running a photographic studio, large or small, and would like to start aiming for the big advertising accounts. It's also possible that backed by considerable experience as an amateur or with formal photographic training, you are just about to start moving into the field of professional advertising photography.

Whatever your background, the success of your new venture rests on astute planning. Begin by taking four inventories: (1) your present equipment; (2) the equipment you will need; (3) your financial assets; (4) your technical ability.

The equipment you need will, to a certain extent, be determined by the type of work you intend to seek. If it's specialized work, you'll possibly need equipment suited to that particular type of work. If you intend to work in many different fields, your equipment will have to be such that you can use it for a wide range of subjects. Define

your objectives as accurately as you can, within the bounds of your present knowledge. If there is a particular field that has a very strong attraction for you, then concentrate on that field and determine to succeed.

Prepare yourself mentally. Know that you can succeed. Equip yourself with every scrap of knowledge you can gather. Research and study the advertising that has been used in that field and try to assess the possible advertising requirements for the next two years. Build a file on all other fields that have a bearing on the one in which you're interested.

If you have industry or an area of commerce as your target, know all there is to know about the advertising agencies that have accounts in those fields. If working for advertising agencies is your primary objective, discover as much as you can about the accounts handled by those agencies. The knowledge you gain will help you to assemble the precise equipment you're going to need. In this way, you can avoid investing money in expensive equipment that does nothing but gather dust on a shelf.

Apart from the studio and darkroom equipment, you should include in your inventory sufficient office equipment to enable your business to run efficiently: filing cabinets, account ledgers, desks, a few chairs, and perhaps a small area that can be set aside as an office. It should be a place sufficiently attractive for you to receive visitors but essentially a place from which to direct your business.

Also included under the heading of equipment should be samples of your work and an accurate idea of what your fees are going to be. Study your competitors. Watch local, national, and international trends in current advertising photography. You will not necessarily be following those trends, but you must be aware of what is happening around you at all times. Make it a point to subscribe to several trade magazines, not only those of the photographic profession, but those covering the fields in which you will be working.

When you begin taking inventory of your financial status, remember that your capital should be sufficient to keep you going for at least six months. Take into account the cost of buying supplies, rent, utilities, and salaries—including your own. Try to avoid the risks of undercapitalization. Probably more businesses have been forced to close due to undercapitalization than for any other reason.

The sometimes tedious but vitally important business of accounting will be dealt with at greater length later, but you must give your finances close attention from the moment you begin contemplating your new venture. It is well to consider that you may not receive your first paycheck until 28 to 60 days after completing your first assignment.

The fourth inventory, your technical ability, means that you should have a thorough understanding of your own qualifications. Don't be deterred by lack of experience or lack of technical ability, but make a truly unbiased appraisal of what you know and what you can do.

Profit from Self-Evaluation

Any areas in which your skill or knowledge are weak can be improved by study and practice. Experienced photographers will tell you that no matter how much you know, you will continue to learn with every assignment in which you become involved. Although you must be as prepared as possible before actively seeking assignments, you will always be gaining knowledge. The knowledge you gain from experience is sometimes expensive, but it is always the most valuable.

Advertising photography has no restrictions with regard to race or religion.

Sex is no barrier and neither is age nor educational standards. The one qualification you must have is the ability to take photographs that sell, and this is something you already possess or have to learn. You become stronger the moment you frankly acknowledge your limitations and your qualifications.

Make a list of your personal worth. This will include not only your present financial status, but your borrowing power, your education, your training in any field, all jobs or positions you have held in the past, and your personal hobbies.

Although you may not have had reason to give it much thought before, your borrowing power can be quite considerable. Credit cards can provide money in a hurry, and most banks will be willing to give financial support if you can offer sufficient security. Banks are usually reluctant to supply funds for a new business venture but will loan against life insurance policies, automobiles, boats, and some types of machinery.

Loan companies approach the business of lending money in a manner similar to that of banks, although they are sometimes willing to extend themselves against a smaller security. Because of the higher risk factor, loan companies usually have a slightly higher interest rate.

The Federal Government has one or two programs for making money available to businesses that are fighting to become established. Information on these programs may be obtained from your City Hall or public library.

If all the avenues for obtaining financial backing seem to be closed to you, there's always the private lender who will assess your potential and stake his money against a relatively high interest or part of the business.

It is far better to establish a business within the bounds of your own capital, but it is wise to know the extent of your borrowing power and to confirm this during the period in which your business is growing. It is always easier to borrow money when you don't really need it. You should, of course, never borrow money for the sake of borrowing it, and if it ever becomes necessary to take out a loan, make sure that you know beforehand exactly how much you need, how the money is to be used, and then make sure that it earns you at least double the interest you have to pay.

The telephone as a prop adds interest without being distracting. Photo by courtesy of Harry R. Becker.

In assessing your personal worth, the education you received has its own measuring stick. A broad education provides an outlook on life that will prove invaluable in any business. Advertising photography is the pivot point of a circle that encompasses an unbelievable number and variety of other businesses.

Although formal education is of great value, many men and women have reached the heights of fame and fortune without the benefit of education. So if your grades were not so good, you'll just have to try a little harder until you're looking back at those who had a flying start.

Your past jobs and training can be invaluable assets, because you have gained experience and knowledge that have been denied to many other people. Let us suppose, for instance, that you have been a door-to-door salesman. Even without consciously trying, you have learned what it takes to sell a product. You know how much the appearance of a product can affect a sale, and you know the value of advertising and sales material.

In certain areas of advertising photography, assignments are given only to photographers who possess an intimate knowledge of that particular field. Some mechanical-engineering projects frequently require photographs that can only be taken by a person with a background in mechanical engineering. Aerial photography is another field where previous experience is a considerable asset.

Your self-evaluation starts paying the highest dividends when you begin listing your hobbies and recreations.

How to Exploit Personal Preferences

Those hobbies and recreational activities in which you have become deeply interested can be placed high on your list. Regardless of what those interests may be, they can play an important role in creating an enviable niche for you in the field of advertising photography.

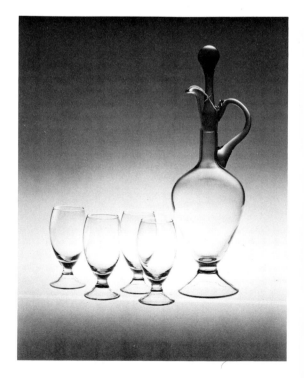

Photographing glassware can be one of the toughest assignments offered a photographer. It can also be the basis for an entire career. Photo by courtesy of Gerald William Hoos, International Photo-Art Service.

Careful selection of viewpoint can make the difference between a run-of-the-mill publicity picture and one that has dramatic appeal. Photo by courtesy of Gerald William Hoos, International Photo-Art Service.

There are many advertising photographers who were artists before they changed their medium from paint and canvas to film. There are top advertising photographers whose hobbies are cooking, butterfly collecting, scuba diving, and gold prospecting. In every instance, they have successfully used their special knowledge to further their advertising photography.

Although you may not have had the desire to go so deeply into your lesser interests, they too will add a considerable amount to your store of knowledge. It is a treasure chest of information that can suddenly prove invaluable. The following examples will illustrate my point.

With a little more knowledge of art, the photographer who recently constructed a modern dining-room set would not have been guilty of placing a Picasso reproduction upside down. And with more knowledge of professional archery, a recent advertisement would not have featured a beautiful model without a wrist guard.

A well-known soup manufacturer spent a lot of money to produce a photograph of a lavish meal in which the guests had been served tomato soup. Unfortunately, the elegant lady featured in the advertisement was tilting the soup plate toward herself. Amy Vanderbilt would have had a touch of the vapors.

These may have been minor errors due to a lack of familiarity by the

photographer, but they assumed importance because they were aimed at a specific section of the public, a section well informed and able to notice the mistakes. Those errors destroyed all hopes of conveying authenticity.

Can you imagine any hobby as remotely connected with advertising photography as conjuring or magic? There hardly seems to be any connection at all, yet many of the basic principles of professional stage magic are used frequently in the production of advertising photographs.

A simple example is the photograph of a product suspended in mid-air. It would be a simple matter to suspend a small article from nylon thread and retouch the line from the finished photograph. But retouching color transparencies can be an expensive answer to a fairly simple problem.

The problem becomes slightly more involved when perhaps 30 pieces of fruit are to be shown falling into a can. A magician might suggest pinning the fruit on thin wires protruding from the background behind the fruit. Another way to solve the problem would be to glue the fruit to a large sheet of glass, the edges of which extend beyond the format of the photograph.

The gentle art of deception is practiced every day by photographers to produce many of the startling photographs used in advertising. You may want to devise a method of photographing the flame of a candle but showing nothing in the photograph except the flame—no retouching. Or perhaps you can determine a way to photograph a ballpoint pen writing on a slip of paper, both of which are suspended in the center of a large drinking glass filled with water.

All hobbies and pastimes have the potential of solving problems or adding special effects to routine assignments. Eileen Knowles turns her hobby of flower arranging to good advantage. She specializes in photographing the interiors of very expensive houses for a large firm of real-estate brokers. The vases of flowers, which add that special touch of elegance to the photographs, have become a Knowles trademark.

As you would expect, the majority of advertising photographers climbed up through the ranks of amateurism—from an introduction to photography that rapidly developed into a consuming interest and then that almost inevitable decision to turn a fascinating hobby into a profitable profession. Once the photographic bug bites, the victim stays bitten for the rest of his life.

Turning a hobby into a profession is not too difficult. It usually begins with a gradual awareness of the many different directions in which photography extends and of the many applications in which a person can specialize, including medical, dental, agricultural, portraiture, weddings, aerial, pictorial, and advertising. With the recognition of these intriguing fields comes a burning desire to pursue one of them, either by enrolling in a school of photography or by simply going out and taking pictures.

Photography as a hobby has one drawback, the same drawback inherent in most other hobbies, namely, it costs money. When you've bought the camera, you have to buy film. Then it takes more money to have the film processed. Eventually, you begin to think it may be cheaper to do your own processing, so you begin establishing a darkroom. Your future begins to shape itself. Inevitably, you arrive at a decision to make your photography pay for itself; in this way, you can purchase better and more sophisticated equipment. With the new equipment comes the search for assignments in order to make the equipment pay for itself. This finally leads to more equipment and the need for a building or a studio of some kind in which to use it.

Before you know it, you're a professional, and you're right at the bottom of the ladder. But it's a big world, and you're filled with enthusiasm and a restless urge to progress. The door to a fascinating future is beginning to open.

How to

2

Hit The
Top Money Markets

The Big Three—Fashion,
Industry, and Commerce
The Ready Picture Market
Book Illustration
The Power of Pictures in
Politics

To be successful in advertising photography requires a happy balance between artistic ability and business acumen. There is nothing demeaning in admitting that you intend to use photography to make money. It is obvious that the more successful you become, the more money you will have to become even more successful.

In every profession, there are certain men and women whose lives are rich and eventful, individuals whose fame reaches across continents. Yet in the same profession are people who seem unable to climb more than the first few rungs of the ladder. If you have ever envied, even slightly, the photographers who are at the very top of the profession, remember that you and they have exactly the same 24 hours every day in which to work.

In any given 24-hour period, you can be earning money with your camera. Whether your earnings are in dollars or hundreds of dollars depends as much on the way you spend your time as it does on your photographic ability and the type of subjects you are photographing.

Most photographers enter the field of advertising photography with a predetermined idea of the type of subject in which they would like to specialize. Some, with a desire to combine photography with travel, apply themselves to work with airlines and travel bureaus. Others, intrigued by the bold sweep of a marble staircase or inspired by the dramatic starkness of a glass-fronted skyscraper, may decide to make architecture their specialty. The areas for specialization are innumerable.

Advertising photography is a sparkling gem with myriad glittering facets, any of which will provide an extremely good living for the photographer willing to work for success. But there are certain fields that command an income well above the average. These are the fields that return the highest dollar for every 24 hours of working time.

The Big Three—Fashion, Industry, and Commerce

Fashion photography must, at one time or another, be the ambition of every advertising photographer. Together with theatrical photography, it is certainly the most glamorous branch of the profession.

19

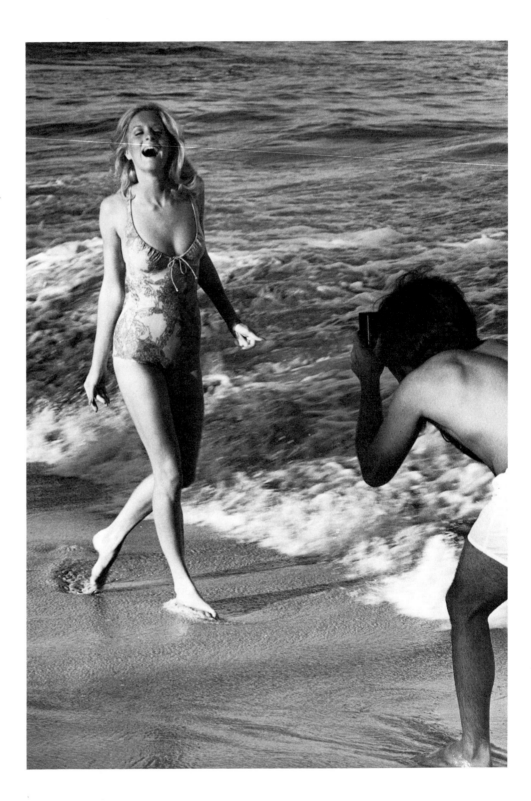

Photographing glamorous models on location in exotic settings is one of the rewards awaiting the successful advertising photographer. Here Steve Berman captures beauty on the run. Photo by courtesy of Hall and Levine Advertising Agency, on behalf of their client Catalina, Inc.

The models—men, women, and children—are stimulating and outgoing personalities who frequently find their way to stardom in the motion-picture industry. Roger Moore, Cybill Shepherd, Anne Heywood, Twiggy, Jacqueline Bisset, and Kim Novak are a few of the many stars who started out as photographic models.

Fashion designers too are exciting people to work with. Creative, artistic, and sometimes temperamental, they bring sparkle to the day's shooting. But beneath all the effervescence and showmanship lurks a deceptively keen sense of business—and the "rag trade" is extremely big business.

Fashion is constantly changing, and the demand for photographs is continuous. Once you are established as a competent fashion photographer, there is an abundance of work, and it is always interesting and challenging work. You could be taking photographs of rainwear in your studio one week and working with fur coats in France or Italy the following week. On one assignment the background could be simply a roll of colored paper and sunglasses as the only prop. Another assignment may require the Parthenon as a setting and a gleaming new Rolls Royce for a prop. Perhaps it is this continuous variety of settings and backgrounds that adds so much to the lure of fashion photography.

To the layman, the term "fashion photographer" conjures up pictures of voluptuous girls in very small bikinis or sultry sirens in slinky evening dresses, the type that so often appears in the glossy magazines. This impression is more fallacy than fact. Unless they are actually being used as an advertisement, this type of photograph is usually taken by the magazine's staff photographer and is part of the editorial content of the magazine.

The bulk of advertising fashion photography is directed toward the production of catalogs and as illustrations for sales representatives to show buyers. These photographs cover the whole range of wearing apparel, including suits, sports jackets, slacks, dresses, shoes, swimwear, and underwear, as well as the bikinis and the evening dresses. The term fashion photography also loosely covers the accessories, such as jewelry and purses.

The equipment needed for fashion photography varies according to the advertising agency's proposals or the requirements of the manufacturer. It can range from a single 35mm camera with a couple of lenses, used on location for the production of the modern-style candid pictures, to an 8″ × 10″ camera and a large studio filled with lights, props, and movable backgrounds.

Some of the larger studios are cutting the expense of taking models and camera crews on location by using front projection in the studio. With this system, the models are photographed against a special screen on which is projected a scene of the required background. This can be any setting the set designer can visualize, from a street in a foreign city to a giant enlargement of garden flowers. With the use of this equipment, the model appears to be part of the scene and can be shown apparently shopping in a street market or stepping out of an automobile. Ten minutes later, she may be skiing down a mountainside or even riding on the tail of a cruising airliner. The possibilities are limited only by the imagination.

The advertising photographer attempting to break into advertising fashion photography is faced with the usual problem of whether to tackle the advertising agency or approach the manufacturer directly. The majority of the larger fashion houses are represented by advertising agencies, and their latest creations appear in the national magazines with predictable regularity. The smaller manufacturers, working with restricted advertising budgets, are more concerned with selling their merchandise through established outlets. They endeavor to expand their markets by means of sales representatives.

Unless you have already established a reputation as an advertising photog-

Although the model is nude, it is the hat that catches the eye. For an advertising photograph to be really effective, it has to stop the viewer dead in his tracks. This photograph does just that. Photo by courtesy of Harry R. Becker.

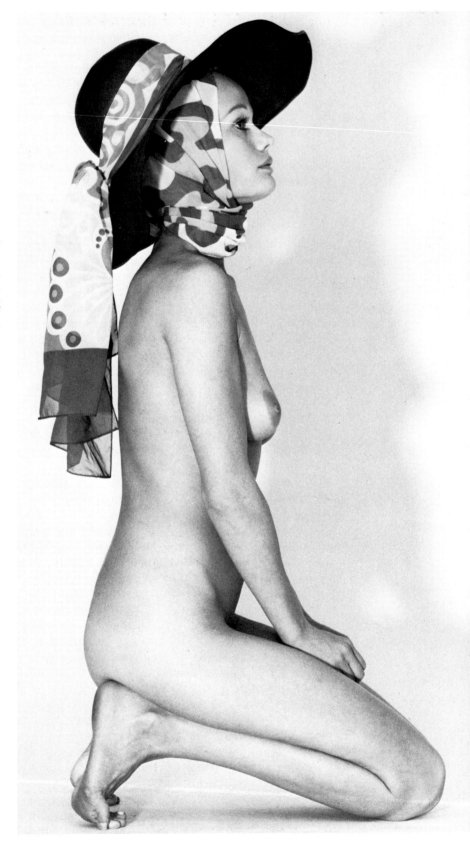

rapher and your name rings a bell with the advertising agency, the quickest way to get started in fashion photography is to approach the manufacturer and show him samples of your work.

The number of photographers who attain world acclaim in fashion photography, people like Richard Avedon and Cecil Beaton, is so small that there's always room for one more. How high you climb is determined by three factors:

1. Your technical ability. This must be above reproach. Your familiarity with your equipment must be such that your camera is almost a living extension of your fingers. Using your equipment should be a completely subconscious action. There should never be distractions in the form of questions regarding shutter speed, aperture, focus, and exposure.

2. Your ideas must be one step ahead of your competitors. To be a leader in any field means that you follow nobody. Train your mind to innovative thinking. Be daring, offbeat, and original. However, when the subject requires a more conventional treatment, then give it conventional treatment, but make it outstanding photography nevertheless. If your skill and your ideas are as individualistic as they should be, your photographs will convey your personality as surely as if they had been signed with your autograph.

3. To reach the top in the profession of fashion photography, you should work for the top fashion houses. Does that sound obvious? It is obvious. But the top designers will never know you even exist unless you bring your work to their attention. You may possibly wonder why top designers would ever consider a newcomer. The answer is in the subject matter itself. Fashion is always changing, always seeking to be unusual, eye-catching, and occasionally sensational.

Many photographers who would like to break into the fashion field are unaware that a large number of well-known manufacturers change photographers every year to ensure that the style of photography is different for every season. This systematic changing affords an unusual opportunity for the newcomer to expand his connections.

Make an appointment to see the advertising director, sales manager, or even the president of the company. Take along samples of your work. The samples do not even have to be of fashion photography, providing they are of eye-catching quality. Most manufacturers will give you a few minutes of their time. And assuming that your fee is not exorbitant and your interest in their merchandise is genuine, they will usually provide you with the opportunity to take a few photographs for them on a trial basis. The samples you show must make it clear that you are a capable photographer and will not be wasting their time.

Industrial and commercial photography cover the remainder of the photographic advertising field, but there are certain areas that are better paying than others. The basic difference between industry and commerce is that industrial products are used in manufacturing and construction, while commercial products are sold to the general public.

Industrial photography could involve you in the photography of heavy industries, such as chemical manufacturing, steel mills, oil drilling, and railroad construction. You may find yourself at the dockside, lugging cameras and equipment across the deck of a battered, old ocean-going freighter or scrambling around in a rock quarry photographing excavators at work. Industrial photography can be hard, physical work, but the energy expended is well matched by the high rates of payment.

Industrial advertising photography is used for advertising in trade and consumer publications, as displays at trade shows, and in applications and presentations for new contracts. Most of the work in this field comes through the advertising

agencies and is best sought with samples that relate to the work in which you are interested.

But be warned. When you are offered work outside your field of interest, be sure it is the type of work you want to do. Nothing can be more embarrassing than to arrive at a building construction site to find everyone ready to hoist you to the top of a high-rise building in a bucket dangling from a crane jib, only to have you confess that you have no head for heights.

Commercial advertising covers such a diversity of products that it would be impossible to list even a fraction of the items you could be asked to photograph. Just look around you; virtually every manufactured article is photographed at some time by someone. The work is not too difficult to obtain, either from an advertising agency or directly from the manufacturer.

The secret of success in this field is in being selective—in choosing the work that has the highest financial return for the time expended. High on the list of desirable work is the production of photographs for the catalogs used by the large mail-order houses. The photography is uncomplicated and usually requires little in the way of creative settings. In many instances where there are large numbers of similar-size objects to be photographed, it is simply a matter of placing them, in turn, on a seamless background, while changes in lighting and camera settings are kept to a minimum.

Mail-order giants, such as die Quelle in Europe, whose bi-annual issue of catalogs runs to more than 7 million copies, and household names, such as Sears Roebuck, Spiegel, and Sunset House, rely on beautifully printed, color-correct photographs for a large percentage of their business. Catalogs are used extensively by plant growers and seed producers, as well as hundreds of manufacturers whose products include lighting fixtures, cookware, bathroom fittings, hospital equipment, camping equipment, and automobile accessories.

For the advertising photographer who is prepared to develop exclusive skills, the solution to two perennial problems will put his services in constant demand for many years. The difficulties arise in the endeavor to convey, by means of a photograph, the fragrance of perfume and the sound of hi-fi.

The coupling of perfume to the photograph of a flower was only effective while perfumes were based on floral bouquets. Modern perfumes, with exotic names, are illustrated as having an erotic effect on the opposite sex. This theme will change as new products with new names appear in this keenly competitive market. The photographer who is able to provide a visual attraction for the olfactory sense will find his bank balance climbing at an unprecedented rate. In the same way, to convey the quality of hi-fi sound pictorially has been the ambition of many skilled photographers and artists, some more successful in their efforts than others. The opportunities are still there, waiting.

The Ready Picture Market

All professional photographers remain amateur snapshotters at heart. They take pictures for a living during working hours and for pleasure in their spare time. It's been said, with more than a grain of truth, that a photographer sees the world as a rectangle. Without conscious effort, he notices the grandeur of a mountain pass; he gives more than a passing glance at the character in a face; and a sunset exploding along the rim of the desert gives him cause to pause in his journeys. Deep within him stirs the unquenchable impulse to capture these impressions on film.

It is this compulsive desire to take and make pictures, together with the

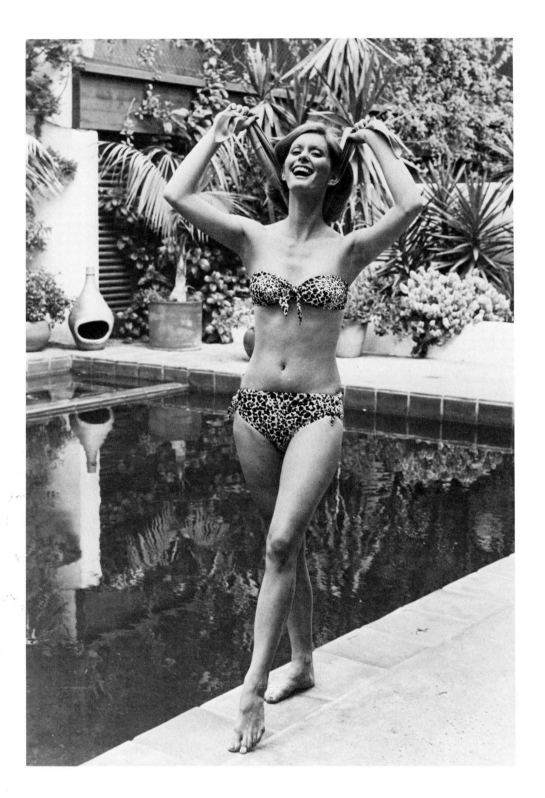

A fashion photograph that has everything: a lovely model, spontaneity, and a luxurious setting. Photo by courtesy of Hall and Levine Advertising Agency, on behalf of their client Catalina, Inc.

knowledge of photography as applied to advertising, that can provide a perceptive photographer with an extraordinary income when directed into productive channels.

The collection and systematic sale of stock pictures is a project that can be undertaken as a sideline, or it can be a complete business in itself. Once the four W's of Who, What, Where, and When are answered, the financial potential becomes obvious. Stock pictures are purchased by advertising agencies, publishers of newspapers, magazines, and books, writers, travel bureaus, city museums and libraries, record companies, calendar publishers, and many of the larger manufacturers.

Newspaper publishers will frequently approach stock-picture agencies for photographs of personalities. Travel bureaus are primarily interested in high-quality transparencies of tourist attractions, both at home and abroad. Their requirements, like the needs of travel associations, tourist boards, and airlines, are for a new and exciting pictorial approach. Photographs of the Eiffel Tower, Beefeaters at the Tower of London, and most of the Rhine castles have been long overworked. The current need is for the dramatic and the off-beat.

Publishers of magazines and hardcover books will sometimes buy stock photographs for covers. Publishers of paperback books, on the other hand, buy a considerable number of photographs every year, especially photographs with a sensual slant.

Not all fashion photographs require props and elaborate backgrounds. Imaginative lighting and careful composition can be equally as effective. Photo by courtesy of Harry R. Becker.

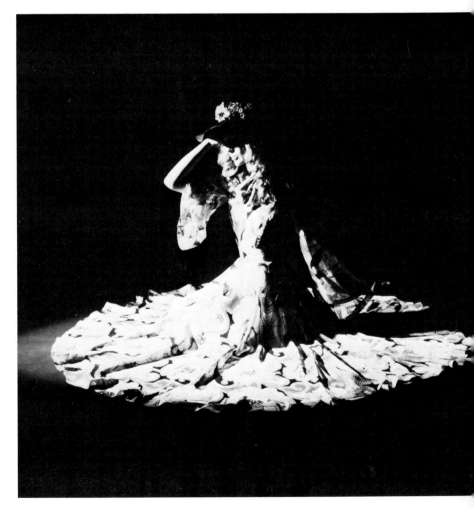

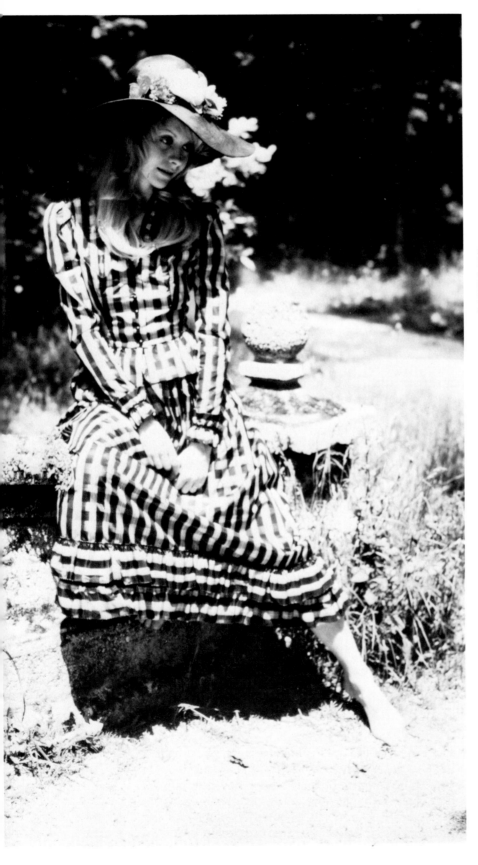

Mood and atmosphere can help to create unforgettable pictures. The relaxed model induces a feeling of tranquility in the viewer. Photo by courtesy of Harry R. Becker.

Although many record companies commission their own photographs for record sleeves, a good selection of colorful transparencies will usually tempt them into accepting those which they consider particularly suitable and attractive.

Writers and advertising agencies have fairly rigid requirements. In the case of a person writing a book or magazine article, the photographs have to relate to the subject matter. A writer in need of pictures will frequently try to avoid the cost of having pictures specially taken by seeking stock pictures that fit the manuscript.

Advertising agencies, particularly the smaller ones, will buy the type of stock photographs that can be used in many different ways—for example, dollar bills fluttering down from the sky, an arrow embedded in the bull's eye of an archery target, a hand rolling dice, or the sun creeping from behind a cloud. Stock photographs such as these need only the addition of a slogan or caption to be useful for many different products. Once your mind has grasped the applications for which pictures can be used, ideas will pour forth in a constant stream.

Photographs are often used in campaigns conducted by political and ecological associations to demonstrate the progress or lack of progress in city and urban development. Recently, a photograph of a beautiful valley was retouched to show how the valley would look if a contemplated dam project were to be approved. Although this photograph was not strictly an advertising picture, it was purchased from the files of an advertising photographer.

Manufacturers of many products, including automobiles, farming machinery, photographic studio equipment, photographic materials, camping and recreational equipment, and boats of all descriptions, will always be interested in considering the purchase of photographs showing their product in day-to-day use. Of course, the more sales appeal these pictures have, the more willing the manufacturer will be to buy.

Obtaining a collection of stock photographs can be pleasurable and relaxing, a welcome break from the strictures of shooting specific subjects. But the organizing and selling of these photographs can prove tiresome, unless tackled in a professional manner.

It is necessary to establish an efficient filing and indexing system so that the photographs can be located quickly and with a minimum of effort. Several systems are given in Chapter 12, and one of them will be suitable for your individual way of working.

Selling stock photographs can be accomplished by printing composites of several photographs on sheets of 8″ × 10″ bromide paper and circulating them to likely clients. The subject matter of the photographs on each sheet should follow a similar theme. Place several sheets of either similar or dissimilar subjects in a folder, the covers of which can be embossed or printed with a self-advertising logo, for presentation to prospective clients.

For advertising agencies that like to have a catalog of pictures close at hand, the sheets of photographs can be indexed under such headings as Industry, Children, Fashion, Sales & Promotions, and so forth. The catalogs should be supplemented regularly and brought up to date with fresh photographs and new approaches to current trends.

Manufacturers are better served by regular mailings of a small selection of pictures slanted directly at their specific market. For instance, firms making fishing tackle would be interested in purchasing action shots of hefty fish being pulled out of the water. It doesn't necessarily have to be their fishing tackle that is being used in the photograph, but if it is, the sale is almost a certainty. Also, automobile manufacturers will buy pictures of their vehicles traveling through picturesque parts of the country. Although large manufacturers have tremendous facilities for producing their own

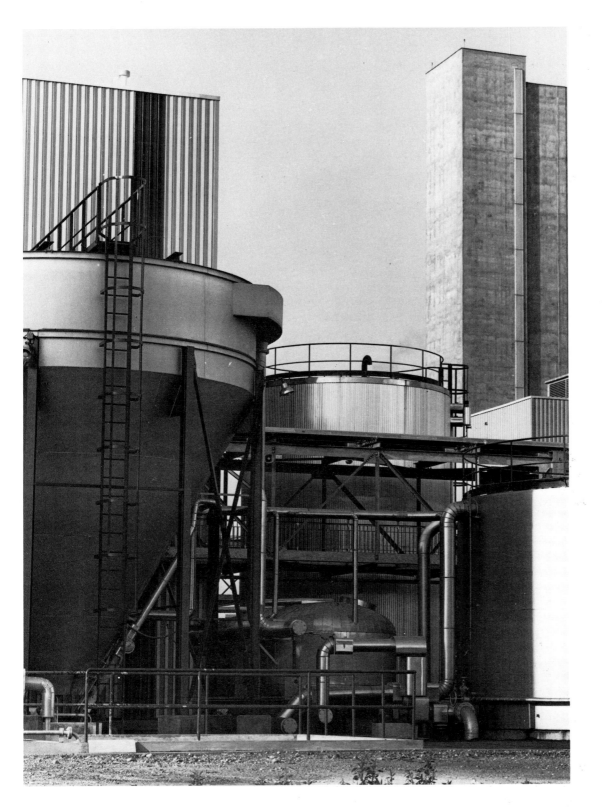

Industrial photographs will often convey a feeling of strength and power rarely found in other branches of the profession. Photo by courtesy of Studio Guy Marché.

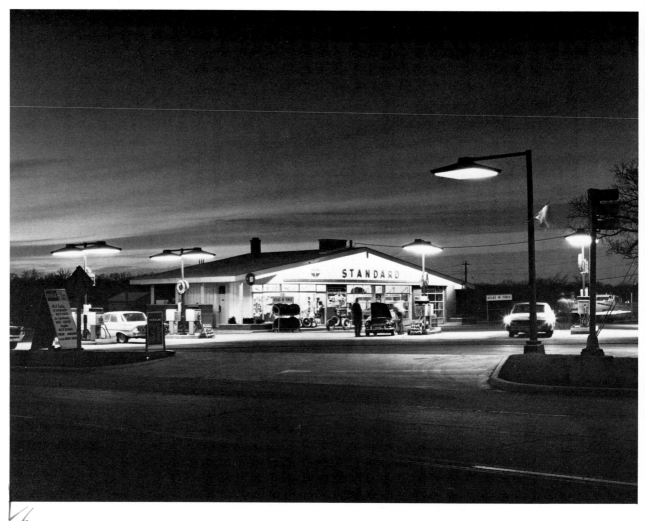

Even the ordinary everyday scene can be made to appear exciting by a photographer with skill and imagination. Photo by courtesy of Gerald William Hoos, International Photo-Art Service.

pictures, genuine "in use" pictures carry the unmistakable stamp of authenticity.

When supplying copies of photographs for use in advertising and people other than professional models are shown, be sure to observe the law that applies to the photography of people (see Chapter 8).

Book Illustration

Although it may be argued that producing photographs for book jackets or paperback covers is outside the field of advertising photography, most publishers would be inclined to disagree. Many a second-rate book has been helped by a good cover, and most people in the publishing business are well aware of cover impact.

There is considerable skill in producing a sales-compelling cover, and once you have demonstrated that you have the ability and can consistently produce the type of photographs required, you will never be short of commissions.

The photographer working with a publisher on a work of fiction is first given a copy of the book to read. From it he will extract some half-a-dozen situations he thinks will lend themselves to illustration. They must be situations that do not reveal an essential secret of the plot, yet are representative of the book's action. These half-a-dozen situations are then discussed with the publisher, and the final selection is narrowed down to perhaps two or three possibles. The format of the photographs will be decided upon, as will the areas to be left free from distracting detail so that the book's title and author's name may be given prominence.

At this point, the photographer is given a free hand to produce his pictures along the lines established and within the time limits of the assignment. Fees for the photographs are negotiated before shooting is commenced.

Covers for paperbacks can be produced and sold in the same way as the stock photographs aimed at advertising agencies. About two dozen transparencies, preferably 4″ × 5″, can be mounted four to an 8″ × 10″ sheet, placed in folders, and circulated among paperback book publishers, with an invitation for them to remove any transparencies they would like to purchase. They can be billed later for those removed, or if they prefer, a check can be included when they return the folder.

It is to your advantage to contact the publisher beforehand, explaining that the transparencies you would like to offer have been taken on a speculative basis. Remind him that although he is under no obligation to purchase, it may be to his advantage to spare a moment to look at the work you are sending. With this approach and the inclusion of a stamped, self-addressed envelope, the possibility of your folder being placed to one side and forgotten is negligible.

It is possible to have three or four of these folders in circulation at the same time. Not only are they a continuous source of income, but as you become accepted and your work becomes familiar, you will be commissioned to do special photographic covers.

Among the types of photographs that have the highest rate of acceptance in the paperback trade are science fiction, westerns, and crime. Science fiction photographs showing spaceships landing on crater-pocked planets or figures in space suits, armed with impressive-looking weapons and facing monstrous insects or cutting their way through forests of giant mushrooms are not too difficult to devise.

Clever ideas have to be supported by hours of careful planning and preparation long before they are ready for the camera. Photo by courtesy of Studio Guy Marché.

They can be table-top projects or involve the use of live models and photographic superimposition. Any costumes and sets constructed for such pictures can be used over and over again.

With paperbacks, the introduction of a little feminine glamor does no harm at all. The best incentive for success in this field is a quick survey of the paperback books on display at the local newsstand.

Producing covers can be extremely rewarding. The opportunities are slanted toward the photographer who possesses a little ingenuity, especially if he has an aptitude for construction. These assets, combined with perseverance, can be the foundation of an intriguing and highly profitable business.

The Power of Pictures in Politics

There is another application for advertising photography that will always be part of man's drive for achievement. Photography plays a vital part in every political campaign. The impact of high-powered pictures is undeniable, and there are two ways in which the advertising photographer can apply his talents to reap a very profitable harvest.

The first of these comes from the assignments provided by the public-relations firms that handle political campaigns. The second is achieved entirely by the initiative of the photographer.

Assignments from public-relations firms usually take the form of requests for candid pictures of the candidate—showing him engaged in a ribbon-cutting ceremony, talking with workmen at a new school-building site, or relaxing with his family at the beach. This type of so-called candid picture, usually carefully posed, is the bread-and-butter photography candidates and public have come to expect.

The real meat in the sandwich comes from those photographs which are judiciously selected and deliberated over by a committee of deep-thinking, experienced people. Such photographs are painstakingly arranged and carefully calculated to have the bite of a barracuda.

Photographs of this type may be required to illustrate the dismal achievements of an incumbent candidate. Slums, unwarranted expenditure on self-glorification projects, unchecked vice, and evidence of local unemployment are typical "destruct" campaign photographs. They are, of course, challenged by photographs that show the virtues and accomplishments of the candidate, photographs taken by a photographer with different political views to your own. The pay for this type of photography is invariably high, but the job requires a photographer who is deeply involved and emotionally concerned with his project. It is not suited to every photographer, but it is certainly very remunerative.

A more independent approach can be undertaken by the photographer who doesn't want to become deeply involved in politics but who has the initiative to see openings and opportunities overlooked by the political machine. The photographer who can visualize the use of photographs in publicity and who is free to plan his own projects can often produce more powerful photographic arguments than the photographer bound by prescribed assignments.

For this type of work, it is necessary to plan well ahead of election date, sometimes a year or more. It requires an accumulation of the type of pictures that will receive an enthusiastic reception from the public-relations firm or the campaign director.

If you can produce pictures that shout a message—a message that can shake an apathetic public into action—political publicity could be your future.

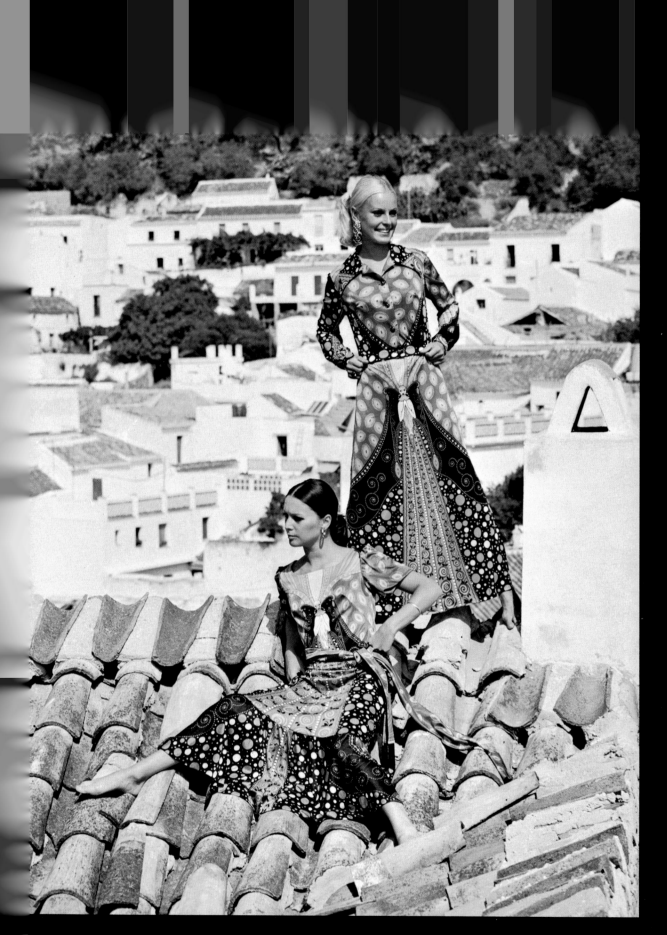

Fashion photography can sometimes be hazardous work, but it never fails to be interesting. Photo by courtesy of Harry P.

This type of photograph has been attempted many times by many photographers. The results are seldom as effective as this. Photo by courtesy of Gerald William Hoos, International Photo-Art Service.

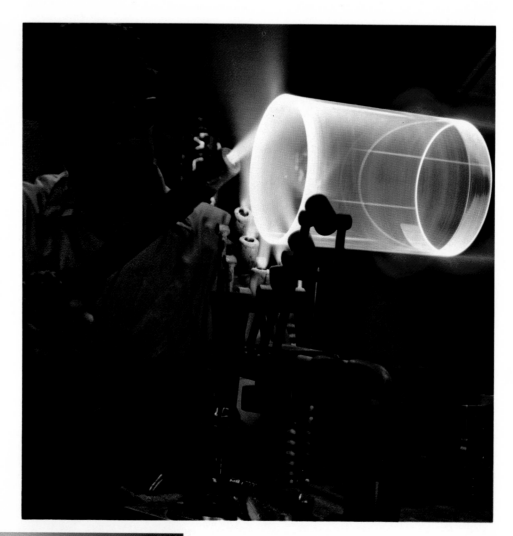

(Above) The challenge of industrial photography is captured in this unusual shot of a glass blower at work. Photo by courtesy of Gerald William Hoos, International Photo-Art Service. (Left) Close-ups are always effective. The public is attracted by details in familiar objects. Photo by courtesy of Gerald William Hoos, International Photo-Art Service.

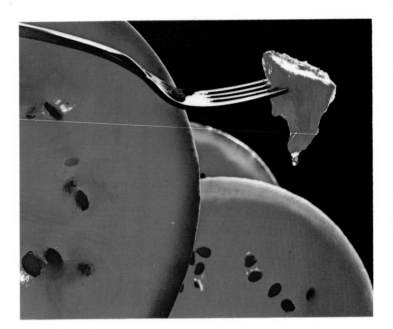

Skillful handling of shape and color result in
a striking graphic image.

A photograph far more difficult than it looks. Note the calculated rendering of form and texture. Photo by courtesy of Studio
Guy Marché.

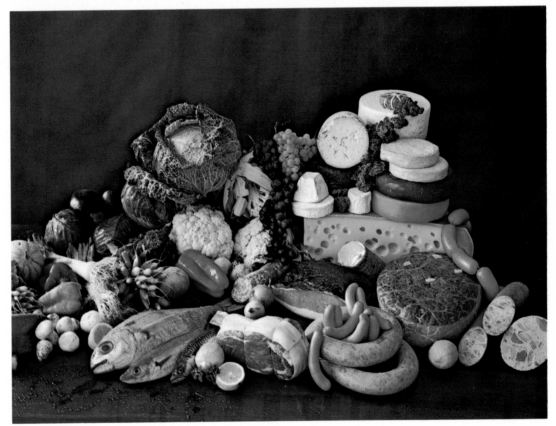

How to
Select
The Correct Equipment

Cameras and Lenses
Studios and Darkrooms
Choosing Special Equipment
Props That Work Miracles

Choosing a camera must be one of the world's trickiest problems. Only in a very few other professions is there such a choice, such a glittering assortment of gadgetry to quicken the pulse and gladden the eye. Every year, new models are introduced, each more sophisticated, higher in quality, better looking, and ever more complex.

The modern photographer must be part artist, part mechanical engineer, part electronics technician, and part chemist. It also helps if he has shares in a bank, for there's no denying that photographic equipment is expensive. The higher the quality, the higher the price.

Like the automobile, new camera models are introduced at regular intervals, each one seeming to be the last word in technical refinement, and then each takes one more unbelievable step forward.

Cameras and Lenses

The person contemplating the purchase of a new camera must either have a very clear understanding of the equipment available and know precisely what it will do for him, or he must put himself blindly in the hands of a photographic dealer.

The latter course is by far the easiest for the amateur. Fortunately, the photographic trade has a well-deserved reputation for honesty. The newcomer to serious photography can take comfort from the fact that photography is almost a fraternity. The people whose lives are built around the profession, whether they are amateur or professional, will always go out of their way to assist anyone with similar interests.

The professional photographer contemplating the purchase of a new camera faces the same confusing selection as does the amateur. But while he too can confidently approach a dealer and request information on the latest models and most recent developments, he has to fit his requirements within a fairly rigid framework.

Most newcomers to photography will buy a 35mm camera. It will produce acceptable pictures with a minimum of skill, and it looks professional. But the professional photographer doesn't want pictures that are just acceptable. He wants a saleable product—a

photograph in the exact form in which it was envisaged. The camera is simply a tool that will enable him to produce that product. What the camera looks like matters hardly at all, providing it will do the work required.

This brings us back to the framework within which the professional photographer must make his choice on a set budget. The camera must be as flexible as possible; it must be able to tackle a wide range of subjects without the need for too many accessories; it must also have unquestionable standards of performance.

Although many professional photographers have several cameras, lenses, and accessories at their disposal, there has to be a base from which to start building a range of apparatus. That base can be determined by a knowledge of the work contemplated and a thorough understanding of the applications of each piece of equipment.

It would take a comprehensive textbook to explore the advantages and disadvantages of all the equipment presently available. Camera manufacturers are able to put forward some very convincing arguments in favor of their particular product, but they would agree that cameras generally can be considered as belonging to one of three classes: 35mm and smaller, $2\frac{1}{4}'' \times 2\frac{1}{4}''$, and $4'' \times 5''$ and larger.

The final decision on the apparatus best suited to your particular needs can only come after careful deliberation, but a brief outline of each of the classes may be of some assistance.

Since the first Leica, the Model A, was introduced to a skeptical photographic world in 1924, 35mm photography has grown steadily to achieve the tremendous popularity it now enjoys. The better-class cameras of today are miracles of engineering and electronic technology.

In the hands of a master photographer, today's 35mm camera will produce photographs of such technical excellence that it would be almost impossible to fault them. But because of the small size of the 35mm negative, every step in the production of the finished print or transparency must be made under meticulous control. Focus, exposure, and processing require a flawless technique.

With the easy and fast film-advance mechanism of the 35mm cameras, it's a great temptation to shoot a large number of pictures in an attempt to obtain quality by means of quantity. Being able to shoot half-a-dozen exposures in as many seconds in the hope that one of them will be satisfactory is simply wishful thinking and no answer to true craftsmanship. The professional photographer using a 35mm camera exposes each frame with care and a complete understanding of the techniques that will give him the exact results he requires.

The 35mm camera has several distinct advantages that must be taken into consideration. Of prime importance is the tremendous number of lenses available, including the invaluable zoom. The quality and performance of the majority of these lenses leave nothing to be desired. They do, of course, cost money, and the more lenses you buy, the more you increase the overall cost of the camera, especially since most accessory lenses require their own filters and shades.

The extreme lightness and portability of the 35mm camera are other big points in its favor. These assets are negated slightly by the number of accessories you add to your outfit, but there's little doubt that for many action shots and for ease of manipulation, nothing touches the 35mm camera.

The $2\frac{1}{4}'' \times 2\frac{1}{4}''$ format camera achieved considerable popularity prior to World War II, with the introduction of the Rolleiflex and Rolleicord cameras. They had the great facility of allowing the photographer to view and compose his photographs on a frosted glass screen, while retaining much of the portability lacking in the larger view cameras. It is always so much easier when you can study the depth of field and composition on the focusing screen. Small details, which sometimes escape the

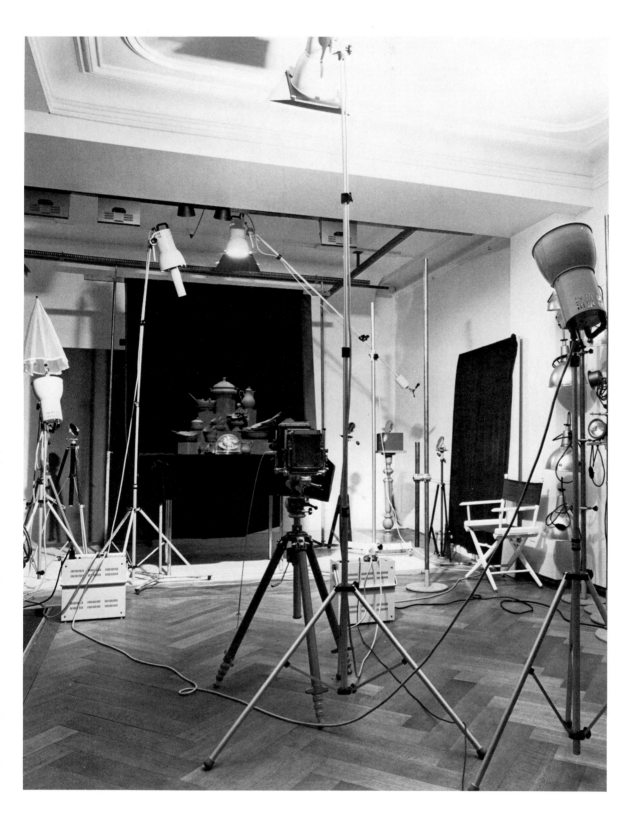

As the studio grows, so the equipment becomes more complex and more specialized. Photo by courtesy of Siegfried.

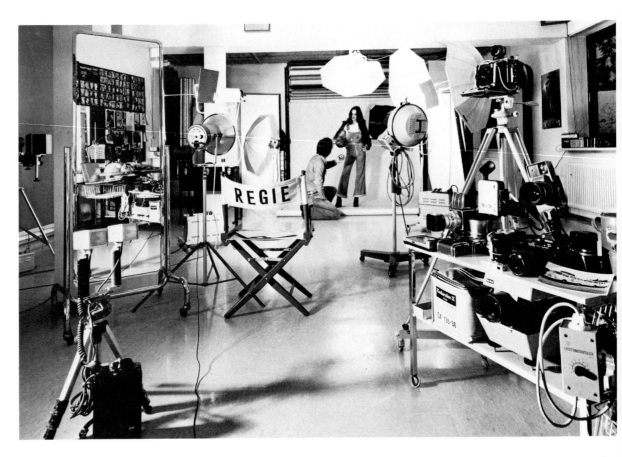

Advertising photographers have to do their share of personal advertising. It never hurts to let your prospective clients know that you have an efficient, well-equipped studio. Photo by courtesy of Harry R. Becker.

notice of even the most careful photographer, suddenly become very obvious when viewed on a screen.

The Rollei gained tremendous fame as an all-round camera and rapidly became one of the most sought-after cameras. In recent years, the comparatively expensive 2¼″ × 2¼″ single-lens reflex has brought the added luxury of inter-changeable lenses and backs. The photographer armed with a few extra backs can switch from one type of film to another in a matter of moments. The matchless quality of these cameras places them in a class of their own, and they dominate the field of fashion photography.

Advertising agencies appreciate being presented with 8″ × 10″ cards on which 12 transparencies are mounted between sheets of protective plastic. They find the transparencies easier to view than 35mm, and there is room on each transpar-ency to crop to the format required.

The roll film for 2¼″ × 2¼″ cameras is easy to obtain, a factor which can be important when the photographer is working on location in remote areas where film is in limited supply. This is particularly true of location work in some of the underde-veloped countries. Professional photographers working on location usually take their

own film with them in refrigerated containers, preferring the tested emulsion to the risks of working with film of uncertain sensitivity.

The 2¼″ × 2¼″ camera probably staked its greatest claim to fame when astronauts took a Hasselblad camera with them into outer space.

Most professional photographers, however, are inclined to lean in favor of the still larger 4″ × 5″ format, the greater bulk and lack of maneuverability being offset by a number of important advantages. For example, extension rings, which are accessories for close-up work with 35mm cameras, are not necessary with most 4″ × 5″ cameras. The bellows extension on 4″ × 5″ cameras is designed to allow the photographer to get really close to the subject without the need for extra attachments. The difference in cost is also a consideration. The smaller, professional-quality cameras, without accessories, will frequently be more expensive than their larger brothers.

But perhaps of more significance to the professional photographer is the fact that interchangeable lenses, and an assortment of backs, film holders, and adapters of various sizes make the 4″ × 5″ camera very versatile. Switching from color transparency film to infrared or from macro lens to telephoto is fast and uncomplicated. The focusing screen is an aid to visual composition, and it is possible to use the camera for action shots one moment and for copying the next.

As with all equipment designed and produced especially for the professional photographer, the 4″ × 5″ camera is extremely practical and capable of producing high-quality photographs. Some of the most important features, found only on the larger cameras, are the provisions for swings, tilts, rise and fall of the lens and film plane, the facility to photograph a tall building without having to tilt the camera, and the means to increase the depth of field without being compelled to use an excessively small aperture.

Before deciding which camera or cameras will be the foundation of your business, study the advantages and disadvantages of each of the classes of cameras. Decide whether the features of the larger camera would be suitable for the type of work you have in mind. Investigate the possibilities of the 2¼″ × 2¼″ cameras, and examine the higher-priced 35mm cameras. Don't let your choice be too restricted by a question of price. A few dollars difference either way, measured over the length of time you hope to be using the camera, must be a very insignificant amount.

If you are knowledgeable about cameras, you will probably be inclined to consider used equipment, especially when you are just getting started. The luxury of buying a camera fresh from the factory can usually be postponed until the clients are established and orders are rolling into the studio.

Professional equipment is meant to be used, so your choice must be a product with a high reputation, one that will stand up to considerable wear and tear. It will be used under scorching sun and it will be frozen by assignments that call for photographs in the depths of winter. Sand from desert winds will test its seals, and location photography at the beach will expose its metal fittings to the most severe corrosion.

Your camera should also be backed by a well-established line of parts and accessories that will enable you to build up a full range of equipment as time allows. Choose apparatus that will not go out of date or become redundant. Careful thought at the beginning can save a lot of money and frustration at a later date.

Although we have been primarily concerned with cameras to this point, they are not too useful unless complemented by high-performance lenses. Modern technology has given us lenses with incredible resolving power coupled with immaculate color correction. Even inexpensive cameras boast of lenses capable of very fine definition.

The more expensive lenses are designed to perform definite functions from wide-angle to telephoto, and your choice of lens must be governed by the photographic field in which you will be working. Never begrudge the money you have to spend to purchase a first-class lens. High-quality photographs are the only doorway to a successful business.

There are times when crispness and high definition are not required. But when a manufacturer wants to see every fiber in his new line of winter coats, you'd better have them there or he's looking for another photographer.

Most manufacturers want to see their product rendered truthfully. You may be asked to emphasize the good points or to provide a dreamlike setting, but the photograph remains free of intentional deception. Using lenses of incorrect focal lengths and choosing the wrong viewpoint can account for a lot of unintentional distortion.

Taking a simple photograph of a line of drinking glasses and maintaining a row of perfect ellipses can prove a problem, unless you are completely familiar with camera movements and lens aberrations. The same problem of distortion exists when photographing such items as a string of pearls. No jeweler would appreciate a photograph of a necklace with perfectly round pearls at the center of the string and egg-shaped pearls at the edges.

Not too many advertising photographers have the opportunity to photograph jewelry. Such work is usually reserved for the studios that specialize in this field. It requires considerable skill and a fertile imagination, but there are great rewards for the photographer who can acquire the special techniques.

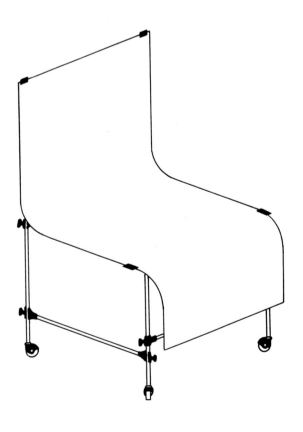

An easily constructed table, or "stage," will facilitate the photographing of small articles. The framework may be made from tubular steel, angle iron, or wood. The platform is opaque, flexible plastic.

Studios and Darkrooms

Advertising photography may be successfully pursued just about anywhere—in the center of a bustling city or hidden away on the outskirts of a rural village. If the work produced by your studio is impressive and able to hold its own in this competitive field, customers will go out of their way to retain your service. It makes no difference whether your studio is housed in an abandoned church, a specially constructed building with every modern convenience, or even an old barn. It's the quality of the work put out by your studio that counts.

The person contemplating his first photographic studio will probably be a little intimidated by the sheer magnificence of some of the studios with which he one day hopes to compete. Their way of business may represent his ultimate goal, but for the present they appear to be formidable competition.

Such fears are groundless. Some of the biggest names in advertising photography work from studios barely large enough to swing the proverbial cat. These photographers seem to revel in their cramped conditions, producing high-powered photographs that surpass many taken in more pretentious studios. The secret of their success is that they only accept the type of work that suits their particular setup. They concentrate their interest and knowledge on certain areas of advertising photography, and they are fully equipped for these assignments. The seemingly chaotic tangle of lighting cables, props, and cameras is really a well-ordered, systematic arrangement, which experience has proved to be best suited to these specialized projects.

The larger studios, making the most of their more spacious premises, usually have several projects going at the same time, with specially constructed sets in various parts of the studio. With their greater floor space, these studios undertake the photography of automobiles, yachts, and earth-moving machinery as part of their day-to-day work. Building a complete kitchen or living room is almost routine.

Some of the more desirable features you should seek to install in your own studio are dressing rooms located close to the shooting stage, an efficient air-conditioning unit (studios can get uncomfortably warm after the lights have been on for a while), and a floor that is easily cleaned and smooth so that light dollies will roll without snagging against projections and cracks. As you will undoubtedly be shooting color film, the walls and ceilings should be painted with a white paint that will reflect light of the correct color balance.

Your studio is your factory. It should be designed for expansion and be sufficiently flexible to accept changes brought about by technical advances and the purchase of new equipment.

Every successful studio, large or small, is backed by a competent processing unit. In the majority of cases, that unit is part of the advertising studio, usually in the same building, but sometimes it is housed in a different building and goes under a different name.

The processing unit, or laboratory, acting as an independent subsidiary, is able to accept work from amateur photographers or other professional photographers who do not wish to burden themselves with the additional task of processing. Sending work to another laboratory for processing is an acceptable proposition when the studio is small, perhaps a one-man operation, or when the processing would necessitate the installation of extensive equipment.

Most independent laboratories, especially those that offer specialized services to professional photographers, will give individual treatment to any film sent to them and make every effort to give the same careful attention that the photographer would give to his own material. But there's no doubt that the advertising studio which can

The prop room of one of the world's largest advertising studios. Photo by courtesy of The Alderman Company.

supervise its own processing has a slight edge over the photographers who send their work out.

If you are interested in doing your own processing, there is the initial cost of setting up a processing station. This can be a simple and small darkroom equipped with a 35mm-4″ × 5″ enlarger, safelights, tanks, film-drying cabinets, timers, and all the equipment necessary to develop film and make black-and-white or color prints. While stainless-steel or Fiberglas sinks and trays make for cleanliness and increased efficiency, plastic is a practical and less expensive alternative that can be replaced with more durable material as the studio progresses.

Your darkroom can also be as elaborate as a fully automated processing laboratory, equipped with preprogrammed machines and capable of turning out anything from an 8″ × 10″ black-and-white print to a huge color transparency mural or a dye-transfer print hand-matched to the original product. The limitations are your personal qualifications or inclinations—and available capital.

Assuming that you are content to start small and grow at a steady speed, there are several reasons why it is an advantage to do your own processing. To begin with, you have greater control over the delivery times; you are able to inject your personal touch into the finished product, imparting that special effect you had envisaged at the time you took the photograph; you can also indulge in a little darkroom trickery to produce those special effects which can be achieved without the use of a camera; there is also a certain saving of money, against which you must offset the time you spend in the darkroom when you could have been in the studio taking more photographs or out seeking new clients.

Your first studio may be started with a minimum of equipment: perhaps two

floodlights, an inexpensive but substantial tripod, a light meter, one or two rolls of seamless paper for backgrounds, and a quantity of fairly heavy-gauge lighting cable.

This is the foot in the door, but gradually as work continues to come into the studio, the need for more extensive and special equipment becomes more imperative: the single camera becomes supported by perhaps two or three more; ceiling and free-standing banks of lights make their appearance; the camera tripod becomes a studio stand strong enough to support the largest studio camera together with front-projection equipment; and the rolls of background paper have accumulated until they are sufficient to meet any requirement.

It is during this stage of development that you may consider switching from tungsten studio lighting to electronic flash. At one time, it was argued that although electronic lighting had the advantage of being the same color temperature as daylight and provided much cooler lighting conditions than tungsten, the photographer had less control over his medium. There were no electronic flash spotlights, and it was impossible to control the intensity of the light. It was also considered difficult to envisage shadows and to judge the relative brightness of fill-in lights.

Progress has changed the situation considerably. Electronic studio lighting now has a built-in modeling lamp, which the photographer can use to position his lamps and balance key lighting against fill-ins. Spotlights may be purchased in several sizes, including remote-control boom, and most electronic flash have at least two settings to give alternative intensity.

The initial expense of equipping your studio with electronic flash is much greater than it would be for tungsten, but it does have a number of advantages worth considering.

Choosing Special Equipment

It is in the purchase of special studio apparatus that you can invest money wisely to acquire equipment that will pay for itself time after time in the production of still finer pictures, with a savings in time and trouble that turns a good investment into profit.

A pocket-size electronic flash unit should be one of your first purchases, and a good one is always worth the acquisition. It is invaluable as a light source for occasional photography under adverse lighting conditions, and it will often serve as a fill-in to lighten shadows created by harsh sunlight.

New advances in electronic flash design have produced a unit with computerized circuit, which automatically calculates the subject distance and gives a flash of sufficient duration to provide correct exposure. This means a greater number of flashes per charge and a faster recycling time.

One of the more important pieces of equipment making its appearance in studios throughout the world is electronic front projection—a means of photographing a model or product against an infinite number of different backgrounds.

This system of projecting a color transparency onto a special glass-beaded screen is much less cumbersome and bulky than the older system of back projection. The screen on which the transparency is projected is specially constructed to reflect all light back to its source with less than 2° of scatter. It is possible to turn a spotlight on to this finely textured surface and watch it reflect back a brilliant white light. But you can see this lighted reflection only when you are standing immediately behind the spotlight. In any other position, the screen would appear to be completely dark and unilluminated.

By means of a surface-coated mirror, the camera shoots down through the beam of the projected transparency and photographs the scene reflected back up

the beam. Although the model may be lighted in the normal way, the brilliance of the reflected background scene is balanced to an equal level of illumination so that the model appears to be part of the scene.

Because the camera is shooting down through the beam from the projector, it cannot see the shadow of the model, cast by the projector onto the background. The shadow is hidden immediately behind the model. Any shadows cast by the studio lighting are not seen by the camera, because all extraneous light falling on the background is reflected back to its source.

It would seem that the camera would photograph the part of the background scene which is projected onto the front of the model, but the light reflected by the model is so much less than the intensity of the same scene reflected from the special screen that it is not recorded by the camera.

Front projection has the potential of cutting down on the substantial expense of sending photographic crew and models on location. All that is required are transparencies of the necessary backgrounds. There is little doubt that more and more use will be made of this system as time passes.

Another small piece of equipment that can be of considerable value is the remote shutter release. This can be either pneumatic or electric, and preferably one that can be easily extended in length. The remote shutter release is particularly useful in fashion photography, giving you the freedom to stand away from the camera and make last-minute adjustments to the props or to instruct the model, while retaining control of the exact moment for exposure.

Often overlooked by the amateur but treasured by the experienced professional is the large folding reflector made of aluminum or foil-covered cardboard. These reflectors provide a soft, even illumination, and they are as useful in the studio as they are outdoors. Many photographers have them in various sizes, including the miniature ones used for table-top photography.

Your work may entail the photography of small items, such as machine tools, glassware, electronic equipment, or any small parts that require you to move in close. For such work, a specially constructed table can save you any number of headaches and provide you with the means of taking some really imaginative photographs.

The table is a framework built from wood or perforated angle iron, shaped like a large chair. The back of the "chair" is provided by a large sheet of flexible, opaque white plastic that comes around in a gentle curve to form the "seat" and then extends down again to the floor. The "seat" or stage should be at a convenient working height, and the back, which serves as the background of the stage, should be of sufficient width so that edges of the framework will not appear in the photograph.

The whole unit, mounted on casters, provides an exceptionally useful addition to the studio equipment. The translucent panels can be illuminated from the rear or from the front, and with the use of colored spotlights, some spectacular effects can be achieved.

Every studio should have at least two large sheets of glass or acrylic plastic, strong enough to bear a reasonable amount of weight. They are useful when it is necessary to photograph products against an out-of-focus background. The sheets of glass or plastic may be supported horizontally on small stands, one above the other, with the product to be photographed on the upper sheet and the objects for the background on the lower sheet.

It takes very little imagination to see the possibilities of such a setup. For instance, a rose could be placed on the top sheet, a large color photograph of an attractively landscaped house on the second sheet, and a still larger photograph of an evening sunset on the floor beneath the third sheet. Another setup could consist
of an ordinary pot scourer resting on the top sheet of glass and illuminated by a white

Electronic-flash studio equipment is more expensive than tungsten lighting, but it has the advantage of providing much cooler working conditions. Photo by courtesy of Bron Elektronic.

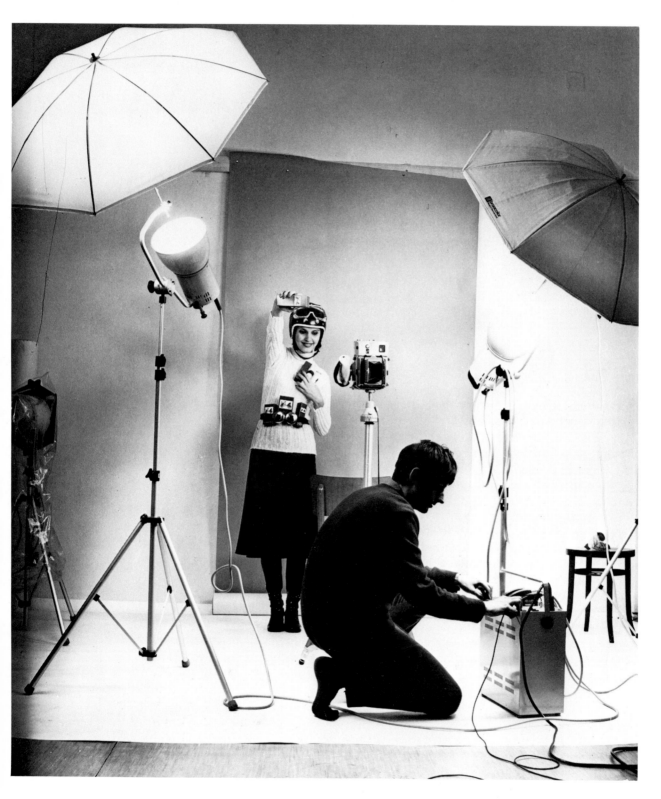

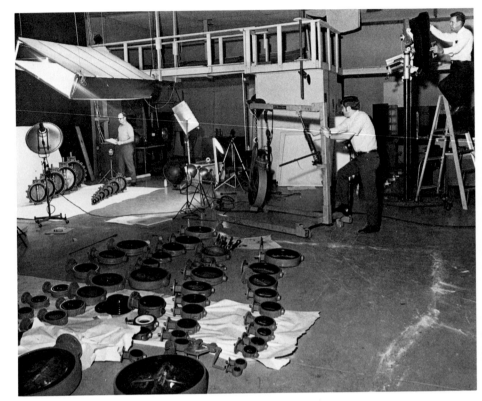

Not all advertising photography involves working with glamorous models, but every assignment is a challenge requiring skill and imagination. Photo by courtesy of Harper Leiper Studios, Inc.

spotlight and a few glistening pots and pans on the second sheet, illuminated by a number of spotlights of different colors.

Every piece of equipment in the studio does not have to have a specifically photographic function. A pair of steps and a couple of ladders will often be worth their weight in color film. Fogging machines that fill the air with a light mist can bring that special mood and atmosphere to location shots taken in early morning or late evening.

Pressurized cans of spray may also be added to your special-effects department. Spray snow, or frost, has obvious uses, while matte brown or black paint can turn a piece of new wood into an old, weather-beaten board. Special lacquers can add a sheen to a dull metal surface or remove troublesome reflections from one that is too highly polished. Even rubberized spiderwebs can be sprayed to give that wine-cellar appearance to old barrels and racked bottles.

While spray cans and fogging machines are not specifically photographic equipment, they add that extra detail, which can lift your work above that of your competitors. There are many other items not normally found in a camera store but without which many photographs would lose that eye-catching quality that is so important in advertising photography.

Props That Work Miracles

With the possible exception of some forms of catalog and industrial photography, most advertising photographs require one or two props to lend atmosphere or to help tell the story. For example, a photograph of a young man waiting on the

Even the camera may be used as a prop.

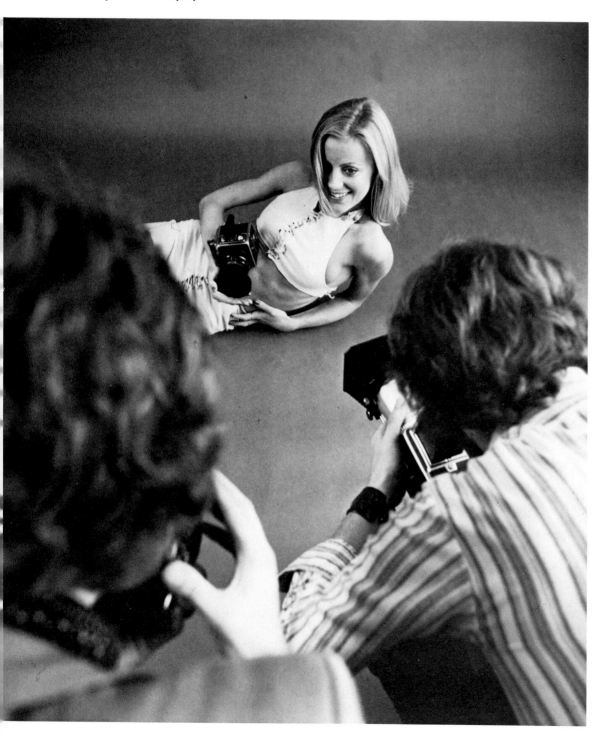

platform at a railway station could mean anything, but put a large bunch of a dozen roses in his arms, and you can almost see the person for whom he's waiting.

The photographer with ideas can find props everywhere. He'll find them at garage sales, in antique shops, and in department stores. A piece of driftwood from the beach or a worn, leather-bound book from the used bookstore can suddenly inspire an idea for a picture and are added to the studio collection. Keep your eyes open for small, unusual items everywhere you travel—things the average person would overlook.

Although your props must never draw attention away from the product, the more selective you are in choosing props, the more character your photographs will possess.

Props can mean many different things to many different people, but there are a few special props that the top photographers find indispensable. High on the list of indispensable props is a good fan or wind machine, especially if fashion is to be your vocation. A photograph of a bikini-clad model standing posed before a front- or rear-projection beach scene will spring to life if a breeze is tugging at strap ends and loose strands of hair. That same wind machine can lift dust around the wheels of an apparently moving vehicle, give slight blur to a foreground of grass, or swirl falling leaves.

If you are likely to be photographing small metal or ceramic articles, such as cutlery, engineering parts, or dinnerware, a light tent will help you to avoid all the troublesome reflections from studio lights. The light tent is a wire or wood framework over which is stretched thin muslin or cheesecloth, leaving a hole for the camera lens. The objects to be photographed are arranged on a table top in the normal way, and the light tent is placed over them. The light tent can be constructed to any size within a few minutes and is well worth the small trouble involved.

A few minutes spent arranging the position of the studio light to illuminate the outside of the tent will provide a soft, even light inside the tent, leaving the objects to be photographed free of distracting reflections.

Other useful items that will eventually find their way into the props cupboard are: rolls of colored gelatin or cellophane film, sunglasses, beach towels, thumbtacks, clothes pegs, a tube of impact glue, powdered styrofoam (snow substitute), some velvet and satin offcuts, and a reel or two of fine nylon fishing line. A large, free-standing mirror placed alongside the camera is an extremely valuable accessory that will enable the model to check her pose just prior to your tripping the shutter.

Another accessory that will inspire superior photographs is a tape recorder. Most models and photographers work better and more smoothly against a background of suitable music—not so loud as to be distracting, but sufficient to convey an atmosphere of relaxed activity. A further use of the tape recorder, and one that is not as well known as it deserves to be, is as a timer in the darkroom. When processing is inclined to be rather lengthy, as is the case with some color materials, taped music helps to dispel any boredom. But more than that, the tape recorder can provide audible instruction and precise timing for each step of the processing procedure between breaks in the flow of music.

The inventive photographer will usually have many pieces of equipment he has devised as time savers or to produce special effects. But there is a special group of accessories without which the studio would gradually grind to a standstill. They are the samples that are used to obtain further work.

The sample you show to potential clients can mean the difference between feast or famine. Those samples must be slanted to each type of work you are soliciting and presented in a way that will ensure a favorable reception.

How to

Get Money-Making Assignments

Samples That Hit the Jackpot
Professional Presentations
Dealing with Manufacturers
Getting the Work
The Presentation
Selling Your Services
The Tie-in Technique
The Requirements of Printers and Publishers
How to Approach Advertising Agencies
Your Personal Interests Pay Off
Applying the Personal Touch
Estimates and Quotations

Ours is a world influenced, guided, and persuaded by advertising: Magazines devote pages upon pages to advertisements; billboards shout at us from the roadside; and even the public transport systems use the areas between windows, above windows, on the back of doors, on the front of doors, over, under, through, and below—anywhere they can find a few inches of space—to provide us with that special message.

With all this advertising, it is understandable that the newcomer to advertising photography would expect to find photographic assignments waiting to be snapped up at every turn. Unfortunately, it doesn't work that way. Photographic assignments have to be earned. They have to be secured by a carefully planned series of actions, one of the most important of which is the preparation and presentation of sample pictures.

Samples That Hit the Jackpot

Power-packed sample pictures are the key to Aladdin's cave. They are the hard evidence that you are as good as you say you are; yet even some experienced advertising photographers fail to realize the vital importance of dynamic samples.

Bryan Seagraves had been an advertising photographer for eight years. He was married, thirty-two years old, and he heard opportunity knocking. It was hammering hard enough to smash down the door.

Bryan had worked steadily to build his business, tackling any jobs that came his way, and gradually had acquired new and better equipment. Over the past three years, he had begun to specialize in the photography of mobile homes. His photographs, mostly straightforward, illustrative shots, were used in the production of brochures and for advertisements in trade magazines.

He was shooting interiors on a lot at the mobile home factory when Don Dimmond, the president of the factory, called him into his office. Mr. Dimmond gestured him to a chair. "We've decided to start using the services of an advertising agency," Dimmond said shortly, "one of the big ones." He paused and then added, "I've told them about you and the work you've been doing for us, and they are very

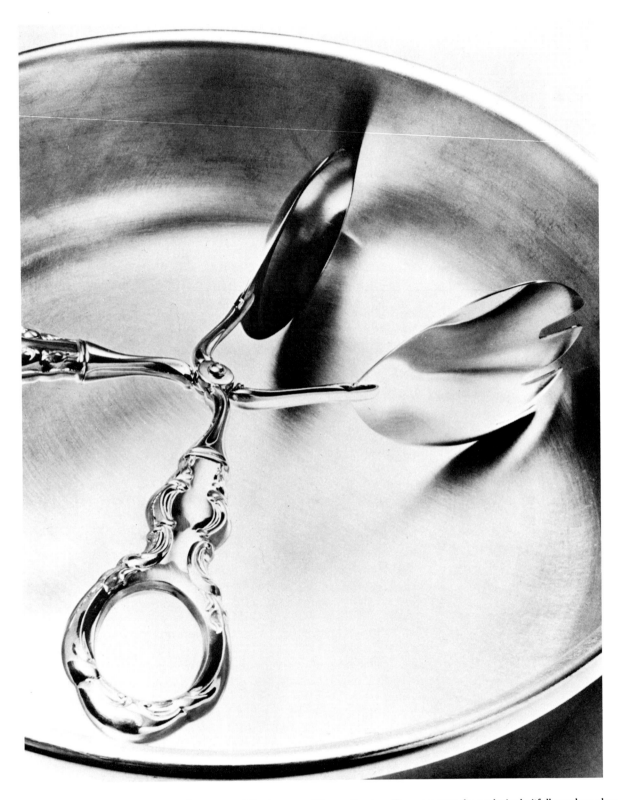

Photographing silverware is one of the more difficult areas of the profession. To overcome the technical pitfalls and produce an artistic interpretation requires a high degree of skill. Photo by courtesy of Los Angeles Art Center College of Design.

interested. They've got other photographers on call, of course, but they suggested that perhaps you might like to take along some samples to show them."

Bryan's eyes showed sudden interest. This was a chance to get into some really progressive and high-paying photography. "Sounds real good. I'd sure like to thank you for the opportunity," he said.

The president waved aside his thanks and pushed a slip of paper across the desk. "Here's the address," he said. "Ask for Bob Reubens. He's vice president and he'll be expecting you." He smiled and added, "Bob and I are old golfing buddies. He's been after our account for years."

Bryan Seagraves recognized the name on the slip of paper as an agency he had canvassed once or twice before but had never managed to get past the receptionist. He wasted no time. The following day he gathered together a portfolio of samples and presented himself at the agency. The receptionist took his card and promptly ushered him into a large, expensively furnished office.

Bob Reubens was a thin, gray-haired man. He greeted Bryan cordially, accepted the samples, and began to examine them one by one. The 8″ × 10″ color prints were scrutinized and handed back without comment. The 4″ × 5″ transparencies were spaced out on a light table and given more detailed study.

The questions were casual. But they were questions Bryan had been asked before and he was expecting them.

"What light source were you using on this one?" Reubens asked.

"Electronic flash," Bryan replied.

"Bounced?"

"Sometimes, it depends on the subject matter."

"How long have you been taking photographs of mobile homes?"

"About three years, but I've had my own business for about eight."

"What type of camera do you use?"

"Most of my work is done with a 4″ × 5″ Linhof, although I sometimes use a 35mm Nikon."

"How much would you charge for, say, a day's shooting on location somewhere local?"

Bryan knew that the larger studios charged a minimum of $65. His usual fee was $55, and although he had been considering increasing it to $60, he did not intend to lose this opportunity on a question of price.

I would take one 4″ × 5″ transparency, one 4″ × 5″ color negative, and one 4″ × 5″ black-and-white for $50. That would include supplying an 8″ × 10″ color print and an 8″ × 10″ black-and-white."

The gray-haired man smiled. "That sounds reasonable enough." He rose to his feet and handed back the transparencies. "Well, it was very nice of you to drop by and give me the opportunity to look at your work," Reubens said. "Leave your card with my secretary, and if anything comes along, I'll be in touch with you."

Bryan Seagraves often wondered why he never heard another word from the agency. He knew his work was above average, possibly better than that of the photographers who were on constant call by the agency, yet something had gone adrift. "It's probably a case of the old Buddy Buddies," he told himself.

He was wrong. No successful advertising agency will give work to a photographer or artist whom it considers unable to provide the high quality required. The field is too highly competitive for an agency to risk losing a client due to ties of friendship. Each contributor to an advertising campaign, including artists, photographers, copywriters, and designers, is appraised entirely on performance—on his ability to present the client's product to the public effectively. And that ability can only be judged, in the first instance, on the samples submitted.

4

49

A photograph that needs no words. Photo by courtesy of Harry R. Becker.

Bryan Seagraves was a competent enough photographer, but in his approach to gain recognition by the advertising agency, he had made several mistakes.

As an advertising photographer trying to break into new markets, you can benefit from Bryan's mistakes, and his first error came with the opportunity to make a presentation. As with every other presentation, this one should have been planned with the thoroughness of a beachhead landing.

The samples Bryan had hurriedly gathered together were "seconds." That is to say, they were backup pictures taken on previous working assignments. The client had been given the best photographs, and Bryan had retained second or third pictures taken at slightly different angles or exposures for his files. They were almost as good as those submitted to the customer, but they were still "seconds."

Bryan's second mistake was his failure to find out the type of accounts handled by the agency. If he had, he would have discovered that the agency had a nationwide reputation for the brilliance of its off-beat ideas. It had established a name for an original, highly imaginative photographic approach. Bryan Seagraves was quite capable of producing this type of photography, but his samples gave no indication of his creative ability.

Professional Presentations

Given the opportunity all over again, Bryan should have immediately phoned Bob Reubens, thanked him for the invitation to submit samples, and said that although he would be out of town on an assignment for a few days, he would phone to make an appointment as soon as he returned. This would have provided time for the necessary research and preparation.

The next step should have been to check the Advertising Agencies' Blue Book, which gives a listing of the leading accounts handled by the nation's advertising agencies. A little research at this time would have revealed the type of advertising put out by this particular agency.

With this information in hand, a set of samples should have been prepared, slanted along the lines established by the agency. In this instance, Bryan could have broken away from his routine mobile-home photography and let loose his imagination. It would have been an excuse and an opportunity for some really electrifying, mind-bending photography—for example, the bottle of perfume, solarized and superimposed in the center of an orchid; the sensitive electronic switch apparently activated by the weight of a butterfly; the bottle of champagne thrusting out through a sea of grapes and photographed on a sheet of glass illuminated by colored spotlights beneath the glass. A little imagination and effort were all he needed.

Regardless of statements to the contrary, there is little doubt that size sells, and Bryan should have had this in mind when preparing his samples. A few 16″ × 20″ color prints are more impressive than a fistful of 8″ × 10″ prints, and half-a-dozen 8″ × 10″ transparencies have far greater impact than three dozen 4″ × 5″ transparencies.

There was one other point on which Bryan Seagraves could have had second thoughts, and that was his decision to quote a low fee. Most business executives know that when it comes to flair and technical ability, "you only get what you pay for." They may negotiate later on a fee for a special project, and this would have to be considered at that time; but when submitting samples, you should quote your customary fee.

Don't be apprehensive when quoting fees. If they are lower than your prospective client had expected, you are already two strides ahead. If they are higher but

A catalog shot that is greatly improved by giving it an appropriate setting. Photo by courtesy of Gerald William Hoos, International Photo-Art Service.

Advertising photography for the manufacturers of photographic materials and equipment must be creative, visually impressive, and above average technically. Anything less than the highest quality photography could seriously affect sales. Photos by courtesy of Ilford, Inc.

your work reflects superior quality, you will not be turned down out of hand. Rather, you are more likely to be given the chance to quote fees on a specific project.

As your business grows, you'll find yourself making presentations and showing samples to many different types of business enterprises, each of them requiring an individual approach. Manufacturers, in particular, need careful consideration prior to a presentation. You will discover that this consideration, when directed along the right lines and with an understanding of the manufacturer's special problems, will bring you as much work as you can handle.

Dealing with Manufacturers

Many manufacturers look on both the professional photographer and the advertising agency with a certain amount of suspicion. They are fully aware that in order to sell their product they need exposure to selected markets. They are also aware that they should present their product in a dramatic or emotional way. Yet they are cautious. They fear that a high-powered, professional advertising campaign can bankrupt a new product before it even gets off the ground.

So what do they do? They settle for half-and-half—they compromise. Jack,

the factory foreman, is given the task of taking the photographs. "He's just bought a new camera, so we should get some good pictures," says the boss. They let Shirley, the president's secretary, write the copy, and the whole project is then handed over to a local printer with instructions to "Run off a few brochures."

The inevitable happens. The half-hearted effort achieves little return, and from then on the word "Advertising" is treated with even more skepticism.

Overcoming this skepticism is really the biggest obstacle facing you as an advertising photographer when you approach a new client. There are periods during a manufacturing run when photographs are not required, but with every new model or modification, with every sales promotion, fresh pictures are needed.

Getting the Work

There are several highly successful techniques which, when properly applied, will practically guarantee you work from the most hypercritical manufacturer.

The first objective is a face-to-face meeting with someone of sufficient authority who can offer you an assignment. This is usually the owner or president of the company. With a very large corporation, it may be the sales director or general manager.

The easiest and most effective method of gaining an interview is by simply telephoning ahead for an appointment. This is a common courtesy many would-be salesmen overlook. The name of the person with whom you wish to meet may be obtained in advance by asking the receptionist. If it is a large corporation, you could check Thomas Register of American Manufacturers in your local library.

In a few instances, the person with whom you are requesting an interview may try to impress you with his authority. He may protest that he doesn't have time to grant you an interview and then demand an outline of your presentation over the telephone.

Don't be bulldozed. Just tell him that you have a specialized service which could help him reach his sales objectives and that you would like to show it to him. If pressed further, point out that it is essentially a visual presentation and that you would be wasting his time trying to explain it over the telephone. This is an approach which is both polite and businesslike. Very few sales-conscious manufacturers will refuse you at least a few minutes of their time.

The Presentation

Having arranged a meeting, there is a definite pattern you should follow in order to make your presentation as effective as possible. If your timing is good and there is an immediate opening for your service, you should be able to walk away from the meeting with a definite assignment. In any event, your presentation must be sufficiently effective so that work will be made available to you within the very near future.

The visual part of your presentation must be striking. Your samples must be clean and fresh and slanted to the product manufactured by the firm to whom you are making the presentation. And remember that with your samples, a good big 'un is better than a good little 'un.

Before the interview, make yourself familiar with the manufacturer's products. Discover what he makes and how the products are used. Ask yourself how your pictures could help sell these products. Your own photographic knowledge and ability should provide the answers.

Be prepared with a basic scale of charges calculated on the type of work you anticipate, but be ready to amend and requote if the work offered is different from what you had expected.

Selling Your Services

It often happens that a manufacturer will recognize the advantages of using the services of a go-ahead, creative advertising photographer but be a little uncertain as to how those talents can be put to use on his behalf. Be prepared to put forward a few ideas. Try and start a train of thought in his mind. You could suggest, for instance, the use of large blowup pictures of the factory or the product as a background for his booth at the next trade show. You may be able to stress the value of fresh ideas in illustrative packaging as a sales incentive.

You might also interest him in the use of photographs as silent salesmen. Just recently, the manufacturer of adult games almost doubled his sales by the simple expedient of placing a small brochure in each of his boxes of games. The brochure, beautifully illustrated with photographs, showed four other games in the series. So many sales stemmed from this brochure that his products began to dominate the market.

Another aspect of photography in industry, which may not have occurred to the president of a busy manufacturing corporation, is the use of 35mm color slides for worker tuition. Quite often a series of lucid photographs will explain a technique in manufacturing far better than hours of verbal instruction. Keep a record of all the suggestions you offer. You may find them useful in other presentations.

As your experience grows, other applications for you skills will suggest themselves. Photographs from your files can be used for exclusive promotional calendar pictures. Showcards, banners, and instruction manuals all have photographic possibilities.

But there is one piece of advice of which you should take careful note. It can save you time, considerable frustration, and resentment. Never offer a photographic advertising concept in its entirety. There are several good reasons why, and here is one of them.

Not very long ago, a clever and inventive young advertising photographer was striving to get ahead. Out of the blue, he visualized a new and dramatic way of tying cigarettes into various aspects of recreational activity. He selected one of the leading brands of cigarettes for his samples and created a series of brilliant photographs illustrating the idea, using games of chess, poker, football, and motor racing as typical themes. The photographs were presented to the sales director of the tobacco company, who thought the idea was a winner and forwarded the photographs to the advertising agency that handled the company's advertising.

The photographs were mailed back to the photographer a few days later, with a brief note saying that although the photographs had considerable merit, they didn't fit in with the established advertising theme. You can imagine the photographer's anger a few weeks later when he opened a newspaper and was confronted with a full-page advertisement showing an artist's rendering of the cigarettes tied into a recreational theme. It was a direct take-off of his idea, and subsequent publications followed up with artists' renderings of boating, cycling, fishing, and so on through a long line of recreational activities.

Needless to say, the young man never received a penny, but it did lead him to develop a different technique for presenting his ideas. At no time in the future would he let his sample pictures out of his possession. The photographs he showed always illustrated a similar product made by another manufacturer. If the person to whom

Providing your clients with top-notch work will undoubtedly guarantee you future assignments from them. Photos by courtesy of Ilford, Inc.

he was making the presentation agreed that such an approach would suit his product, the photographs would be retaken and offered on an exclusive basis. The photographer also stipulated quite firmly that he regretted that he could not allow longer than ten days for a decision on whether the idea was acceptable. His fast rise to prosperity indicates that not only were his ideas acceptable, but his method of presentation was very effective.

Although nine out of ten advertising agents and manufacturers have a very strong code of ethics, it is still good policy to keep your best ideas on ice until the time is ripe to produce them.

The Tie-in Technique

There is one further way of obtaining new business, and several well-known advertising photographers use it continually. It is known as "the tie-in technique" and it works like this:

Let us imagine that you have been asked to take photographs of a swimming pool and assume that you are going to use live models in the picture. You will first obtain the approval of your client, then go along to a swimwear manufacturer, tell him of your assignment, and ask if you could borrow one or two of his best-selling creations. In return, you agree to supply a series of photographs. Don't use the word "free"—it cheapens. Offer the photographs with your compliments.

Most manufacturers will accept some verification of the photographer's identity and agree to go along with the idea. The advantages of an arrangement of this kind are quickly obvious. The swimming pool manufacturer obtains some very attractive props, the swimwear manufacturer is presented with a set of first-class pictures, and the photographer, in offering the photographs to the swimwear manufacturer, makes a presentation demonstrating the quality of his work. It is an effective technique when used correctly, but don't expect to borrow diamond rings or mink coats.

The Requirements of Printers and Publishers

When working with manufacturers, the advertising photographer inevitably comes into contact with the local printer, and this can be of considerable benefit. Working exclusively with printers can be a profitable arrangement, one worth considering.

If your target is to succeed in the business of advertising photography as quickly and competently as possible, you can find sufficient work with printers and publishers to keep you busy 24 hours a day, every day of the year.

Although most printers deal with work of a wide variety, some printers and most publishers tend to concentrate on specific fields. There are, for instance, printers and publishers who deal with horticulture and farming activities to the exclusion of everything else. There are those whose work is restricted to the world of fashion. Still others specialize in engineering, electronics, or aviation. The fields of specialization are innumerable, and they cover the full range of human interests.

The most profitable field of specialization is probably that of catalog illustration. Sometimes, especially in the case of the huge catalogs issued by the larger mail-order firms, the photography is divided up amongst several advertising photographers, each working within his own field of specialization, such as fashion, furniture, tools, or sporting goods. When the catalog is confined to a single line of products, all the illustrations are usually handled by one photographer.

In catalog photography, the photographer is allowed a certain amount of artistic interpretation, but there are firm guidelines established by the layout artist to which the pictures must conform—directions, such as models to face right, backgrounds to be different but related in each picture, or instructions for a piece of equipment to be photographed at a certain angle to reveal a special feature.

When applying for work of this nature, it would be to your advantage to mention that you are able to work from advertising agency layouts or that you are familiar with the problem of producing top advertising pictures, working from a few vague suggestions from the client. This is assuming, of course, that you are in fact able to do so.

Other publications that offer high payment for special photographic techniques or knowledge are, among others, cookbooks, sports, wildlife, horticulture, hobbies and recreational activities, architecture, marine biology, fashion, aviation, archaeology, mineralogy, and medicine.

There are two other high-profit opportunities for the progressive advertising photographer, both of them requiring special techniques and the ability to get into the mind of the client. These are the illustrations for service or instruction manuals and photographs for the paper jackets of hardcover books.

The instruction manuals require clear, self-explanatory pictures of procedures that are easier to show than to put into words, for instance, the dismantling of an automobile transmission or the steps in a surgical operation. Thousands of illustrations for service manuals and textbooks are used every day, and there is room for an expert photographer in every facet of this huge gem.

Book jackets require you to read the book in advance and select two or three dramatic situations you think would make eye-catching cover pictures. From these the publisher will select the one he would like you to attempt.

When making presentations to printers and publishers, it is advisable to show samples of this type of work. If you consider that either of these two challenging fields could be your line, dream up a few typical examples, work on them until you have half-a-dozen really top-rate samples, and then start phoning for appointments. There are so few really accomplished photographers in these fields, that a newcomer with obvious promise is assured an extremely cordial reception.

Publishers frequently work very closely with advertising agencies, especially where the release of a special book is concerned. Printers too usually have close connections with advertising agencies, so it is essential that you know how these agencies operate.

How to Approach Advertising Agencies

To the uninitiated, the Advertising Agency represents an exclusive, big-money corporation with powers bordering on the mystical. In fact, an advertising agency can be anything from a one-man business working out of his living room to the agency with representation in a dozen different countries, hundreds of accounts, and thousands of employees.

To enter the offices of one of the larger agencies is more impressive than gaining admission to the White House or Buckingham Palace. The breathtakingly beautiful receptionist behind the block-long walnut desk, the ankle-deep carpeting, the piped classical music, the closed-circuit television cameras focused on the entrance foyer, and the expensive perfume carried on the softly flowing air provide a precisely calculated impression—that of unlimited success.

To the prospective client, it is a setting carefully designed to promote confidence. To the advertising photographer fighting to gain a foothold in a new and competitive field, it is a scene likely to promote uncontrollable panic.

Be reassured. Across that thick, luxurious carpeting, and behind those richly paneled walls is a man very much like his counterpart working out of his living room. He is an approachable man, invariably courteous, considerate, and knowledgeable. Above all, he is a man looking for someone who can help him make his business more successful. You can be that someone. You can be that special individual who makes an appearance at a time when the agency is groping for fresh ideas, when the agency is seeking an entirely new slant on a current problem. The samples you are carrying may spark an idea that could build into a million-dollar advertising campaign. It is your method of approach that is so important.

The secret of a successful interview is in making sure that you meet with the right person. With the smaller agencies, you will probably be talking to the owner or one of the partners. This presents no special problem, because they are people who are ever on the watch for new talent. The meetings are usually informal and friendly. But remember, they are busy people, so keep your discussions short and let your samples do most of your talking for you. Your presentations to the larger agencies will probably be centered on a meeting with an account executive; and if your samples are sufficiently outstanding, a subsequent meeting with one of the vice presidents follows.

Make your customary telephone call beforehand, asking for an appointment, and don't be too disheartened by a refusal. Be persistent and strong minded. Skillful, thought-provoking photography is not an everyday talent, and no agency will knowingly let such ability go to a competitor.

Most advertising campaigns are the result of weeks or months of careful planning and research. Ideas formulated by the agency are presented to the client for his approval, a budget is established, and when everything is finalized, the program is set to go.

The majority of advertising agencies do not have their own photographic studios. They call upon the services of experienced advertising photographers whose work they have come to know and on whom they can rely. A few advertising agencies have subsidiary photographic companies. Once you know which ones

Once in a while, it's all worth it.

Once in a while, one of your students will show that tiny spark, that you know, with proper guidance, will burst forth into a giant talent; that miraculous time when he sees not just notes on a piece of paper...but music.

At times like these, you're happy you invested in a better piano. A piano that brings out the best in your newfound prodigies. A piano whose tone is unequalled. Whose response is instant, cat-like. And a piano that will stay in tune longer; will give years and years of faithful service. In short...a Baldwin.

Not all of your students are going to turn out to be great pianists, but all of your students need the extra help they can get from a great piano. We know, and you certainly know, teaching is not all sunshine and roses, but . . . once in a while it's all worth it.

We would like to invite you to come by our showroom, sit down for a couple of hours and try a Baldwin. There are 36 different styles to choose from. We think you'll feel it's worth it.

Baldwin
The Sound Investment

A successful advertising photograph is rarely the result of a one-click-of-the-shutter shooting session. The photographer must work with his subject, taking many pictures before the right combination of elements is hit upon. In the picture above, the unnatural pose with the right leg hidden would have proved disconcerting to the eye; in the picture at left, a subtle shift of position made all the difference.

operate this way, you will be able to save time by avoiding them, as they rarely place work outside of their own satellite studios.

Your Personal Interests Pay Off

Your greatest opportunities are with the advertising agencies that specialize. If your personal interests are in photographing people in action, look for the advertising agencies that handle political campaigns, accounts for sporting goods, or public relations for civic centers. This will give you a chance to use your skills in portraying people to their best advantage.

If you prefer photographing sprawling meadowlands and majestic mountains, gather together your samples and make appointments with agencies handling accounts such as International Harvester, Mercury Outboard Motors, or Sturm, Ruger and Co. Agencies handling accounts for travel associations, tourist boards, airlines, and recreational vehicles often have need for good scenic pictures.

As before, always make your applications to those agencies producing advertising pictures and copy dealing with subjects that interest you. Your enthusiasm for that subject will be reflected in the samples you submit.

Advertising agencies may be busy places, but the people who work in them are alert individuals. They are people who have a sensitive finger on the pulse of public opinion. They are intensely interested in other people. They keep abreast of current political trends; they watch for phrases and slogans that capture the public's imagination; and they are constantly aware of new products, people in the news, and the efforts of their competitors; and if approached in an interesting fashion, they will be interested in you.

Applying the Personal Touch

Make your business cards different in appearance (not in size, as this could result in their not being suitable for a business-card filing system).

Be knowledgeable in the type of advertising currently being evolved by the top agencies.

Watch for "snob cycles" and adapt your approach to cope with them. Snob cycles are strange periods of something akin to ultra-conservatism, and they seem to occur in certain trades and professions. Advertising agencies are subject to them as are, among others, the fashion trade, big-time sports, artists, architects, designers, and the acting profession.

At one time, no advertising photographer was considered the complete professional unless he owned a Hasselblad camera. Whether he could use it or not didn't seem to be very important. There was also a period when it was the "in" thing to be the product of a certain university.

For some strange reason, American advertising photographers are extremely popular with English advertising agencies, while English advertising photographers receive a very warm welcome in American agencies. Perhaps it's something to do with the grass being greener.

Watch for these trends and turn them to your advantage. While you may not fit into the category presently finding favor, you can often find a way to turn the spotlight in your direction.

More than one advertising photographer has started his own trend. There was, for instance, the well-known photographer who held a one-man exhibition

ESTIMATES & QUOTATIONS

Shots Required	Number Taken	Number Requested	Size	Material Cost	Processing Cost	Total Cost
Black & White						
Color Transparency						
Color Negative						
Prints						
black & white						
color						
Flashbulbs						
Travel Cost						
Assistant's Fee						
Shooting Time _____ hours @ $ _____ per hour						
Retouching						
Stationery & Postage						
Model Fees						
Model 1.						
Model 2.						
Model 3.						
Special Equipment Rental						
Special Equipment or Accessories Purchase						
Setup Time _____ hours @ $ _____ per hour						
Model Changing Time _____ hours @ $ _____ per hour						
Time (Consultations with Client) _____ hours						
Time (Travel Time to Client) _____ hours						
Insurance						

Total _____

Profit Calculated at _____ %

Estimate Quoted _____

Date _____ / _____ / _____

4

featuring nudes of very beautiful women. He mentioned to the press that the world's most beautiful women came from Bulgaria, and he would never think of using a model from any other country. Almost overnight, it became the fashionable thing to be known as a photographer of Bulgarian womanhood. Years later, the photographer admitted that the models came from several different countries—not one was from Bulgaria.

Estimates and Quotations

In covering most of the aspects of working with advertising agencies, there is one subject that is the cause of some concern to the photographer taking his first big strides—that of giving estimates and quotations.

To some advertising photographers, giving a quotation is all part of making a presentation, and they take it in their stride without a worry. To others, it represents a delicate balance between accepting a very small profit or not getting the work at all. Being able to give accurate estimates and quotations is essential. They are the foundation on which a successful business is built. Every quotation you give must be accurately calculated and based on up-to-the-minute factors.

You must know how many shots are required and how many will actually be taken. You must take into consideration the cost of film, flashbulbs, time, travel, and postage. You should be aware of hidden expenses, such as insurance, setup time, and outside labor costs.

To make it easier to arrive at accurate cost and profit figures and to ensure that no expenses are overlooked, prepare a form. List every conceivable expense and cost, together with the profit you have decided is necessary.

A list of this kind will help you avoid the possibility of underestimating expenses that could eventually be the difference between making a reasonable profit or suffering a substantial loss. You may find it necessary to include provision for other expenses that occur from time to time, such as overnight accommodations, meals, location search fees, or preshooting location visits.

Allow for the unexpected or last-minute change of plans. The time expended waiting for the sun to move into exactly the right position or to come out from behind a cloud may only be a matter of 10 or 15 minutes, but in terms of wages for yourself, assistant, and models, it could amount to more than $100. Any expenses you haven't allowed for in your quotation are paid out of your profits.

The amount of profit you make is a personal matter and calculated on the competition you face from other photographers and sometimes on the size of the firm for which you are working. Occasionally, you will calculate your profit on the type of work you will be doing. It could be dangerous work, for example, on high buildings under construction, underground photography, or working with wild animals. It could be work where special creative talent is required, particularly when it is your field of specialization.

Never make the mistake of engaging in a price-cutting battle with a competitor. Let your fees be in line with the quality and skill of your photographic abilities, and keep them there. If you are determined to increase your earnings, do so by increasing your ability or by widening your circle of clients.

Once you learn to converse easily with respective clients and are able to give concise, acceptable quotations, assignments will zoom toward you with the unfailing inevitability of a heat-seeking missile. If your work is of consistent high quality and you produce results within the time promised, one project will lead to the next, and you will never want for assignments.

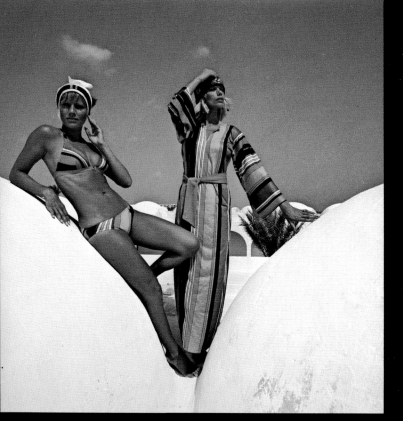

Color photography at its finest. This picture is beautifully composed and carefully arranged to emphasize the brilliant colors by contrasting them with the whiteness of the domes. Photo by courtesy of Harry R. Becker.

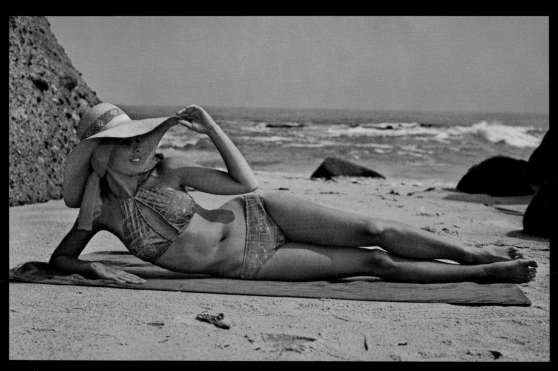

A deserted beach, a lovely model, and a bikini. What photographer could ask for a more pleasant assignment?

(Left) All the difficult subjects successfully rolled into one: the texture of the wood grain, the reflective quality of polished metal, and the smooth roundness of egg shells. Photo by courtesy of Peter H. Fürst. (Below) Dramatic, unusual, and eye-catching—all the ingredients for a successful advertising photograph. Photo by courtesy of Studio Guy Marché.

An old and familiar prop is given a modern look, complete with a powerful message. Photo by courtesy of Los Angeles Art Center College of Design.

How to
Unleash
Your Imaginative Power

Originality Pays Top Dividends
The Dream Session
Find Time for Experiments
Direct Stimulation

Here in your hands, ready for you to use, is the secret of success—a secret known to those successful men and women who dominate the field of advertising photography. It can be the most powerful weapon in your armory, and it's a simple two-word secret. **Be Creative.**

You don't have to be a nationally acclaimed photographer to be creative. Nearly all of today's top advertising studios started small, their equipment often limited to a single camera, a few lights, inexpensive darkroom equipment, a shoestring venture backed by a great amount of enthusiasm and very little besides—very little except the ability to be creative.

Being creative is an elusive ability which, like all other skills, has to be continually practiced. Many large studios, working against deadlines, pressure themselves into stagnation, although they have everything in their favor: first-class equipment, large premises, trained personnel, and top-name accounts. Work pours in from every direction, and they have everything except time—time in which to be original and creative.

The successful techniques of yesterday are routinely applied to the assignments of tomorrow. Production is slick and streamlined. The work acquires that high gloss of sophisticated professionalism, which shows little more than technical competence. Then gradually, imperceptibly at first, work begins to ease off. The orders stop coming in.

Originality Pays Top Dividends

There is no guaranteed system that will ensure continued success. Every commission you undertake must be given thorough and individual consideration. Every job must be treated as a special assignment. To the client, only one thing is important—his product—and your photographs must lift his product out of the commonplace. He wants you to present his product to the public as a manufacturing masterpiece. He wants it illustrated in a way he hopes will make the public want to rush out and buy. Even the manufacturer of an item as unglamorous as a garden spade wants it to look as attractive as possible. He has spent considerable time,

An attractive model, movement, and an unusual prop evoke a feeling of happiness that reaches out to the viewer. The picture sings! Photo by courtesy of Studio Guy Marché.

thought, and money on its appearance in trying to outsell his competitors in every way possible, and he wants you to help him.

Can you be creative? Can you take an object and visualize a finished photograph that makes it appear compellingly attractive?

At first, you may find such visualization difficult. Your mind may seem sluggish and bogged down. Ideas come slowly. It takes steady, applied effort before inspiration suddenly bursts forth like a flash of sunlight on a cloudy day. It can require considerable effort before your mind becomes tuned to thinking along original lines, but the rewards are worthwhile. Recommendation travels quickly. It is amazing how swiftly one satisfied customer will bring you ten more and how those ten grow to fifty.

You will find that presentations to new clients become noticeably more successful. Most manufacturers and advertising agencies see a lot of presentations during the course of the year. They are experienced people, hardened by continual exposure to a cynical public, and they need to be excited and enthused. If you show

them the type of photographs they have seen so many times before, they will remain remarkably unimpressed. The need is for fresh thinking—for clever ideas skillfully applied and well presented and for new twists to a popular theme.

Many advertisements become classics and achieve extraordinary public acceptance—for example, Hathaway's man with an eye patch, Benson & Hedges' long cigarette that's always getting bent, and the "Think Small" slogan of Volkswagen. Clever ideas such as these are worth a fortune. Whether they stem from the inventive mind of an advertising executive or are evolved in the studios of a progressive photographer, they mean rocketing sales for the manufacturer.

A new approach is quickly copied by competitors and eventually ploughed into the ground, but it is the manufacturer first in the field with an original presentation who reaps the golden harvest. First-time ideas pay big dividends.

Many advertising photographs that are commonplace today were once first-time ideas—products of creative thinking. Typical examples are ideas such as "Before and After" photographs; deliberate wide-angle lens distortion; lettering projected across the soft contours of a nude model; solarization; and the strange, often beautiful, effects achieved by attaching a single light source to a body in motion in darkness and giving a prolonged exposure. All of these widely accepted ideas are striking examples of cleverly applied photographic techniques, and they were always there, waiting for someone to use them.

Originality means hard cash. Competent photographic ability, coupled with a well-trained imagination, can create such a demand for your services that with careful management, prosperity is inevitable. Advertising agencies will turn to you because they will come to know that a project assigned to your studio will often meet with a suggestion that transforms it from a clever idea into a brilliant presentation. Manufacturers who do not retain the services of an advertising agency will come to know that you can lift their product out of the rut of the commonplace. They will discover that you can quickly grasp the possibilities of a product and then evolve an approach that will invariably stimulate sales.

Producing original and creative photographs is a combination embracing an understanding of photographic fundamentals and an unfettered imagination. Nothing can be created unless it is first conceived in the mind. Many advertising photographers recognizing the importance of originality become frustrated by an apparent inability to discover new approaches or fresh innovations. They labor for new ideas, but creativity eludes them.

If your mind obstinately refuses to yield that brilliant, original concept, there are a few simple techniques that will help you overcome the mental blockage and set your mind racing along exciting, unexplored channels.

The Dream Session

More ideas come and go in a day than you could possibly count—fleeting thoughts that slip through the mind almost unnoticed—and harnessing them is the problem. Ideas are always hardest to obtain when you really need them.

One certain method of encouraging your mind to provide you with outstanding ideas is the "Dream Session." This method of self-stimulation helps you to establish and organize your thoughts into a set pattern.

First, state the problem. Write it down in a few words but as fully as possible. The mind always seems to pay more attention when the problem is posed in written form. You may need inspiration for a dramatic new method of photographing a familiar household appliance. Or you may need a new concept for some

fashion photographs. Or perhaps the work you've just completed didn't have the sparkle you'd have liked. Whatever the problem, write it down.

Next, having posed the question, let your mind wander free among the possibilities. Relax. Sink into an armchair and allot yourself 20 minutes to do nothing but relax. Your mind will provide answers quicker if your attention is not diverted by other distractions. For instance, Sir Winston Churchill found that the monotony of laying bricks and building brick walls gave him mental relaxation. Liszt would sit and stare at the piano keyboard until he heard the music he sought running through his mind. Napoleon would stand and gaze steadily at a plain wall before he plotted his next military advance.

Many busy professional photographers may think they couldn't possibly spare 20 minutes from their hectic daily schedule. However, those 20 minutes would pay for themselves many times over. But you must train your mind and body to recognize that 20 minutes of every day is "inspiration time."

At first, you may find that you're unable to relax because the mind does everything except provide good ideas. Give it time. Your mind will accept very quickly if you can arrange to have your Dream Session at the same time each day. Tell your staff and the people around you that this is your "idea period." Tell them that you don't want to be disturbed under any circumstances for 20 minutes, and then go someplace where you won't be disturbed.

Having established the Dream Session pattern and posed your question, the next step is to receive and recognize the answer. Sometimes the answer you seek will leap into the forefront of your mind almost as soon as you've settled down to relax. At other times, the answer is slower in coming. It can come at any moment of the day, completely unexpectedly, perhaps when you are doing something totally unrelated to the question.

When it comes, pause for a moment and write it down. Don't trust your memory. The answer may come as you awake in the morning. It could, if the question is of sufficient importance, even wake you in the middle of the night. If it does, don't just smile happily, roll over, and go back to sleep. Arouse yourself sufficiently to write down the answer that has been given to you. Keep a pencil and notebook by your bedside permanently. Don't use a notepad, because those pages might turn out to be more valuable than dollar bills, and you don't want to risk losing any of them.

Some professional people who long ago realized the rich rewards of the Dream Session have switched from the notebook and pencil to pocket-size tape recorders. They like to have one with them wherever they travel. Ideas often flood into the mind while driving or flying.

Mealtimes and taking a shower or shaving are other times when the mind will suddenly provide inspiring ideas. Perhaps because the body is restricted and the conscious mind continues to cope with such routine actions as driving or shaving, the subconscious is able to reach through with ideas.

There are, however, occasions when the assignment demands that extra touch of brilliance, and no matter how hard you try, the results fall below what you know is possible. Perhaps an important presentation has been scheduled and you would like to offer something just a little above the average. Relax. Take a short break. Go fishing. Lie on your back under the trees in a quiet meadow and watch the clouds drift across the sky. Give your batteries a chance to recharge, and your work will reflect the inspiration that will surely come if you let it.

A surge of creative force will inspire you to produce pictures that possess a dynamic power you would never have believed possible. If you need a comparison between the placid and the dynamic, imagine an old steam locomotive standing

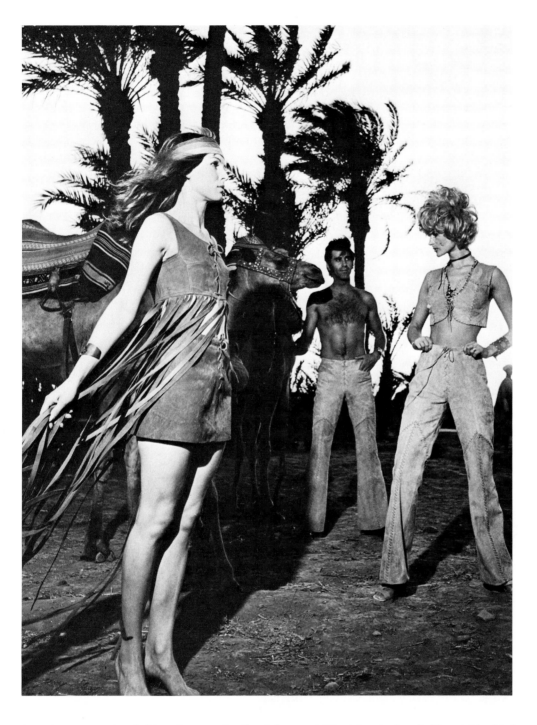

A modern approach to fashion photography. Carefully posed, this picture is aimed with considerable force at a specific section of the public. Photo by courtesy of Harry R. Becker.

patiently in a forgotten siding. Paint peels from the boiler and rust coats the once brightly polished steel. Even the track is rusty and weeds sprout between the sleepers. Only the chirping of a lonely cricket disturbs the silence.

Now imagine the same locomotive at full steam, rounding a curve in the track, piston rods flashing, wheels thundering along the rails, and smoke belching back in heavy clouds above the tops of the following coaches.

It's the same with your creative photographic ability. It can either be static and unimpressive, or you can unleash a power potential no manufacturer or advertising agency can ignore.

Start adding movement and life to your photographs, even those in which the subject matter is immobile. At one time, hamburgers would be shown on a plate with a few pieces of lettuce and a handful of french fries. Now hamburgers are

Creativity. The need to be daring. Originality. Humor. The outcome—a winning photograph. Photo by courtesy of Studio Guy Marché.

Because of its unusual approach, this off-beat venture into the world of fantasy succeeds. Photo by courtesy of Gerald William Hoos, International Photo-Art Service.

shown about to be bitten into by the most attractive teeth you've ever seen. Today, roses are always sprinkled with dew, cigarettes are smoked by old-time cowboys or sexy young women, and dishwashing liquids are more often illustrated with graceful hands than dirty dishes.

It's time for change. It's always time for change. You can either be the photographer whose ideas crackle like a charge of high-voltage electricity, or you can be the steady, plodding craftsman who is satisfied to make a fair living without having to become too involved.

Your mind is able to supply fresh and creative ideas, but your technical knowledge and abilities have to be equal to the ideas. The mechanics and fundamentals of photography can be taught, but the ability to combine creative ideas with technical skill is something that must come from within you.

No one can have your ideas for you, and before you even begin to visualize

A tremendously effective use of black space makes this a photograph that refuses to be ignored. Photo by courtesy of Gerald William Hoos, International Photo-Art Service.

innovations in your mind, it is necessary to have a comprehensive understanding of your equipment and all its applications.

Find Time for Experiments

New ideas, new techniques, new approaches all require the same invaluable commodity—time; time to experiment.

Original and creative ideas captured in the mind are still only the beginning. Transferring them to film is the next step. Sometimes an idea that seems simple and straightforward is somehow not quite so easy when it comes to putting it into practice, but you'll never be able to do it until you try. So the first positive step is to put aside an hour or so at the end of the day and devote it entirely to experimenting with new equipment, new lighting techniques, and unusual backgrounds.

Time is always valuable, and there is a natural inclination to resent the use of time for experimenting and learning when it could be used for earning money. Be firm. Set aside a regular time each day for self-instruction.

Once you get started, you'll find one idea leads to another, each more intriguing than the previous one. The background of weathered driftwood you had envisaged for a cosmetic advertisement becomes more interesting with the addition of the sand, shells, and starfish you used a few months ago in the "wristwatch in the aquarium" photograph.

Perhaps that giant clam shell gives you an idea. You wire it so that it remains half open, place one of the vials of perfume in the lower half of the shell, drape a few pieces of seaweed to the side, add a few rocks, and view it on the focusing screen.

Something is lacking—atmosphere—so you add a few sprinkles of water and change the floodlighting to a single, low-level spotlight at 90° to the camera. Better, but still lacking that extra something. A quick search through the prop cupboard turns up a piece of green gelatin film. You tear a small ragged hole in the center of the film and clamp it in front of the camera, an inch or two from the lens.

Even before you check your focusing screen, you know you've got what you wanted. The perfume and shell are crisp and sharp, surrounded by misty, greenish sand and rocks. You add a smear of Vaseline to the gelatin, making the surrounding props even more shimmery.

After exposing a few sheets of film, you clear the floor for work the following day and go home. The photographs may sell to the manufacturer of the perfume or its advertising agency. If the pictures are as good as you think they're going to be, they would be worth offering on a speculative basis.

But the experiments you've been conducting have a deeper value. On some future occasion, the knowledge you've gained will suddenly leap into your mind at the very moment you need a special effect. Every experiment should be a journey into the unknown and the unexpected.

Make the most of your equipment. Work through all sections of your apparatus systematically. You could set aside one experimental period for working with a single light source. Or you might try bringing out the texture of material with an obliquely angled mini-spot. You could also try giving an extended exposure and "paint" a room interior with a hand-held flood.

These experiments should be applied to everything in the studio, including cameras and lenses, backgrounds, lights, props, and sensitive materials. For instance, a piece of jewelry could be given an ethereal appearance by using a candle in an elegant candle holder and giving multiple exposures, making sure to move the candle to a different position in a predetermined pattern before each exposure.

5

(Right) A photograph that is open to several interpretations: the camera as a means of communication, or perhaps a suggestion that the photographer is only as far away as the telephone. You read in it what you will. Photo by courtesy of Studio Guy Marché. (Far right) This is the type of advertising photograph that reaches out and grabs attention. Who could resist pausing long enough to find out what the girl is doing in a packing case? After all, you read this caption, didn't you? Photo by courtesy of Studio Guy Marché.

Don't be restricted by accepted practices. Go ahead, break a few rules. Let your imagination guide you into startling new techniques and brilliant new concepts. Your mind will reveal a depth to your abilities that you never knew existed.

You need creative ability most when work is pouring in and you hardly have time to load film. You know that plunging ahead without taking time out to be original can lower your standards, so you try desperately to think of something brilliant—some new approach that will make your client sit up and take notice. But no matter how hard you try, your mind is a great, empty nothing. Inspiration evaporates faster than water on a hot rock. It's time to resort to "Direct Stimulation."

Direct Stimulation

This is a fast way of jogging your mind. It is a method of obtaining auto-response when work is building toward danger point and deadlines are closer than your next breath.

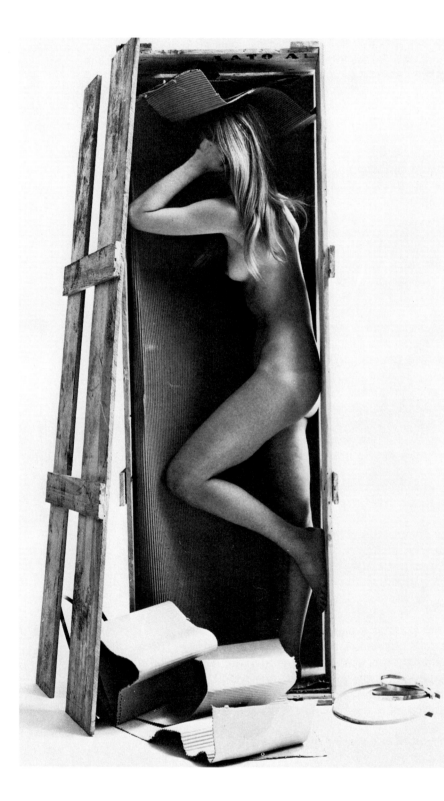

To discover and project the excitement in a product, look at it from a different angle. There's excitement and drama in every product if you know where to find it. The photograph of a man standing on the ledge of a building can be utterly static—completely lacking in interest. Now move to a different angle and show that the man is poised 30 floors above traffic in the street below, and you've added drama.

You can add drama or excitement to the majority of items you are asked to photograph. If the product is small, take it in your hand and examine it from all sides. One aspect will gradually appear more interesting than all others. This is the dramatic angle you need.

When the product is too large to move, walk around it. Stand on a ladder and look down on it; or get down on your knees and look up at it. At one point, you'll find the very angle that will give you a reputation-building picture.

Direct Stimulation can come from picturing the product in an unusual setting or environment—for example, a beautiful model in a Dior creation, posed with a pneumatic drill and a road-repair crew; or a surgeon with mask, gown, and gloves, using that special scalpel to open his breakfast egg.

Bic pens have been shown chipping through ice and punching holes in jar lids. Timex has strapped wristwatches to the propellers of a speedboat and the ankle of a long-distance runner. Playtex has shown its rubber gloves being worn by the hostess at dinner, and Maidenform bras have been worn by models in some of the most unusual locations, including London's Trafalgar Square at rush hour.

Train yourself to formulate at least one original idea every day. There are many ways of getting your ideas started. You can stress the quality or convenience of a product by using a form of time lapse—"Before and After" pictures, for instance. A new automobile engine could be photographed, run for 50,000 miles using a special oil additive, and then rephotographed to show the minimum engine wear.

On the same theme are photographs illustrating summer and winter, old-fashioned and modern, indoors and outdoors, used by men and used by women, and works equally well when wet as it does when dry.

Thinking along the lines of symbolism is another way of stimulating new ideas. The bowler hat, rolled umbrella, and copy of the London **Times** is more than sufficient to indicate a typical Englishman. The Rolls Royce and Cadillac are accepted symbols of wealth and elegant living. Even single objects such as a checkered flag, a crystal ball, and sunrise are sufficient to convey the exact image you require.

Imagine a long boardroom table in a paneled room. Around it are seated several serious-looking men in dark business suits. On the table in front of them are a few sheets of important-looking papers, and all of the men are looking at the head of the table, directly at the camera. In the immediate foreground, dominating the photograph, is a well-groomed hand holding an expensive cigar. That single symbol, the cigar, spells tycoon. The entire theme would have been meaningless if it had been a pipe or cigarette.

Having constructed the symbol, it now only remains to introduce the product. If the tycoon's other hand is brought into the photograph, the viewer will be led to understand that tycoons wear "X" wristwatches, or "Y" watchstraps, or use "Z" writing pens.

Conveying an image and producing photographs that focus attention on any given product is the prime objective of the advertising photographer. But even the most inspired pictures have to possess one essential ingredient: They have to be pictures that sell.

How to
Produce
Pictures That Sell

Putting Punch into the Picture
How to Capture Mood and
Atmosphere
Techniques That Please the
Client
Subtleties of Showmanship

Advertising photographs have one major function: They must stop the viewer dead in his tracks. Whether that person is leafing through a magazine or riding on the subway, the advertising photograph must cause the viewer to pick up an entirely different train of thought. It must make him suddenly thirsty for a cool drink, desire a cigarette, or even yearn to take a trip to an attractive vacation area.

Some wonderful examples of advertising photography do just that—photographs that sizzle off the magazine page or make a product on the shelf of a supermarket absolutely irresistible. These are examples of advertising photography at its best.

But many advertising photographs reaching the public lack that touch of brilliance; they just miss the target. Perhaps the advertisement was poorly devised or maybe the photograph just simply failed to attract attention. In either case, they leave the viewer completely cold, because they lack dynamic appeal.

What gives a photograph dynamic appeal? Why should one photograph convince a person that he should pause and read the advertising copy, while another photograph has almost no effect at all?

Try a little experiment. Pick up half-a-dozen different magazines and casually turn the pages, one at a time. You'll probably be surprised to discover that you too find it difficult to ignore certain advertisements.

There you are, completely unbiased and conducting an experiment, yet almost without thinking, you paused at certain pages. In every magazine, two or three advertisements are going to attract your attention, and before you realize it, you'll have read a few lines of the copy. The photographs in those advertisements have appealed to you on a certain level.

The subject matter has a lot to do with this appeal, as does the magazine in which the advertisement appears. The advertising agency, having studied the product and decided in which magazine the advertisement will appear, has chosen the audience that will be viewing the advertisement.

The photographer too must be aware of his audience. Once he knows the media in which his photographs will appear, he must be able to use his photographic ability to make the product especially attractive to that section of the community.

Putting Punch into the Picture

There are special photographic techniques that add power to a photograph—techniques that add drama or realism. Most advertising photographers use these techniques in their work, some through experience and training, others almost instinctively.

Probably one of the most eye-catching and startling techniques is the close-up. People are always intrigued by detailed photographs of familiar objects. Wristwatch mechanisms, pocket calculators, and electric shaver heads are often seen in close-ups.

A photograph of an ordinary lead pencil would normally have little impact. But move in close to show a well-shaped thumbnail and the ridges at the tip of the pencil, left by a pencil sharpener, and the inanimate suddenly springs to life.

There used to be an old adage that when nothing you can do will give a photograph impact, move in close. The close-up is as effective today as it ever was. Combined with other techniques, the close-up will give sparkle to the most uninteresting item.

One of the techniques usually coupled to the close-up is harsh sidelighting. Photographs intended to show texture are often handled in this way, leather goods or engraved articles in particular. These techniques may be applied to many small items, and in color photography, when the sidelighting is from two different colored spotlights, the effects are truly dramatic.

Skillful lighting is one of the secrets behind most dramatic photographs. There are very few advertising photographers who have not spent many hours experimenting with various lighting effects, and most of the finest advertising photographs owe a great deal to the care taken in lighting the product.

In some forms of photography, the lighting is unobtrusive. Photographs of the interior of a mansion, showing the entrance hall and curving marble staircase, could require hours of painstaking care to ensure that the lighting is correct. The finished photograph would show no signs of illumination other than that apparently coming from the huge crystal chandelier suspended in the center of the hallway. In the more dramatic photographs, the lighting is much more forceful, very much a part of the photograph.

The truly competent photographer knows exactly how to get the effects he requires, from special lighting and close-ups to unusual angles.

Every manufacturer wants his product shown to advantage, and usually one side of a product has more sales appeal than another. The photographer with a flair for dramatic photography will find an angle that provides visual impact while stressing all the pertinent sales points.

From small engineering parts to the largest industrial building, and from beautiful models to something as everyday as an electric light bulb, it is possible to find unusual angles—angles that add excitement and make the distinctive difference between the ordinary photograph and the photograph that grabs attention.

Photographs of models with strong personalities will often give a product a tremendous boost; so much so that models who help to bring a product to national prominence become typecast, and it is difficult for them to promote other products.

While giving the model full credit for looks and ability, it is usually a strong empathy between photographer and model that gives the final photograph the dynamic appeal which is so readily accepted by the public.

Some photographs are able to attract attention as much for their content as their technical quality. There are occasions when the subject matter is so mentally

unacceptable, so contrary to what is considered normal, that people have to stop and read the copy in order to satisfy their curiosity. Examples that come to mind are photographs of a hand crushing a beautiful orchid; a snake with a head at both ends; or people seated at lunch with the table floating in the center of a lake.

Bizarre? Maybe. But this type of picture catches the eye and is remembered. It is a difficult theme to tackle, and unless it is well executed, it fails completely. This is one of the reasons why so few photographers or advertising agencies are willing to attempt such themes. However, it may be a field in which you excel.

Another approach to advertising photography, which many photographers seem unwilling to tackle, is humor. Again, it's one of those subjects that can succeed admirably or fail dismally. There is no in-between.

There are photographers who are able to produce humorous photographs almost without trying. They have a built-in streak of comedy that bubbles to the surface, bringing about advertising photographs that linger long after the campaign is ended. Like the cartoonist, these photographers see life in all its grim reality, but they twist it to show how things could be if we could only let ourselves resist the conventional.

If you have a knack for producing pictures that make people smile, you're already halfway up the ladder of success. It's a wonderful talent. By making people smile, you cause them to relax. You create a diversion, a mood of ease and pleasure. Being able to project mood and atmosphere by means of a photograph is a skill worth learning. It can transform an ordinary photograph into a true work of art.

Working with celebrities is always a pleasure, and Peter Sellers must be one of the most stimulating personalities. Photo by courtesy of Trans World Airlines.

How to Capture Mood and Atmosphere

Photography has the almost incredible power of being able to stir the emotions. Not only can a photograph make you smile or chuckle, it can make you feel sad, create sudden anger, mystify, or inspire. It can even promote romance. These emotional feelings can be aroused by atmosphere and mood in a picture.

Most of the world's greatest painters knew the secret of creating atmosphere and mood. "Whistler's Mother" is at once sad and peaceful. Constable could bring the serenity of the English countryside to your living-room wall. His windswept clouds and rolling meadows were an expression of his inner contentment. Rubens carries his spectators along on the tide of his volcanic energy, his paintings brimful of life and movement.

Our day-to-day existence is very much subject to our mood of the moment. if we suffer a setback at the beginning of the day, we become dejected, and it seems that one catastrophe has to follow another. It becomes one of those days when it would have been better to have remained in bed. Then, happily, there are those glorious days when we can't put a foot wrong.

Photography is capable of projecting those moods. Pictures by inspired photographers have affected entire nations. During recent wars, governments on both sides bolstered confidence in their people by publishing photographs that demonstrated the country's readiness and strength, pictures showing long lines of armored vehicles, troops in training, and aircraft on the alert, ready to handle any emergency. At the same time, photographs of atrocities by the enemy were used to create far deeper anger and hatred than any written word could have accomplished.

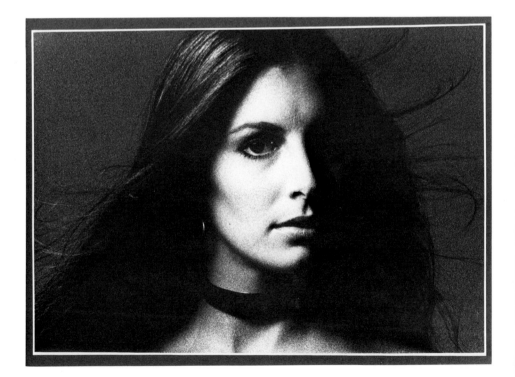

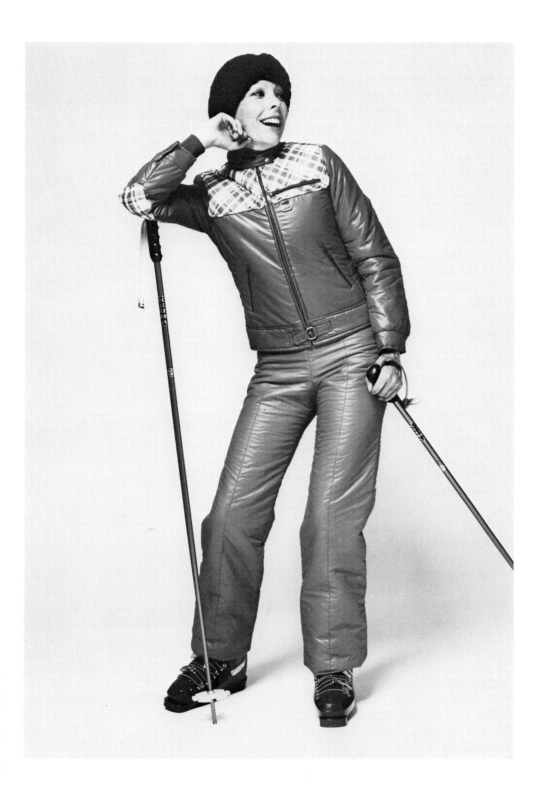

(Left) A lovely face, a flawless photographic technique, and the result—a picture that will haunt you for a long, long time. Photo by courtesy of Los Angeles Art Center College of Design. (Above) A simple fashion or catalog picture that sets out to do little more than present the sportswear as attractively as possible. Photo by courtesy of Studio Guy Marché.

The advertising photographer who is able to project mood and atmosphere can give added depth to his pictures. He is not only presenting the product visually, he is also compelling the viewer to sense the purpose of the product. He is putting the discoveries of motivational research to work.

Once, not too long ago, it was sufficient to show a bar of soap and tell the viewer that it made the skin softer. Today, viewers want to **see** the softer skin. They want to see the abundant lather and the creaminess of the soap. Photographs can fulfill those requirements. If the photographer is really inspired, he can almost make the viewer smell the perfume.

Perfumes, cosmetics, music, and wines are "atmosphere" products and are often tied to a romantic theme. The photographer not only has to photograph the product, he also has to imply that it's essential to romance.

How does one set about portraying an intangible subject like romance? Most advertising photographers rely on pastel shades, subdued lighting, and a soft-focus attachment on the camera lens. Sometimes a dreamlike atmosphere can be created with a vapor machine or by smearing the camera lens with Vaseline. The invaluable tape recorder, loaded with the right type of music, is also a great aid to creating the right atmosphere in the studio.

When using models, it's necessary that they appear romantic. That special look in the eyes or the unconscious gesture of the hands must be seen and understood by the viewer. Many of the top-ranking advertising photographers spend a considerable amount of time before they begin taking romantic-type photographs, making sure that the models are relaxed and able to project a mood of quiet happiness.

The experienced photographer knows that the atmosphere on the set will come across in the photograph. If models are tense or uncertain, their uneasiness will be painfully apparent in the finished picture.

Mood and atmosphere can play a large and important part outdoors as well as in the studio. From the soft "dawn light in a forgotten forest" to the "rugged man against the elements," mood and atmosphere can be successfully projected to the viewer.

Familiar scenes can quickly establish the mood for outdoor shots, whether it's a couple walking along a beach, silhouetted against a setting sun, or a group of young people gathered around a campfire. They are locations and scenes the viewer can quickly recognize.

The manufacturer whose product you are promoting, whether it's ciga-rettes, soup, or wedding rings, wants you to take photographs with which the viewer can easily identify. Your photographs of a group of deer hunters gathered around a pot of steaming soup must look so inviting that the next time the viewer sees that brand of soup on the supermarket shelf, he'll want to try it because he would like to visualize himself as a rugged outdoors man.

Gaiety, happiness, loneliness, and mystery are four more feelings of mood and atmosphere you will be asked to project from time to time.

Gaiety is the homecoming, the party, and the carnival.

Happiness has long been a warm puppy; it's also the new baby, the en-gagement, the wedding, and the new home.

Loneliness can be a sad thing—the elderly or the boy with no friends. It can also be a satisfying contentment—the fisherman beside a remote lake or the man in a glider soaring high above the clouds.

Mystery can be a woman's smile, the cobwebbed cellar door, or simply a deserted street late at night, with the wet pavement reflecting the shadowy figure of a man leaning against a lamp post.

Here is a fashion photograph taken by a photographer who knows the secret of getting his models to relax. Photo by courtesy of Harry R. Becker.

There is, however, one important factor that must be kept in mind all the time. No matter how clever your photographs or how much time and trouble you've expended to create the exact mood and achieve technical perfection, they can all mean absolutely nothing if they don't please the person for whom you are taking them.

Techniques That Please the Client

To expand your business, you must turn out work that pleases the client. The client must come back to you every time he wants photographs taken, and he's only going to do so for as long as you continue to produce photographs that please him.

It is very much in your interests to take the time to discover exactly what pleases each individual client. Industrialists, manufacturers, advertising agencies, and civic bodies all have specific requirements and firm views on what the photographs should do for them.

It is essential that you find time to talk to the customer and discuss his particular needs and requirements. But before your scheduled meeting, do some research. Find out if he has had similar photographs taken before. If so, find out why he isn't going back to the first photographer. Perhaps it's a question of price, or more likely, that the photographer was unable to produce pictures which satisfied.

Study the previous advertising put out by your client and look for any obvious errors. It could be that the photographs failed to show the important features of the product, or maybe the quality was not as good as it should have been.

If you have the opportunity, examine the product before your interview with the client. This will give you the chance to formulate a few ideas on how you would handle the assignment.

It's always better if your client will come to you rather than you go to him. There are two reasons why this is important: (1) Nothing is more frustrating than a conversation punctuated by long-distance telephone calls. (2) You have the added advantage that any samples you may require are close at hand.

During the interview, try to discover exactly what the customer wants, although many times he won't even know himself. He knows he wants his pictures to be interesting and attractive, but his attitude frequently is, "You're the expert. You should know which type of photographs are required." This is the time to put forward some of those ideas you have previously formulated.

Know where the pictures are to be used. If they are to appear in a newspaper, know which one and when. If a magazine advertisement is contemplated, be sure you know which magazine. It can be vitally important. For instance, if your photograph was going to appear in **Playboy,** it would require a much more sophisticated slant than it would for **Family Circle** or **Good Housekeeping.**

Having decided what you think the client requires, there are certain steps you can take to make sure the photographs will do all you require of them, especially if live models are to be used.

When the set is ready and a few days before the models are scheduled for the production shooting, take a few Polaroid shots and have them approved by your client. If any corrections to the set are required, they can be made ahead of time. Models can be one of the greatest expenses, and to have them come back for a reshoot is not only expensive, but could also cause your client to have second thoughts on his choice of photographer.

When you begin taking the production photographs, try to shoot a few pictures for yourself. Follow the shooting instructions as requested by your client, and then shoot a few pictures along lines you think may be more effective.

If the client likes these more than the ones you were asked to take, that's fine. You will have justified your client's faith in your creative talents. If they're not as good as the ones you were asked to shoot, destroy them. Don't be tempted to keep them as samples.

Make sure you know what is special about the product and ensure that it's featured in the photograph. Try to watch for errors in the product. It was one of those errors, which sometimes slip through, which brought red faces for a manufac-

Superb fantasy—romance in a setting that only lovers would recognize. An inspired advertising photographer has shown that dreams can come true. Photo by courtesy of Studio Guy Marché.

turer and his advertising agency. Because of the time that elapses between the time an advertisement is prepared and the time it appears in a magazine, it is often necessary to prepare a dummy sample ahead of a regular production run. In this case, it was a bottle filled with a liquid that looked like the real thing and for which a label had been specially printed.

When the photograph appeared in the magazine, it was discovered that the label read, "We carp about our customers." Although it is doubtful whether anyone else noticed the error, the manufacturer rightly considered that the mistake should have been spotted before it got to the magazine.

For magazine advertising to be fully effective, it has to be part of a carefully planned program in which considerable money is invested. The photographs are only a small part of the overall expense. Advertising agency, artist, copywriter, models, magazine space, and photographer can total quite a large amount of money.

Sometimes when the product is specially prepared for the photograph, it can be a very expensive part of the program. For instance, it may be an electrical generator sliced down the center to show its internal construction; or it could be a completely disassembled automobile that has to be shown in various stages of completion.

With such an expense before him, it is unlikely the manufacturer or advertising agency picked your name from the **Yellow Pages**. Something in your work has appealed to them, something that gave you the edge over other photographers. That something could well be your style.

Every photograph you take should reflect you—your way of looking at things, your techniques, and your ability to take photographs that are just a little bit different and a little bit better than the next man. One of those differences should be a small element known as showmanship.

Subtleties of Showmanship

No one would question that Alfred Hitchcock is a master of the suspense movie; he is also a master showman. His face and figure are familiar to the public because he has taken pains to make sure that they are seen frequently. He is no blushing violet, and one of his "trademarks" is the fact that he appears briefly in every movie he makes. Perhaps he considers this idiosyncrasy his good-luck charm. Whatever the reason, he has made certain that the Hitchcock film is different from all other mystery movies.

It must be the same way with your photography. Your photographs must not only be distinctive technically, but they must also carry your personality. There are several ways in which this can be achieved.

You can become known as the discoverer of attractive models. By careful and personal selection, your models can be your signature on the photograph. But it becomes necessary to retain your chosen models on an exclusive basis, which is difficult to arrange if they are represented by a model agency. Almost invariably, these special, exclusive models are discovered and brought to prominence by the photographer.

Another signature on the photograph is the small item that makes its appearance in every photograph, not obtrusively, but always in evidence, in much the same way as Hitchcock appears in all his films. Even the way you organize your photographic sessions can be a form of showmanship, and it is a way you can increase your profits considerably.

How to
Increase Your Profits By Shrewd Organization

7

Artists and Layouts
Backgrounds and Locations
Preshooting Approval
Meeting Deadlines

The successful advertising photographer is also a very capable businessman. He is on top of his job and he knows it thoroughly. There is no detail that escapes his attention, and for every problem that arises, he has, or will quickly devise, an answer.

The evidence of success may be seen any day in any large town by comparing two advertising photography studios in different areas. It could be that they both began business at approximately the same time, both have access to the same potential clients, and both are on a similar level of technical ability. Yet it is apparent that one is far more successful than the other. One studio has the lost look of a business that is barely holding its own: Very few cars come and go from the parking lot; the building needs a coat of paint; the studio opens about 15 minutes later in the morning than its sign says it will; and it closes promptly at 5:30 P.M.

The other studio has an air of vitality: There is activity in and around the building, which is clean and well maintained; trucks move in at regular intervals to unload merchandise to be photographed; and the studio's hours of operation seem to be completely flexible. Even the most casual observer would notice the signs of success.

What is it that takes one photographic advertising studio ahead of another? What secret formula will produce progress? The answers rest in the ability of the studio director to organize his business in a way that will produce maximum results. He knows all facets of the photographic advertising profession, and he knows how to dovetail those facets together for full efficiency. One of his prime concerns is the smooth coordination between the advertising agency and the studio. Until the studio is completely instructed as to the type and style of photographs required, it is unable to even begin preparations for shooting. These instructions usually come from the client—manufacturer or advertising agency—in the form of artwork and written instructions.

Artists and Layouts

The advertisements that appear in magazines and newspapers are usually the result of a combined effort supplied by the staff of an

The artist's rough layouts pave the way for the finished product—the successful advertisement. Note how the original concept develops from one stage to the next. Photos by courtesy of Hall and Levine Advertising Agency, on behalf of their client Catalina, Inc.

YOU HAVEN'T DISCOVERED IT ALL:

In a world shrunk so small that what's new today in Paris shows up tomorrow in Poughkeepsie, and last year's out-of-the-way spot now features a packaged tour each week, we offer you something still to be discovered.

It's a small, quiet crescent of a bay sparkling like an aquamarine in the sun of the Kona Coast. Serene on the surface, but alive beneath with nature's spectrum of multi-hued tropical fish and the challenge of big game fishing. Part of an island so young, geologically speaking, that its volcano still fountains and its primitive quality remains untouched.

And ringing the bay, three luxurious resort hotels, each with its own special appeal, but all with the wonder of the sea to view and the traditional warm, happy, welcome of Hawaii to enjoy.

King's Pond runs deep in Hawaiian history yet lives on in perfect harmony with the modern Keauhou Beach Hotel.

CATALINA, KEAUHOU-KONA AND CONTINENTAL AIRLINES.

The place is Keauhou-Kona. There's discovery even in the way you pronounce the name. It's easier than you thought. Kay-a-ho. Keauhou-Kona on the Kona coast of the island of Hawaii. Luxurious, splendid, private, and possible — one of the last beautiful-without-faking-it corners of the world you still can get to within a reasonable flying time.

The hotels are the Kona Surf, the Kona Lagoon, the Keauhou Beach. Choice condominiums to rent or own are also a part of the Keauhou scene. They join in a wealth of recreation ranging from scuba diving, big game fishing, tennis and catamaran sails to a 6800-yard par 72 championship golf course.

How to get there? Continental Airlines. The island of Hawaii is easily reached directly from any Continental city, via DC-10's. Your travel agent is Continental's partner in getting things done for you.

She wears Catalina awning stripe seersucker bikini. He wears the Duke Kahanamoku laced front surfer in reverse Hawaiian print. They are enjoying the early morning sun at Disappearing White Sands Beach.

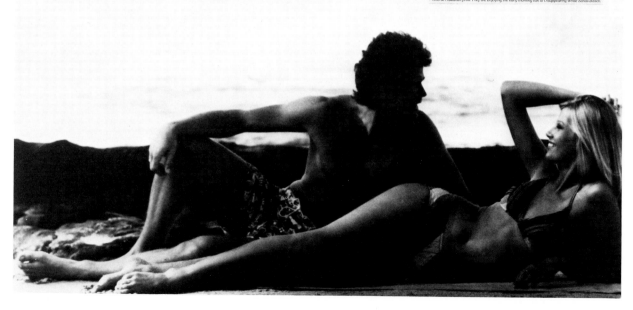

advertising agency and the photographic advertising studio. Although the photographer may sit in on meetings with the advertising agency and its client—presumably a manufacturer or producer—the actual work in the studio doesn't begin until the advertising agency has had its program approved by the client. After the program has been approved in outline, each advertisement, as it will appear in print, also has to be approved before production can be started.

Perhaps a glimpse behind the scenes of a progressive California advertising agency will provide an example of how the typical agency approaches its task of publicizing a product.

Hall & Levine Advertising, Inc. is a young, aggressive agency, not yet as big perhaps as J. Walter Thompson or McCann Erickson, but servicing some very attractive accounts, including Catalina, manufacturers of sportswear and swimwear. The initial approach of Hall & Levine is similar to that of most advertising agencies. The agency is first given a provisional budget figure within which it must work. At a meeting of executives, which might probably include the client's president, sales director, and advertising manager, together with the account executive and art director from the agency, a decision is reached on the general format the advertising will take.

After this meeting, the advertising agency will have several meetings with its staff. It will research the markets into which the manufacturer's goods are to be introduced and decide which type of advertising will be most effective.

With the swimwear, Hall & Levine had several choices. The agency could try to sell on formal lines, simply showing a series of models wearing the new beach style. It could also take a romantic approach; or adopt a carefree style to exemplify the self-assertion of today's young women; or the agency could give the advertisements a dreamlike quality, conveying an impression of golden beaches and soft, warm breezes.

The decision on the type of illustration to use was based on the results of its research, and the agency prepared a number of art sketches and some sample copy to present to the client. The agency also offered its recommendation on the type of medium in which the advertisements should run, the period over which the advertisements should appear, and the frequency.

With the layouts and copy approved by the client, it was time to schedule the photography. Most magazines require that advertisements be placed three months ahead of publication date; and allowing four weeks for the photography and processing, plus the time necessary to decide on locations, choose the models, manufacture the fashions for the models, and provide models and photograper with sufficient notice, the advertising agency is working almost a year ahead of publication date.

On this occasion, it was decided that the swimwear photographs would be taken in Hawaii. From that moment, the photographer began listing the equipment he would be taking with him; the advertising agency started preparing copy and taking space in the magazines that were to carry the advertising; and somewhere in the agency, artists began sketching the layouts to be used as a guide for the photographer.

The artist's layouts provided by the agency are generally firm in their format, while giving the photographer plenty of opportunity to use his own creative ability to get pictures that will sell. The format established by the layout could require the model to be moving or looking to the left or to the right, and it could require an area, free of fussy detail, where the copy and logo would appear. This could be in the sky, the foreground, or off to either side.

This information and all of the necessary equipment and props must ac-

company the photographer and models as they leave for the shooting locations. It would be expensive to have to make a series of phone calls asking for more details on the assignment, especially if the location is on the other side of the world.

Good organization can help the photographer to avoid cutting into his profits by having to scramble around at the last minute. A forgotten lens can force the photographer either to purchase another one, which could be difficult if the location is in a remote area, or to endure delay while the studio mails his lens out to him, with all the inevitable problems at the customs shed.

The best cure for problems of oversight caused by a frantic, last-minute rush is prevention. A fully detailed artist's layout is essential, and so is a travel checklist. The list can be sectionalized, with all the necessary supplies and equipment needed for each type of assignment fully itemized. There should be a listing of cameras, tripods, lights, flash, exposure meters, filters, reflectors, and all the accessories you would consider necessary for location photography. With experience, you will be able to eliminate some items from your list and add others you find indispensable.

Almost all assignments can be planned well in advance, and the more thorough your planning, the more time and money will be saved. There are times when final decisions by the client are postponed until it is almost too late to carry out the assignment, but these are almost always small jobs. People who intend to spend considerable money on an advertising campaign will usually plan everything well in advance or pass the project to an advertising agency whose entire business is making sure that the advertising campaigns in which they are engaged reach the public exactly on schedule.

The advertising photographer can often help to meet his own schedules by gathering together knowledge on backgrounds and locations, which can be used on possible future projects.

Backgrounds and Locations

The advertising photographer who does very much work on location is always on the alert for new and interesting backgrounds. As he travels on vacation or at weekends, his mind automatically registers the scenery around him and how it may or may not prove suitable for a future advertising assignment. The waterfall, which could possibly be used in the projected cosmetic soap advertisement, or the cabin by the lake, which could be the background for advertisements on fishing tackle, rifles and shotguns, boats and boating equipment, or even a wood preservative. There is a possible use for every attractive scene in some future advertising program.

Although these scenes stay in the mind and suggest themselves at a later date, it is often very difficult to recall, perhaps a year later, where it was that you saw the scene you would now like to use. In your mind's eye, you can see the model posed against the gnarled and twisted trunk of an oak that had been struck by lightning. The only trouble is that you can't remember where you saw the misshapen tree. Or perhaps you recall a grove of pink-blossomed almond trees at the foot of a white-tipped mountain. Some time later, when you are asked to photograph some spring fashions, you would like to suggest the grove of almond trees but can't remember where it was.

Most advertising photographers have restless minds. They are continually seeking new ideas, trying to give each new assignment freshness and vitality. Thoughts come and go, constantly moving and circulating, and it is too much to

7

C

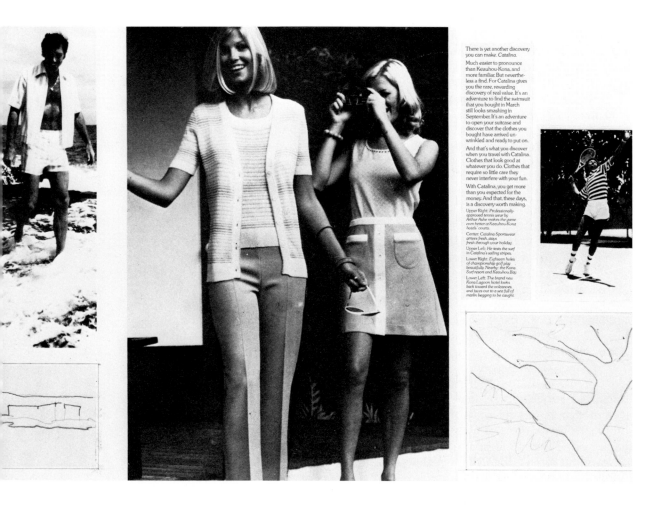

There is yet another discovery you can make. Catalina.

Much easier to pronounce than Keauhou-Kona, and more familiar. But nevertheless a find. For Catalina gives you the rare, rewarding discovery of real value. It's an adventure to find the swimsuit that you bought in March still looks smashing in September. It's an adventure to open your suitcase and discover that the clothes you bought have arrived unwrinkled and ready to put on.

And that's what you discover when you travel with Catalina. Clothes that look good at whatever you do. Clothes that require so little care they never interfere with your fun.

With Catalina, you get more than you expected for the money. And that, these days, is a discovery worth making.

Upper Right: Professionally-approved tennis wear by Arthur Ashe makes the game even better at Keauhou-Kona hotels' courts.

Center: Catalina Sportswear arrives fresh, stays fresh through your holiday.

Upper Left: He tests the surf in Catalina's sailing stripes.

Lower Right: Eighteen holes of championship golf play beautifully. Nearby: the Kona Surf resort and Keauhou Bay.

Lower Left: The brand new Kona Lagoon hotel looks back toward the volcanoes and faces out to a sea full of marlin begging to be caught.

7

There is always room for change, even in the best-planned layout. In the sketch at left, the emphasis is on swim attire, and the tennis player is overpowered by the building behind him. In the client-approved layout above, there is no doubt that the variety of sportswear is the focus of attention. Photos by courtesy of Hall and Levine Advertising Agency, on behalf of their client Catalina, Inc.

expect the mind to be able to recall every detail ever seen on any trip or vacation. But to a photographer, the solution is simple, namely, photographs of every location, fully documented and filed in a three-ring folder. On any future occasion where a woodland setting is required, you simply flip the index tag. Lonely beaches, unusual city scenes, fountains, mountains and parks, you have them all listed and filed for ready reference. As one further incentive to collect location settings, it should be mentioned that it is quite in order to charge a finder's fee. When a special setting is required for advertising photographs, it can take considerable time and expense to discover exactly the location to suit the agency artist's impression of what is required.

Another type of setting, which is worth filing photographically, is the background constructed in the studio. Unless there are vast storage facilities available, it would be quite impossible to keep each background when it is no longer needed. But photographs of the background being constructed or used should be kept in case it is ever necessary to rebuild it.

Backgrounds may be rolls of seamless paper, draped satins, crumpled aluminum foil, black velvet, imitation brick, or draped colored polyethylene. Backgrounds may take any form the creative mind can devise. A cloud of soap bubbles has been used as a background, and so has dry-ice fog, balloons, sheets of newspaper, library shelves filled with books, massed flowers, and even three circus elephants.

Certain backgrounds are requested more frequently than others, and it is worth keeping these popular backgrounds ready for use. A large sheet of imitation brick, big enough to be used as a background for a small group of people and mount it on rollers for ease of mobility. It can be backed by an equally large sheet of plasterboard finished as a stucco wall. It is only necessary to swing the background around to change the setting. If the two boards are separated by strips of wood on three edges, the two sheets form the front and back of a large, flat box open down one edge. In this box you can store sheets of material, such as cork, imitation marble, felt, or any other type of background material that has only to be removed from the storage space and leaned against the face of the background to form an entirely different setting.

Although the manufacturer or advertising agency may request a beach or sand dunes as a setting for their advertising photographs, it could be a considerable problem for them to describe exactly what they require and for you to provide it. In the same way, you too would find it difficult to describe places and settings with which you are familiar. Of course, your file of pictures can be used to help make your description clear, but outdoor settings change. What you saw in spring would look entirely different in winter. So if your client is firm in the type of setting he requires, you have no alternative but to provide him with recent pictures or go with him to visit the location.

Preshooting Approval

No advertising photographer could possibly consider undertaking a major assignment without first obtaining the approval of the client. This not only means that the client has to approve the general concept of the advertising campaign, it also means approving the choice of models, the way in which the product is presented, and the particular way in which the setting is arranged.

When the location for the photography is a considerable distance from the studio, in another country perhaps, the approval has to be taken for granted, and

those assignments are usually given only to photographers whose work is known to the client and who can be trusted to produce the right pictures.

But when you are working in the studio and the client is unsure that the results will be to his satisfaction, the safest course is to get his approval at every step of the preparations. If it is not possible for the client to approve personally, then Polaroid shots should be offered and preferably signed by the client to signify his approval.

This preshooting approval can, on occasion, save you from having to re-photograph due to an error you have made. If you ever have to rehire models and take the time from a busy schedule to reshoot photographs due to a mistake, at least try to make sure that it is not your mistake. Not only is your reputation safeguarded, but when reshooting is caused through a mistake or second thoughts by the client, you should expect to be paid for your trouble.

Reshooting creates a number of problems. It may be necessary to order fresh color film and then find it difficult to match the batch number. You may have become involved in your next project, and it is sometimes disturbing to interrupt a flow of creative ideas. Reshooting can also throw your schedule out of line, causing you problems with deadlines.

Meeting Deadlines

The people who engage an advertising photographer do so expecting to receive several definite services. They expect specialized and creative advertising photographs. They expect that all the people concerned with the advertisement, including the photographer, will be able to notice anything that would detract from the message they are trying to put across. And they also expect that the photographs will be ready when the photographer says they will be.

This latter expectation is important. Notice that it is not that the photographs will be ready when the client requests them, but rather when the photographer says

7

Reverse side adobe

Imitation brick

Storage space for different surfaces

Any handyman could make this portable background in a few hours. The surfaces can be crumpled aluminum foil, stucco, imitation brick, matte black, or any other type of surface that would have photographic application.

that they will be. There is a difference, and it is very important to the building of the successful advertising studio.

A potential client may walk into the offices of an advertising studio, explain the type of pictures he requires, and state that he wants them to be ready on a certain date. At that point, the photographer can agree whether or not to take the job. But if he does agree, then the photographs **must** be ready on the specified date.

This one factor is probably responsible for more photographers losing clients than any other single reason. Poor workmanship, lack of creativity, and too-high prices can all cause an advertising photography business to falter; but given a second chance, the fault can be remedied. Not so with deadlines that are not met. Months of work by the manufacturer can be meaningless if the photographer is unable to maintain his schedules. When work is pouring into the studio and the hours skid by on greased rollers, it is often difficult to maintain the strict routines that ensure the work going out on time. When fresh work is offered, especially from a new and highly recommended client, there is a strong temptation to accept the work and "fit it in somehow!"

Sometimes it works out well and everyone is happy. But if the work is not ready when promised, there can only be loss of prestige and another client looking elsewhere for a new advertising photographer.

Only careful work control can ensure that all work accepted is within the scope of the studio and that shooting schedules do not conflict. All the bottlenecks that exist in every studio must be watched, and if work begins to lag behind its production time, steps must be taken immediately to correct the situation. Bottlenecks occur during the construction of sets, the unavailability of certain models (this can happen when a model has become recognized as representing a particular product and no other model will suffice), or problems can arise in the processing laboratory.

Another schedule destroyer is frequently the client himself. Vital decisions are delayed and final instructions are held in abeyance until the very last minute. This lack of urgency occurs quite often when preshooting proofs have to be approved; perhaps the advertising director is out of town or just that slight changes seem necessary, but it becomes difficult to decide what those changes should be.

When this type of holdup occurs, the studio executive responsible for maintaining schedules must approach the client and tactfully inquire the reason for the delay and point out that if the work is to be completed on time, too great a delay could result in the advertisement missing the deadline.

The availability of models is rarely a cause of delay. Models seem to be able to shuffle schedules like a well-trained magician shuffles cards; and as with the magician, everything seems to fall into place and come out right in the end. But models are a vital part of advertising photography. A talented model can put an advertising campaign firmly on the road to success, while an indifferent model can cause the photographer and his client a great many misgivings.

There are advertising photographers who seem to work a spell with models. Their photographs beckon the viewer with models who are extraordinarily attractive and who seem able to take poses that are completely natural. These photographers exude a certain charm to which models respond instantly, and the result is always first-class pictures.

You too can gain this special skill of working with models, of being able to inspire them to produce the very mood and expression you need. It is a skill that comes with practice, and if you are going to succeed in advertising photography, it is a skill you must acquire.

Food has to look good enough to eat, and you can almost taste this soufflé. Photo by courtesy of Los Angeles Art Center College of Design.

This alluring picture exudes all the delicate beauty of an old painting. Photographs such as this can be tied to many types of products. Photo by courtesy of Peter H. Fürst.

(Right) A masterpiece of imaginative photography. Photo by courtesy of Harry R. Becker for Ariella. (Below) Pictures of recreational vehicles always pose the same problems: finding an attractive setting and then getting the vehicles to the site. Photo by courtesy of The Alderman Company.

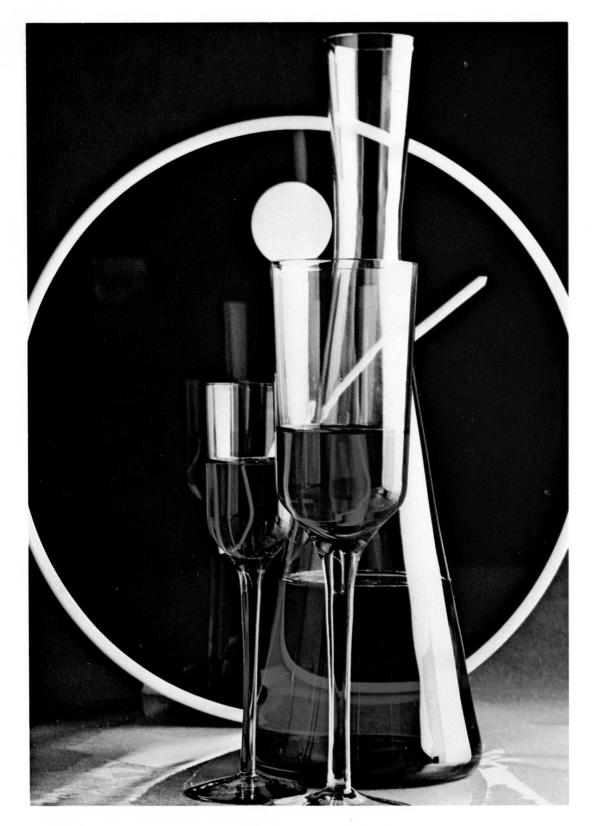

The high technical quality of this fine composition is almost taken for granted. Photo by courtesy of Los Angeles Art Center College of Design.

To pose a model against a pile of cans and produce a photograph as attractive as this takes considerable skill and technical ability. Photo by courtesy of Harry R. Becker.

How to
Get The Best From Your Models

Professional Models and
Enthusiastic Amateurs
Scales of Payment
The Accidental Model
Models and the Law

Every advertising photographer finds himself working with live models sooner or later. It may be a simple advertising photograph for a local manufacturer or a series of fashion shots that involve several weeks of planning and shooting. In either case, models have become such an essential part of advertising that they are featured in more than half of all national and international advertising. Every day, hundreds of models appear on the pages of magazines and newspapers, and the advertising photographer quickly learns to distinguish between the skilled model and the model who is still striving to make the grade. He knows which model agencies have high standards and require their models to maintain this level, and he also knows those agencies which have little regard for the professionalism of the models they represent. Good models are expensive. A first-class model can earn as much in an hour as the average person earns in a week, and a top model's fee for an hour's work may be more than the average household income for an entire month. So it's extremely important that the photographer knows not only where to find his models, but how to bring out the best in everyone with whom he works.

Although the cost of producing an advertising photograph using two or three well-known models is quite high, to some of the larger manufacturers it is only a small part of the total advertising budget. The greater part of the budget is scheduled for the purchase of space in which the advertisement will appear. But for the smaller manufacturer working on a restricted budget, using a model in a photograph could almost double the cost of producing a brochure, so it becomes necessary to decide whether the expense of a model is justified and exactly why some models are able to command higher fees than others.

Advertising agencies have conducted considerable research to find out which types of advertising photographs catch the eye and are remembered. They wanted to know why some photographs will bring immediate sales response and why others are almost completely ineffective. They discovered that the inclusion of a model in a photograph helped viewers identify with the product. They also found that an attractive girl not only helped increase the sales of products intended for the feminine market, products such as kitchen gadgets, baby food, vitamins, furnishings, and cosme-

tics, but a pretty model also promoted the sales of items used almost exclusively by men. After-shave lotion, tobacco, firearms, and power tools all sold better with the assistance of an attractive model. The male model has not been quite so effective in penetrating the feminine field and usually plays a secondary role in advertising photographs with the exception of a few products, such as men's fashions and items requiring the services of a rugged outdoors man.

The professional photographer is quickly able to assess the potential ability of a model, and the difference between a good model and a poor one is soon obvious. A good model and the photographer inspire each other to be creative and produce top-quality work, while a poor model can cost a manufacturer hundreds of dollars.

Professional Models and Enthusiastic Amateurs

A good model is interested in her work, is on friendly terms with other models, and possesses a well-developed personality. Time is always a precious commodity, both for the model and the photographer, and it helps if the model is something of a quick-change artist, especially in fashion photography where the photographer may be faced with photographing 10 or 15 different dresses an hour. With the move toward authenticity in advertising photography, it is a definite asset for the model to have a flair for amateur dramatics or possess the ability to be convincing in the scene being photographed. The model must be able to blend in with any setting and appear perfectly relaxed and at ease, regardless of all the activity that may be going on elsewhere in the studio.

For the photographer to be able to establish a good working relationship with his models, he should know some of the reasons why models become models. He should know something of the background of the girls with whom he is working. With many professional models, modeling is a step toward national or international recognition and the most direct route to a career in the movie industry. But there are many models who are content with simply being a model. In many ways, they are their own boss. The work is suited to their temperament and provides them with a special aura of glamor to be found in no other profession. They find the work emotionally satisfying and financially rewarding. In many respects, it is like the entertainment profession; and like the professional entertainer, the professional model is able to produce that extra-special performance when the audience is appreciative. The photographer who takes the trouble to compliment his models and shows a genuine interest in their efforts to improve their modeling skills will always find his consideration rewarded with photographs that sparkle with vitality. On those off days that every photographer suffers occasionally, a skilled model can often spark new ideas or provide that flash of inspiration so necessary to creative photography.

Almost all professional models work through model agencies. A top-line agency obtains many of the assignments, schedules appointments, and on occasion, acts as adviser, helping the model on her climb to success. Models come to the agency from all walks of life, some of them merely bored with routine office jobs or tired of standing behind a counter in a department store. Others travel to the big cities with their minds closed to everything but success in a career as a model. Housewives of all ages turn to modeling as a diversion or to supplement their husbands' earnings.

All of these people, completely new to modeling, have to make a start somewhere. The only way they can gain experience is by working in front of a

This photograph lends itself to almost any advertising theme. A skilled copywriter can tie this type of picture to almost any product. Photo by courtesy of Gerald William Hoos, International Photo-Art Service.

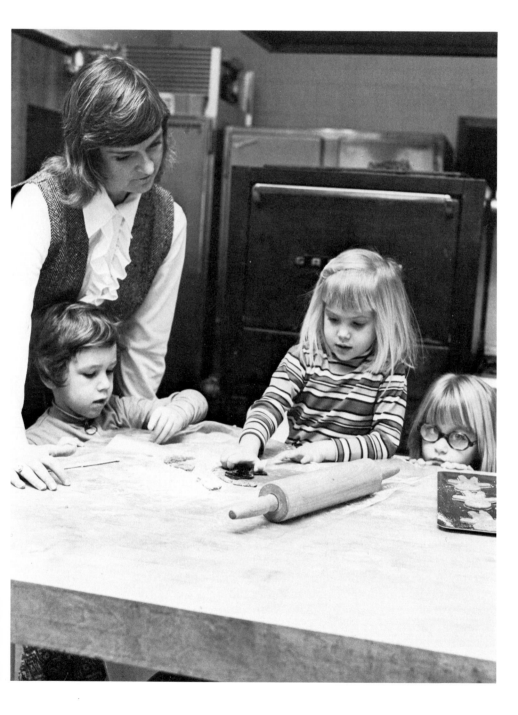

camera. At first, it would seem that the opportunities for gaining experience are very restricted. After all, which busy studios can take time out to teach models to model? No advertising agency or photographer would engage the services of a newcomer to modeling for a project costing their client many thousands of dollars, yet the opportunities for a novice do exist; and sometimes when the model has a natural flair for modeling, those opportunities can lead to overnight success.

Photographers too have to learn their trade, and model agencies are very willing to send new models along to a photographer, providing he meets their qualifications. They would first want to see samples of his work and to assure themselves that he was conducting a legitimate business. They would also make sure that the photographs taken by the photographer were not sold by him; rather, the agency would select from them suitable shots the model could use to start building her portfolio of pictures. In other words, the model is providing her services in return for photographs. It is a convenient arrangement, one which furthers the careers of both model and photographer.

As the photographer gains experience and works with a wide variety of models, he learns why some models are more expensive than others and why some models are a pleasure to work with while others prove to be unsatisfactory. A model who is on the set, ready to start work on time, is always a joy to work with. Nothing can destroy a photographer's concentration faster than a model who arrives late and then spends too much time in the dressing room. Another model who pleases the photographer is the one who is willing to learn. There are those who are willing to tackle an unusual pose and others who find the whole thing rather boring.

Probably the easiest models to work with are those whose work takes them in front of the public. Film stars, politicians, and well-known sports figures are usually relaxed, patient, and willing to help the photographer get the pictures he wants. Perhaps the entire essence of being a good model is the ability to relax and be natural in front of the camera. Some models can relax or give the appearance of being relaxed without any trouble at all. The newcomer to modeling has yet to discover the secret.

If the photographer expects his models to care for their appearance, to be attractive and prepared to work until the results are satisfactory, the model too has rights that must be respected. One of the biggest criticisms leveled at photographers is that they don't give the models or the model agencies sufficient notice. Most models arrange their schedules well in advance, and the more notice they are given, the easier it is for them to fit in the maximum number of engagements. Any delays in a shooting schedule should also be made known to the model as soon as a date change or cancellation becomes unavoidable. Sometimes the photographer himself is unaware of a shooting delay until the very last moment and has no opportunity of advising the model. In these circumstances, the model would expect to be paid even though she does no modeling.

When shooting on location, perhaps in a foreign country, it is sometimes less expensive to use local models. This can frequently be arranged through those model agencies which have branches overseas or by contacting photographers abroad through their photographic associations. On those rare occasions where a foreign country has no professional models available and it would be uneconomical to send models abroad with the photographic team, it becomes necessary to obtain the services of amateur models.

Working with amateur models has several advantages, and there are many photographers who would rather work with amateurs than with professional models. In the strict sense of the word, both types of models are professionals in that

they are paid for their services, but we shall take the term "amateur" to mean someone who doesn't model for a living, people who model in their spare time and use their model fees to supplement their normal income.

One of the advantages of working with amateur models is that being untrained or inexperienced, they are very natural in front of the camera. The professional model can step into a series of poses with practiced ease and skill, and while this can be an advantage when time is at a premium, it does tend to lead to stereotyped poses. The amateur may feel a trifle awkward at first, but a skilled photographer can soon put her completely at ease and produce a set of pictures noticeable for their spontaneity. Amateurs lack that slightly hard gloss of the professional.

Many advertising photographers get a lot of pleasure from discovering their own models—the interesting face in the restaurant, the bronzed lifeguard at the beach, or even the person passed on the street. The majority of people are flattered and quite prepared to model once they have recovered from the initial shock of being approached by a complete stranger. If you meet someone who you think has the looks and personality to be a photographic model, give the person your card, tell her the type of work you do, and ask her if she would care to let you take some test shots. Suggest that she telephone your studio and ask your receptionist for an appointment, and tell her that she may bring along a relative or friend. Husbands and parents must be satisfied that everything is perfectly genuine and aboveboard.

The need to discover new faces presents a constant problem; and to discover someone with tremendous modeling ability and watch that person grow from obscurity to international fame is more than just gratifying. It has, on more than one occasion, also brought the photographer to prominence. Local beauty contestants are usually good material, as are members of amateur dramatic societies. If there is a lack of models in your area, a small advertisement in a local newspaper will meet with a response that will surprise you.

If you are just getting started in advertising photography and finances are stretched rather thin, you will find that many amateur models will be prepared to work on a payment-by-results basis. This is a particularly helpful way to get started when taking photographs on speculation. The photographer may arrange to work

Children and pets make ideal subjects for advertising photographs. Photo by courtesy of Gerald William Hoos, International Photo-Art Service.

together with his model on a project basis. In such a case, the photographs could be intended for use as book covers, product packaging, or as samples to obtain further work. And if the photographs sell, the photographer arranges to share the profits with his model after expenses have been paid. If further work comes from the mutual effort, the model is paid a commission.

As the scope of your work is enlarged, you'll find that it will pay countless dividends to keep your own model file, even if you get your models through an agency and regardless of whether they are amateur or professional. Your personal model file should contain a photograph of each model you use, duplicate shots of the photographs accepted by the client, the date the photographs were taken, the model's measurements, hobbies, and agency or telephone number. The best system for your file is to divide it into types. This way, when you are called for a secretary, a swimwear model, or a tanned, deep-sea fisherman, you've got the information at hand. You will also find it useful to make a note of any special features, such as good teeth, attractive smile, well-shaped legs, expressive hands, and beautiful eyes. If you cross-file this information in a small card file, you can quickly locate the best model for any specific work you may be asked to undertake.

Scales of Payment

There is no set fee for the photographic model. Payment for a day's work can range from a set of photographs to several thousand dollars. When the work has been assigned by an advertising agency and it has assumed responsibility for engaging the models, the photographer need only be concerned as to whether or not the model is one with whom he can work efficiently. Payment is arranged by the agency. When the photographer has to engage the models, he must make sure their fees are within the budget established for the project.

Most of the larger model agencies retain 10% of the model's fees as part of their commission. They require another 10% from the photographer or advertising agency who engages the models. For that commission, they are able to supply models of all types at a moment's notice. Some model agencies specialize in children or juveniles; others concentrate on girls between the ages of 16 and 25; and there are agencies whose files contain listings of all types of people, from babies to senior citizens, but whose services are directed almost exclusively to supplying artists or models for television commercials.

When you become known to the model agency, you will be placed on its mailing list. From time to time, you will be sent a catalog and regular supplements that keep you informed on new models who have joined the agency. This mailed information is often followed up with a personal visit by the new models who make the rounds to all photographers and advertising agencies. The model agencies know from experience that a model who introduces herself stands more chance of getting work than the model who relies on a photograph sent through the mail. Too often, the photograph is placed in a file and forgotten, but a model with dynamic personality can leave a lasting impression.

Try to make a point of interviewing every new model who comes to introduce herself. These are the alert, willing-to-work models, and although they may lack experience, they usually compensate with a great deal of determination.

While model fees can vary over an extremely wide range, the amount they can expect to be paid is based on their experience. Models just getting started don't expect to receive top dollar, and you would never engage the services of one of the foremost models unless the work required such an established personality. In such

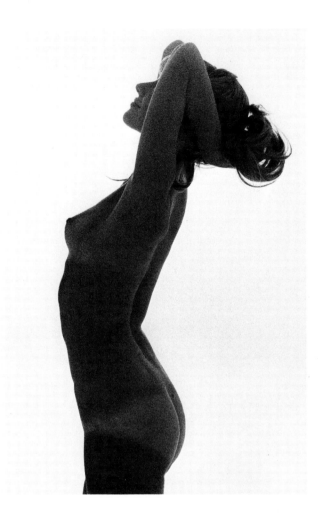

The man who can turn this page without reading the copy has yet to be born. Photo by courtesy of Studio Guy Marché.

a case, the model's fee would have been established and included in the client's advertising budget long before the photographer was consulted.

Some models who are used in advertising photography do not really fall into any model classification, and their scale of payment has to be arranged in advance. They are people who become models almost by accident.

The Accidental Model

Not all of the people you see in advertising photographs really intended to take part in an advertising campaign. They are the accidental models—men, women, and children who get into the advertising photographs because they were in the right place at the right time. The photographer is well aware that these people are in the photograph; in fact, he often welcomes them and arranges his viewpoint to take advantage of their presence, although they had no previous intentions of acting as models.

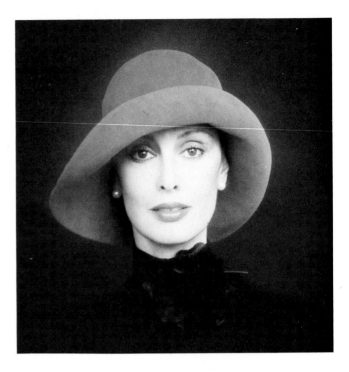

These eyes are almost hypnotic. If an advertising photograph should grip the attention, this one succeeds admirably. Photo by courtesy of Peter H. Fürst.

A typical accidental model is the person passing by in a city street location shot. Accidental models are also the people watching at an excavation site for a new building when the photographer is photographing the construction equipment. Accidental models can be the crowd at a street market, the people on a beach, or the children at a county fairground.

While the photographer may be working with professional models on a location shot, it is almost inevitable that people will gather to watch, especially when the location is in the heart of a busy city. Sometimes these people can be a nuisance to the photographer and an embarrassment to the model, although an experienced model is at much at ease in front of a gawking crowd as she would be in the privacy of a studio. But there are times when the presence of an audience can add interest and occasional humor to an advertising photograph. The trouble always seems to be that a crowd will form when and where they are not required, but by a twist of the perverse fates that can materialize a crowd out of thin air, people are never around when the photographer really needs them.

An advertising photographer was asked to photograph a well-known film star to help publicize a clothing manufacturer. It was arranged that the celebrity would walk from the stage door of the theater where he was playing and pause to sign autographs with his new Silver Cloud Rolls Royce as a background. To take advantage of the available light and to give the photograph an unposed look, it was decided that shooting would take place following an afternoon matinee rather than an evening show. It was also arranged that the film star would delay his exit a few minutes in order to give his fellow performers time to leave so they wouldn't walk out onto the shooting session.

The photographer visited the location twice previous to the shooting date in order to verify the visualized viewpoint and lighting conditions. But he overlooked an important consideration. It was arranged that the celebrity would walk toward his car as he did every day, pausing once or twice to sign autograph books. At a signal from the photographer, the star would pose at the curbside, at which time the photographer would tell the fans that this was an advertising photograph and that those who wished to remain in the photograph could do so and would be paid for their assistance. It was anticipated that the majority of fans would leap at the opportunity to be in the photograph.

At the appointed time, the photographer took his position at the stage door. There were only five fans waiting, but he took comfort from the knowledge that on the two previous occasions he had visited the location, there had been at least 20 people waiting. But by the time the other artists had left the theater and the actor/model had waited a few minutes, the photographer was the only person standing outside the stage door.

At the very last moment, the photographer noticed a tour bus full of people pull into the parking lot of a nearby restaurant. He ran across and told the tour guide that the celebrity was just about to leave the theater and that any of the tourists who wished to participate could appear in an advertising photograph. When the celebrity walked through the door, he was almost overwhelmed by 30 excited people waving pencils and notepads.

There are many occasions when members of the public may be pressed into serving as impromptu models—for example, the beach or mountain scene that can be improved by the inclusion of a solitary figure, or the special placement of a spectator at a sporting event. It is rare for anyone to refuse.

Sometimes the advertising photograph is taken before the person in the photograph is even aware that he has become a model. The photographer driving through the countryside is attracted by the scene of a farmer ploughing a field and the cloud of dust and flock of birds following the plough all silhouetted against a flaming red sunset. The possibility of using such a photograph for advertising purposes is enormous, and strictly speaking, the photographer has no need to ask the farmer's permission; however, it is a courtesy most professional photographers will extend. In circumstances where delay would jeopardize the opportunity, the photographer would take the photograph and then visit the farmer, describing the scene that had just been photographed and offering to send the farmer a copy. Many friends have been made as a consequence of such a gesture, and the outcome has also been responsible for many more fine pictures.

Although the photographer is allowed a considerable scope with regard to the people and places he may legally photograph, there are legal restrictions he must observe, particularly with reference to the use of models in advertising photography.

Models and the Law

Without getting too deeply into the legal aspects of photography at this time, the photographer should be aware of the rights of individuals with regard to the Invasion of Privacy. Although this is an involved subject which requires a person with legal training to fully comprehend it, the photographer can protect himself against the more common legal actions by following a few well-established rules.

Any photographer or corporation that uses the name or photograph of a living person for the purpose of trade without first having obtained the written

consent of that person, or in the case of a minor, the consent of a parent or guardian, is guilty of a misdemeanor.

The statute that covers this rule goes quite a lot deeper, giving the wronged person the right to sue for damages. Because of the publicity this rule receives from time to time when some thoughtless photographer or business is hauled into court, most photographers have a healthy respect for this section of the Rights of Privacy and will have their models sign a release immediately after the photographic session is completed.

Although the Rights of Privacy are sacrificed to a certain extent by people who have become famous, they still retain the rights to sue if their photograph is used to promote a product without their written consent. In fact, the more famous the person, the more valuable that person's endorsement of a product, and in consequence, the stronger their right to sue. This is easy to understand if you put yourself in the other person's place. If you had struggled for many years to achieve public recognition as an entertainer or sports figure, you would certainly resent someone else using your name or photograph to make money. You would be even more resentful if that someone ran an advertisement stating that you drank Brand-X beer or wore a Y-type hairpiece, especially if you were religiously opposed to alcohol and proud of the fact that your hair was your own. Such false or misleading statements bring us into the law of libel.

A photograph or statement that brings disrepute, ridicule, or contempt to, or injures a person in his business is said to be libelous. Any person who can complain that your photograph has brought distress can sue for any monetary loss that could ensue, such as cancelled contracts or loss of business. This monetary loss can be calculated in dollars and cents, but more dangerous to the photographer could be that person's complaint that the photograph has caused an emotional upset. In this case, the damages awarded against the photographer could be any amount, and it's very vagueness increases its danger.

An advertising photographer engaged in the normal day-to-day work of advertising photography is not too likely to run foul of the law of libel; he is not taking pictures likely to be considered malicious or defamatory. It is when the photographer is taking photographs for sale on a speculative basis that he must be on guard. Even the standard model-release form does not remove the obligation of the photographer or publisher to ensure that an advertisement does not damage the reputation or standing of a model. If a model's virtue or reputation is impugned by a photograph that casts doubts upon her morals, even by implication, the photographer is wide open to legal proceedings.

One other legality worth mentioning concerns those people who are photographed on the street or in a public place—the accidental models. Generally speaking, any person or people in a public place or attending a public event may expect to be photographed, but they may not be singled out.

If you have taken photographs that may result in a libel action, destroy them or lock them up in a safe place. Don't simply throw them in a trash can; destroy them completely. If they are pictures that are to be used in an advertisement and there is the slightest doubt as to their freedom from a lawsuit, have them cleared by a legal authority before you release them from your custody.

Although the legal side of photography, concerning the rights of people to protect their privacy, is now fairly well established, the advertising photographer is faced with continuing expansion and development of the advertising profession. It eventually becomes almost impossible for one man or one business to cover the entire spectrum of applied advertising photography; it becomes necessary for the photographer to specialize.

How to

Establish
A Nationwide Reputation
As A Specialist

Ten Thousand Golden
Opportunities
Self-Advertisement
The Importance of Research
Style Is Like an Autograph

As the field of advertising photography expands, it becomes increasingly necessary for the photographer to have a deeper knowledge of the products with which he is working. The manufacturer or the advertising agency will usually supply the photographer with a detailed description of the photographs required, but unless the photographer is completely familiar with the product, he is unable to allow his imagination full freedom to produce eye-catching pictures.

When the photographer understands the product with which he is dealing, whether it is a new building, a machine part, or even household detergent, he is able to bring out the important features. He knows why the product is superior or different to other products, and he is able to emphasize this difference by skilled, inventive photography. The photographer who is not familiar with his product is likely to miss special features or neglect to give them the prominence they deserve.

It is because of their interest in certain products that many advertising photographers decide to specialize. Their experience and knowledge help them to produce photographs that convey authenticity. The advertising photographer who is an enthusiastic golfer will know exactly where to go for just the right backgrounds when he is asked to illustrate goods for a golfing-equipment manufacturer. The photographer who is an experienced yachtsman will be able to produce better regatta photographs than the photographer making his first trip on the water.

As the needs of industry and commerce become increasingly more demanding, the manufacturer and advertising agency are able to turn to the photographer who specializes, knowing that the resulting photographs will be exactly what they need. Instead of having to go into detailed explanations, they can confidently leave the photographer to produce photographs that are not only attractive but illustrate all the most important sales features.

Ten Thousand Golden Opportunities

The fields of specialization are unlimited. There are photographers who specialize in travel pictures and others who specialize in food.

Some fields are even sub-divided into sections, which are themselves subject to specialization. For example, horticulture has many divisions, including roses, orchids, ground cover, cacti, water plants, fertilizers, greenhouses, and sprinkler systems. Every product offered for sale in this highly technical age can be the subject of specialized advertising photography. Many studios start out by accepting all the work they are offered, but as time passes, they find themselves concentrating more and more on just two or three products, and as a consequence, are able to offer a more comprehensive service.

In many instances, specialization in just one or two areas of advertising photography is an extension of the photographer's hobby or previous training. It can also be the result of concentrating on specialized industries close to the studio. Specialization in the products of local industries will sometimes necessitate the purchase of special studio equipment or require studio modification to enable the photographer to handle his assignments efficiently.

The photographer who is going to spend the greater part of his day photographing automobiles will need a studio large enough to handle the project, sufficient lighting equipment to provide adequate illumination, and ground-level entrances to the studio, large enough to enable automobiles to be driven onto the set with a minimum of inconvenience. The photographer who intends to specialize in the photography of ceramic ornaments or underwater engineering installations would require an entirely different type of equipment and studio facilities.

There are occasions when specialization forces a studio to grow to such an extent that it expands into other fields. Alderman Studios started in 1898 as a one-man, one-camera business with a studio in a room above a drugstore. For many years, advertising photography for the furniture industry was its only business. But as the clients' needs grew, it became necessary to enlarge the field of specialization to include color separation, printing, binding, sales training, films, and television commercials. As the studio continued to expand, it entered the field of industrial displays and eventually developed into a huge visual merchandising company offering products and services to many different industries.

Today, the Alderman Company is the largest advertising photography studio in the world, with over 325 people employed in an operation that is housed in a modern four-and-a-half-acre building set in the rolling hills of North Carolina. Interior designers, artists, carpenters, photographers, and copywriters are part of a large crew of experienced technicians who will build, decorate, and photograph complete room interiors with swift, smooth efficiency. So vast is the studio that there may be as many as 30 full-size sets being photographed at the same time.

Such growth can only be accomplished by providing a service that satisfies clients and draws new customers to the studio in ever-increasing numbers—a service that indicates a thorough knowledge of the product and provides every possible facility for illustrating it in a way that will help to increase sales.

Specialization that comes through a photographer's interests is virtually assured of success from the beginning. Not only is there an understanding of the product, but the photographer is also a consumer and able to view the product objectively. He knows how to present the product visually to make those features appear even more appealing.

If your inclinations are toward becoming an advertising photographer who specializes, there is a large incentive. The fees paid to photographers who specialize are far higher than those paid to photographers engaged in all-round photography. The client who has a product that requires a photographer who possesses specialized knowledge is well prepared to pay higher fees.

While there is tremendous scope for the person who wants to specialize in a

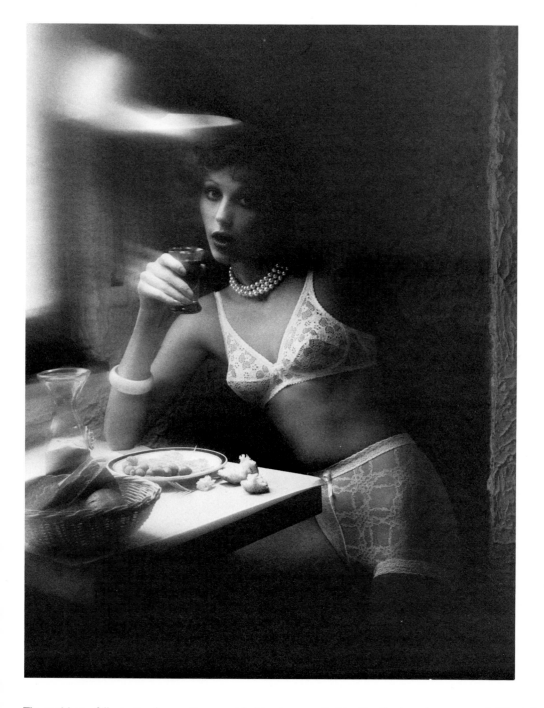

The problem of illustrating lace patterns and fashion in a way that is attractive has always proved difficult. In this photograph, simple props have been combined with low-key lighting very effectively. Photo by courtesy of Peter H. Fürst.

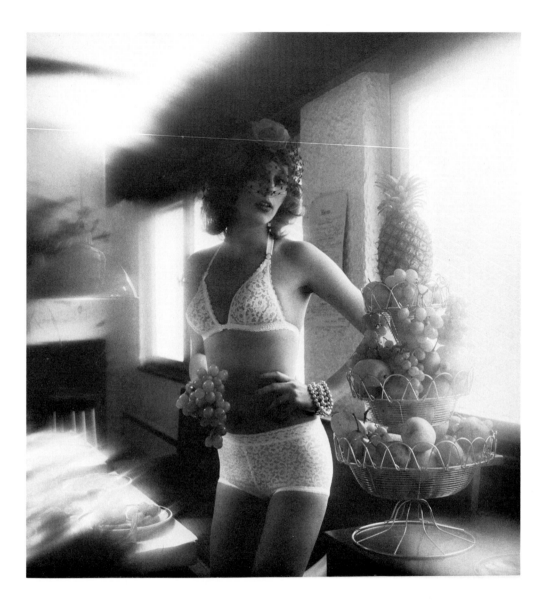

Props and soft lighting have again helped to produce an advertising photograph that is both attractive and illustrative. Photo by courtesy of Peter H. Fürst.

particular field of advertising photography, getting the assignments is not quite so simple as it is for the all-round photographer. Although your skill as a photographer may be well known, the clients who require the services of a specialist must be made aware that you are able to give them what they need.

Self-Advertisement

When the client is dealing with merchandise that is outside the range of day-to-day advertising photography, he is usually unwilling to hand the assignment to a photographer who may encounter problems or lack the necessary special equipment. It then becomes the photographer's duty to contact possible clients and inform them of his services and qualifications in their particular field.

The customary method of making appointments and showing samples must be followed in the normal way. There is no substitute for a face-to-face meeting with a proposed client, and when the samples are attractive and well displayed, work will inevitably follow. But advertising photographers are in a unique position: They have a better-than-average understanding of advertising techniques; they know the type of pictures that attract attention; and they have the facilities and experience to produce those pictures. Self-advertisement should be part of every advertising photographer's business, especially when the photography is specialized; yet a surprising number of photographers overlook the importance of personal publicity.

Self-advertising is a skilled art. Its style should echo personality and whether you are an outgoing person or inclined to be quiet and reserved, and it should match the character of the business. If your studio is showy and always in the public eye, gentle advertising would be lost. To be effective, advertising for a flamboyant studio should be exciting and strong, although this should always be supported and backed by more subtle publicity. The studio that takes a more dignified approach would be better served with advertising that is gentle but no less powerful. Its advertising style should place stress on the quality and reliability of the services offered.

The advertising of an advertising photography studio should follow the lines established for advertising any business. First is a decision on how much money can be budgeted for advertising; then a study of the people whom the advertising must reach; followed by a determination of the methods to be used to reach those people; and finally a firm date on which the advertising campaign is to be launched.

There are several other factors that should also be taken into consideration, namely, the length of time the advertising campaign will run; the methods to be used to verify its effectiveness; the form the advertisement will take; and the establishing of a systematic follow-up on all responses.

When your business is sufficiently large, it would be preferable to turn over all advertising planning to an advertising agency or establish an advertising division within the business. But for the advertising photographer just getting started with his budget strained to the limits, it becomes necessary to use a little imagination and ingenuity to get as much publicity as possible without crippling the finances.

Many advertising photographers struggling to become established as a specialist may think that spending any money at all on promotion presents a major problem. There are so many pieces of equipment that could be purchased, equipment that could help produce even better pictures with even greater ease. There are also new materials to be tested and new processes to be tried. With so many demands on already strained finances, the importance of self-advertisement is

paramount. Unless potential clients know you exist, you get no work. Regardless of how sophisticated the equipment or how advanced your photographic techniques, unless you make yourself known, you might just as well close the business.

Your first contacts are going to be made personally. You will make a list of possible clients within calling distance, telephone them to make an appointment, and then call on them. When you meet the person whom you hope to interest in your services, you will show your samples and quote fees. But what happens after you leave?

It is then that some of the finest selling takes place. The brochure you leave behind and the follow-up action you take are powerful weapons in the art of selling advertising photography. Make sure that the brochure is not only illustrated, but illustrated with really fine examples of the photography in which you specialize. Don't use a brochure that tries to sell your services by means of breathtaking copy. Use some copy to ram home the advantages of using your services, but let the photographs do your selling for you.

Even if you get an outright refusal, don't neglect the follow-up; first a short note thanking the person for the courtesy of meeting with you, and then at regular intervals, mail promotional material, such as calendars, price revisions, invitations to a one-man exhibition, and any other material planned and dovetailed into a systematic follow-up program.

Keep your mind alert for self-advertising ideas. Don't be content with a standard letterhead; make it spectacular. You're in the business of advertising photography, so make advertising photography work for you. Wrap your minute-to-minute thinking around advertising photography, both for yourself and your clients. When an idea occurs to you, write it down; alongside it write the date when it will be put into operation, and hold to that date. This positive approach will help you bridge those times when you feel a trifle slow and uninspired. By establishing a firm date for the commencement of any advertising program and sticking to it, you avoid the unforgivable "I never did get around to it." Keep moving forward all the time. Remember, even if you're on the right track, you'll get run over if you just sit there.

The more unique the methods you use in promoting your business, the more effective they're likely to be. Send out Christmas cards with a difference; they may offer the season's greetings, but let them also show your studio and its facilities. If you use a commercial van for making deliveries, take out the side panels and install illuminated transparencies made from nonfading Cibacolor transparency material. Make your business cards unforgettable; all you need is a little thought to prepare business cards that are really striking.

As your business expands, try using some of your free time to become involved in civic affairs. Offer to teach photography or give lectures to local youth organizations and camera clubs. Be as liberal with your knowledge and time as you can; you'll find it repays itself time after time.

All professional photographers develop individual techniques or devise new photographic procedures. If you find that improvisation and innovation come easily to you, use these skills to help keep your name alive in the photographic trade. Send your ideas to the photographic magazines and trade journals. The more people who know your name and the type of work in which you specialize, the more work will be referred to you.

Self-advertisement comes from putting your name in front of the public as frequently as possible. There are photographers who appear on TV talk shows or hold one-man photographic exhibitions. Some photographers attend public functions accompanied by the most astoundingly glamorous partner imaginable, and it

is almost inevitable that their photograph appears in the morning's newspapers. Advertising photographers have been judges at beauty contests, appeared on the panels of quiz shows, and even have arranged to have themselves paged several times at a manufacturer's convention. The people who are likely to engage the services of a specialist in advertising photography can do so only when they know the photographer exists, either from recommendation or the advertising carried out by the photographer.

The people who require the services of a specialist photographer also know precisely what they want. They are experts in their field and expect the photographer to be equally knowledgeable in his approach to the photography. Such expertise is to be expected when the photographer is working in a field with which he has had considerable experience; but for the photographer on his first assignment or in the process of widening his field of activity, it becomes important that the photographs are as factually accurate as possible.

The Importance of Research

Even the photographer who is completely familiar with his subject has occasional need to verify facts and ensure the accuracy of his photographs. If he is on uncertain ground, the need becomes imperative. It is very probable that the people looking at the advertisement will be knowledgeable and able to spot errors immediately.

It could be that the setting is wrong for the product or that the product is being used incorrectly. Take, for example, the photographing of orchids for use in trade catalogs. In almost every instance, the grower prefers his blooms to be photographed head-on, down the throat of each individual bloom. In this way, the delicate color-streaking and petal shape are clearly illustrated. The inexperienced photographer may be tempted to take a profile or include the whole plant, and while this would be alright for a pictorial photograph, the grower who is hoping to sell his new varieties to a wholesaler or private collector has to have photographs that illustrate the selling features.

The photography of most sporting goods is also best undertaken by people who know what they are taking and talking about. To pose an angler taking a fish from a fast-flowing river when it is a fish found only in deep lakes would invite criticism from the anglers at whom the advertising is directed. A golfer using the wrong iron or a sportsman hunting deer with a shotgun would also bring unfavorable comment.

Even the photography of such an everyday commodity as wines and spirits requires a good knowledge of the subject. Brandy in a liqueur glass or wine that should be served at room temperature being poured from a chilled bottle would cause the client considerable misgivings. The photographer who photographed a bottle of brandy against a background of wheat probably still doesn't realize why his client preferred the photograph of the brandy, taken in a studio at a later date.

No experienced advertising photographer is going to make mistakes that are quite so obvious, but when the subject is highly specialized, it takes a person knowledgeable in that subject to be certain that the photograph will bear the stamp of authenticity.

The photographer venturing in a new field has two alternatives. He can obtain the assistance of a technical expert to supervise and watch for errors, or he can spend sufficient time asking questions and reading about the subject to be certain that errors will not occur.

When the work is only temporary, it would be sufficient to have an expert on hand, ready to advise. But if the work is the beginning of a steady stream and likely to develop into the main line of business, it is necessary for the photographer to become completely familiar with the product and its application.

In many ways, this acquiring of knowledge can be considered a business investment. There is an investment in the time spent studying, and there is an investment in the materials used while gaining experience. The photographer, like all other businessmen, must endeavor to turn all investments to a profit, and in advertising photography, the investment in time and materials will show a profit from the work gained through specialization.

When the product to be photographed is small, most manufacturers will provide a sample for the photographer a day or two in advance so that he may become familiar with it. But when this is impossible, as with a building or an

If advertising photography is your business, then the world should know about it. Photo by courtesy of Laursen Mitchell.

114

industrial plant, the photographer is compelled to spend time on the site, selecting camera angles and estimating light values. There is no substitute for research when working in a specialized field. The research may be physical examination, verbal instruction, or a technical report, but unless the photographer is fully informed, his photographs will never be as forceful as they should be.

The ability to produce powerful pictures is based on photographic ability and correct choice of approach to the subject. It requires that the viewpoint be correct, the lighting exactly right, and the finished print or transparency technically perfect. Most advertising photographers reach this stage of competence with time and experience. Their work develops a style that can be easily recognized by fellow photographers and, on occasion, by the public.

Style Is Like an Autograph

As an advertising photographer, you will be working in a medium that combines artistic expression with technical and mechanical competence. As your ability grows and your insight into creative photography develops, you will evolve a style that is as distinctive as an autograph.

In the field of art, such masters as Salvador Dali, Picasso, Rembrandt, Degas, and Monet produced work that people can recognize instantly. Photographers such as Peter Gowland, Kishin Shinoyama, Ansel Adams, Margaret F. Harker, and Regina Relang have developed individual styles that make their work outstanding.

If you too are to become one of the leaders in advertising photography, you must consistently produce photographs that could only have been taken by you. To achieve this, you must analyze and dissect the reasons why some photographers are able to gain international distinction while others remain in obscurity.

One of the prime elements of individuality is the ability to criticize one's own work—to see your photographs as they really are and not as you imagine them to be. Every photographer, amateur or professional, has taken photographs with which he is more than delighted. You too have taken photographs like this, and at the time they seemed masterpieces. They expressed the mood of the moment; they were technically good; and they completely satisfied. Then you placed them in an album or filed them carefully for posterity.

A few years may pass before those photographs are looked at again. In the interval, a strange metamorphosis may have taken place. The photographs, which formerly gave such pleasure and satisfaction, are now less than second class. The tones, which once seemed so clear, are now muddy, the composition could easily be improved, and the theme, which once seemed so clever, is now painfully amateurish.

It's not that the photographs have deteriorated through the passage of time; it's simply that you have taken several strides forward, and the improvement has been so gradual that you have not noticed how your standards have grown. By looking back at photographs you took in the past, you will probably be a trifle surprised that you could have been as satisfied as you were. You may notice that in one of the photographs the background is terribly confusing, and you now realize that increased depth of field would have given the foreground just a little more bite. Why were these things not obvious at the time? How can you see these faults now when such a short time ago the photographs were so pleasing?

It stems from the common failure of seeing only what you want to see. Your memory retained the image from when you took the photographs, subconsciously

transferring the impression to the finished print. Looking at your own work with an unprejudiced eye is a skill that has to be cultivated; and it's a skill that will only come with a strong determination to be your own critic. As soon as you have developed the ability to see your work with your client's eyes, you will produce work that pleases him.

This doesn't mean that you should restrict your creativity to please someone else; this would merely hold you back, forcing you into the very rut you should try to avoid. But it does mean that your photographs will be exactly as you intended they should be. Your clients will come to you because of your ability to be creative, and they will be presented with photographs that are precisely as you envisaged.

Individuality makes exacting demands on the photographer. He has to be on the top line at all times, and although he will progress, that progress will be further development of his style. Individual style should never be developed for its own sake. This could result in photographs that are meaningless. Clever pictures, which make no real statement, will prove interesting for a while, and then familiarity will rob them of their ability to attract attention.

Style can be a rigid conforming to the normal, or it can be a bizarre distortion of standard techniques to achieve new visual effects. There are people who dislike new innovations or progressive ideas, but fresh thinking is always a step toward public recognition. Any photographer first in the field with a new way to achieve visual effects or to give a photograph an unusual degree of naturalness will be credited with that innovation until it is replaced by an even more progressive idea.

Given the same subject, no two photographers will produce identical prints. Every photographer will have his own interpretation and ideas on how any subject should be photographed, and it is this personal approach which can be developed into a style that draws clients like bees to a jar of preserves.

Your studio can be a total success and the envy of competitive studios. It can be hidden away in a small building on a side street, far from the main sector of business, and yet still be deluged with work from the most desirable clients. The secret is in specialization combined with an individualized style. These techniques can be yours with a little effort and consistent practice.

Although specialization can come through previous training or diversionary interests, practicing to attain an individualistic style can prove a little more difficult. How can you tell if your style is individualistic or even if it's style at all? The answer is in setting yourself a target.

Direct your practice along lines that appeal to you—conventional, surrealistic, futuristic, or any other art form you consider has possibilities in current advertising trends—and then find ways of presenting everyday objects in that form. For instance, take a chess piece and practice photographing it to give it dynamic visual appeal. Try the same thing with a glass vase or an automobile hubcap. When you have progressed to the point where you can take everyday objects and give them your special treatment, take those articles which themselves present problems—items such as silver or stainless-steel cutlery, ice cream, or the nude figure—and try giving them individualized styling.

Without your becoming consciously aware of the fact, your photography will gradually develop special characteristics that are as individualistic as a coat of arms. Your style will flow through each photograph you take and be part of the specialized field in which you are working.

As your particular style becomes pronounced, you will discover that the ability to create special effects and exciting visual patterns can be widened by applying special darkroom techniques.

How to

Perform Darkroom Magic

Combination Printing
Screens and Grids
Solarization
Tone Separation
Reticulation
Photo Patterns Made Without a Camera
The Trick with Proofs
Reproduction in Color
The World of Fantasy

Whether you decide to be a specialist in any branch of advertising photography or prefer to accept a wide range of varied assignments, the skills you use to capture your impressions on film can be supported by darkroom processing techniques that will open up an entirely different route to effective advertising photography.

Although a well-executed conventional photograph can attract attention and grip the viewer's interest, it is the unusual that really catches the eye. The readers of a magazine may pause to look at an amusing photograph of a baby or be interested in a picture of a cowboy lighting a certain brand of cigarette, but it's the unusual that really intrigues and grabs the attention.

Ingenious, creative processing can produce photographic effects that are staggering in their visual impact. Many of these effects cannot be repeated or duplicated exactly, not even by the photographer who produced them, and this very exclusiveness adds to their value.

Most darkrooms can be used for the production of photographic effects, and the photographer to whom this type of photography appeals may wish to modify his equipment to enable him to enlarge the scope of his work.

The following ideas are only treated lightly, but the photographer who finds that this style of photography satisfies mentally and financially will quickly realize the possibilities and adapt many of the principles to his own way of working. The techniques may be applied in color or black-and-white, and nearly all of them can be used singly or in combination to produce an infinite number of different effects.

Combination Printing

This, together with double exposure, is probably one of the oldest and most widely used effects. Even though it is used so often, it is a very effective way of taking a photograph out of the realm of realism. Clouds can be added to a clear sky, mountains to a flat landscape, or a lightning flash to a nocturnal scene. The ways in which combination printing can be used are endless, and a description of all the possibilities would be impossible since the very object

of trick printing is to obtain photographs that are the outcome of inventive thinking.

Once the principles have been grasped, countless ways of using combination printing in advertising photography will present themselves. The sunglasses worn by the man on the beach can mirror a girl in a bikini; a house can be apparently enveloped in flames; or a person asleep in an armchair can be pictured with a misty "dream" forming overhead.

Combination prints can be made in black-and-white or color by enlarging or contact printing two or more negatives onto the same sheet of paper. Combination transparencies are made by sandwiching two or more transparencies together. The effects are even more striking when texture screens or grids are added.

Screens and Grids

Photographic prints may be given the appearance of a textured surface by using a specially prepared screen or grid negative. A photograph is taken of a fine mesh screen, and the resulting negative is superimposed on a standard print during enlarging. The exposure during superimposing can be light, providing almost a high-key effect, or it can be so heavy as to dominate the picture. In some instances, you may wish to sandwich the print negative and the screen negative together in the enlarger and print both at the same time, or you may prefer to aim for more selective results by printing them separately and controlling the exposure of each.

These texture negatives need not only be photographs of screens. Any interesting surface can be photographed and used as a superimposed texture. Rock formations, clouds, rippled water, smoke, lace, and glass paper all form interesting patterns which, when photographed and superimposed on another photograph, will give it an entirely different appearance.

Advertising photographers are rarely short on new ideas, and some interesting pattern negatives have been used to achieve special effects, including photographs of a slice of bread, a leaf skeleton, a flattened egg carton, a shower of feathers, and wet concrete. Again, there are no boundaries except those created by your mind.

Solarization

Solarization, or the Sabattier effect, is another darkroom dodge that is used frequently. Briefly, it is an effect achieved by deliberately exposing a partially developed film to light and then continuing the development to conclusion. The result is a strange, partial reversal of the negative, and the effects vary, depending on the contrast of the subject matter, the type of sensitive material used, the type of developer, the development time before the second exposure, the length and intensity of the second exposure, and the length of time the negative is left dormant before development is resumed.

The procedure is extremely uncertain and the same patterns rarely form again, but it is an interesting procedure and can result in some really startling pictures. The same solarization effects can be obtained using color film, and further variations are possible using a colored light for the second exposure, which is given during the first development period.

When you have spent considerable time taking a photograph, you may hesitate to experiment with it during processing. The answer is to make a duplicate negative or transparency. The slight loss of quality sustained from the duplication

and really breathtaking—the result of a completely unfettered imagination. Photo by courtesy of Los Angeles
e of Design.

Darkroom techniques help to produce an advertising photograph that tells its own story. Photo by courtesy of Los Angeles Art Center College of Design.

could even add to the ultimate effect.

Even the making of duplicate negatives offers an opportunity to achieve the unusual. Try sandwiching the negative or transparency to be copied with a piece of sensitive material of the same type and size; separate the two with a piece of thin, clear plastic or a piece of film from which the emulsion has been cleaned; then expose the sandwich to a low light source sufficiently to achieve a copy with approximately the same density of the original.

Because of the clear plastic spacer, you will now have a copy negative or transparency that is a shade larger than the original, the difference in size being controlled by the thickness of the plastic. If the original negative and the copy are then bound together and printed as one, the effect will be an outline picture, the normal printing areas of the original being masked by similar areas in the duplicate. Variations on this effect can be made by changing the exposure and consequently the density of the duplicate and by using a spacer that has a pattern or color of its own.

Tone Separation

This is another darkroom technique which can produce interesting photographic effects. In its simplest form, tone separation is a print made from two different negatives of the same subject, with one of the negatives being underexposed and registering all the detail in the highlights of the subject and the other negative being overexposed and containing all the detail in the shadow areas of the subject. When the two negatives are printed in exact register with correct exposure, the resulting print has a range of tones that extends beyond the range normally provided by photographic films.

These tone-separation effects can be taken a stage further by making copies of the two negatives on identical film material to obtain positive transparencies, copying the positive transparencies onto graphic arts high-contrast film, and then printing them slightly off-register. The combinations and variations are so numerous that you have only to go into the darkroom with a little time for experimenting and a few ideas on the effects you would like to obtain, and you will discover a new world of special effects beginning to unfold.

One of the easiest ways of creating unusual darkroom pictures is by deliberately distorting the bromide paper under the enlarger. The effect is similar to the distortions seen in the curved mirrors of amusement parks, and it can be varied by simply pinning the paper to the enlarger baseboard in curves or ripples. The only photographic fundamental that should be observed is that the enlarger lens must be stopped down sufficiently to cover the area of focus that will extend from the top of the curves to the bottom of the valleys. Because the top of the ridges will receive more exposure than the part of the paper that is further away from the lens, it will be necessary to partially shade the ridges during exposure. This is not too difficult to accomplish, because with the lens stopped down, exposure times are lengthened, and it is an easy matter to shield each ridge for a part of the exposure time.

Many eye-catching darkroom pictures can be created by working on the negative itself. If the original negative was expensive to produce or is irreplaceable, it would be advisable to make a duplicate. This is done by contact printing onto a similar piece of film to obtain a film positive and then recopying to obtain a duplicate negative. This double step may be avoided by the use of direct reversal film, but sometimes the two steps can prove to be an advantage, offering opportunities for further experiments. If you find that this type of darkroom photography

From the quick, imaginative mind of a creative photographer comes another of those pictures which immediately arrest the attention. Photo by courtesy of Los Angeles Art Center College of Design.

gives you pleasure and the results are acceptable to your clients, it would be worthwhile to make a special contact-printing bench with a controlled light source. This is extremely useful in the production of many effects and particularly so for making duplicate negatives or transparencies.

Reticulation

Some spectacular effects can be obtained by deliberately reticulating the emulsion of a negative. Although this can happen accidentally during processing when the solutions are too warm and the rinse water too cold, deliberately reticulated negatives can be interesting, especially when the reticulation is controlled. In this experiment, you may again prefer to work on a duplicate, as the results are quite unpredictable.

The best type of negative for this effect is one that has very prominent subject matter, say, a bottle of perfume against a background of draped satin. The emulsion of the negative is treated with a solution of formalin, using a small paintbrush; this toughens the gelatin of the emulsion. The area treated should be restricted to that of the subject matter.

The negative is then deliberately reticulated by immersion in warm water, followed by a rinse in cold. Sometimes when the emulsion is tough, it is necessary to give the negative a preliminary bath in dilute ammonia. The final effect is a negative showing the bottle of perfume clear and crisp in a mosaic pattern of satin drapes.

Photo Patterns Made Without a Camera

A simple photo pattern may be obtained in the darkroom by placing a leaf skeleton or a piece of lace on a sheet of bromide paper and exposing it to the light from an enlarger. The subsequent print, processed in the normal way, will show a white outline of the leaf or lace against a black background.

This simple technique can be made more sophisticated by placing coiled pieces of colored cellophane on a sheet of color film, which is then solarized and reticulated. Once again, you can put your imagination to work. Paper cutouts can replace the cellophane and opaque lettering can be superimposed while making a duplicate. There are so many permutations, each one open to specialization. You can achieve a reputation for eye-catching advertising pictures without even owning a camera.

When any photographer produces startling photographs, it sometimes becomes necessary to convince the client of their effectiveness. This is a little strange, because advertising photographs must attract the attention to be effective, and it should not be necessary to have to convince your client that your photographs are still effective, even though they do not follow an accepted line.

But clients can be cautious people. They sometimes need convincing that your photographs, while unconventional, will do what is required of them. They have to be shown that your photographs will not fail to catch attention.

The Trick with Proofs

Some photographers will submit proofs to their client in a way that does nothing to

10

enhance their reputation. Proofs are sometimes mailed in envelopes without protective packing; sent without reference number or business stamp; or almost unbelievably, handed out in black-and-white as proofs of color prints.

Proofs are not merely a rough sample of the finished print, they are a selling tool. Good proofs can strengthen a client's faith in the photographer and encourage him to place an order. Poor proofs can create concern and disappointment, even though the finished photographs may eventually be of high quality. If you want to build orders and attract new clients through recommendation, there are several steps you can take to give your proofs that extra punch.

1. Don't submit too many different proofs of the same subject. A good salesman will tell you that if you show a customer too many similar articles, you only confuse. It is far better to restrict the customer's choice to two or three articles, with positive emphasis directed toward the article that would prove to be most satisfactory. This limiting of choice also means that you automatically eliminate any proofs that are technically poor.

2. Offer your proofs neatly mounted on boards or in folders. They should appear as attractive as possible, despite the slight additional cost.

3. Make sure that your name and a reference number are on each proof. It's quite probable that the person with whom you are dealing will eventually file your proofs for future reference. If that person should be replaced for any reason, the newcomer may find it difficult to know where he may obtain further photographs.

4. Enlarge and crop the proofs to the format of the final photographs. Some photographers will submit proofs with the area to be enlarged marked off with a felt-tip pen, expecting the client to visualize the photograph as it will appear in its final form. Other photographers make a practice of submitting proofs in the form of 8″ × 10″ sheets, with rows of 35mm strips contact-printed on them. Apart from the fact that the client may have poor eyesight, most people, other than those with training in the arts, have difficulty visualizing the finished print.

If you can keep in mind that proofs are part of your sales material and that many of your clients have had no real photographic experience, you will always submit proofs that are equal in appearance and quality to the finished print. On those assignments where you are requested to shoot transparency material, submitting proofs is impractical. Instead, you may wish to submit Polaroid shots for client approval before shooting the more expensive 4″ × 5″ or 8″ × 10″ transparencies.

There is one business institution that can create a headache for the photographer; it is known as the **committee.** When the proofs have to be approved by a single person, the firm's advertising executive or the company president, for instance, the photographer will know very quickly whether his pictures are satisfactory, and if not, why not. With a committee, several different people, often with widely divergent tastes, will try to decide exactly what they want, and then when it is given them, they redecide whether it is really what they wanted.

Here is an instance when the proofs must be as eye-catching and appealing as the finished picture. Every person nominated to any committee feels it a duty to criticize. Fortunately, each also feels it a duty to approve, so if your proofs are not simply hurried roughs, your pictures have more chance for a swift and unanimous approval.

It is sometimes difficult to explain to committees or even individual clients why printers can obtain better reproduction from a color transparency than they can from a color print. These people are not interested in a discussion on the principles of light transmission and reflection or a discourse on reproduction techniques, so it is sometimes necessary for the photographer to act as technical

adviser to the client when decisions on brochure production are being made.

Reproduction in Color

Before a printer can reproduce color photographs in the form of a poster or brochure, he has to break down the colors in the photograph into three basic colors—blue, green, and red—on three different sheets of film. This is normally done in a process camera or on one of the several types of electronic scanners. From these three sheets of film, three printing flats are made, which will transfer three different colored inks to the paper in successive runs through the printing machine, each printing being perfectly superimposed over the previous one.

While it is true in theory that the three primary colors—red, blue, and yellow—will provide every possible color in correct combination and densities, it has been found that in practice, a fourth plate, printing black, will give the finished picture more vitality. So the color printing or reproduction process is usually referred to as four-color printing.

Most printers will be able to advise their customers on the correct type of stock to be used for any particular project. They are knowledgeable on paper surfaces, weight or thickness, economic cutting sizes, and bindery requirements. But when it comes to the photographs that are to be used, customers are very much in the hands of the photographer.

Put your fingers over the figure, and the photograph becomes just another picture. Remove your fingers, and the photograph is suddenly filled with drama. Photo by courtesy of Los Angeles Art Center College of Design.

10

125

Not just two beautiful girls, but a carefully composed photograph handled with flawless technique. Photo by courtesy of Los Angeles Art Center College of Design.

In most instances, a printer prefers to work with color transparencies rather than color prints. The reason is easily understood. To make the separation negatives, the printer simply places the transparency in front of the light source and photographs it four times through four different filters—blue for the yellow separation, green for the red, red for the blue, plus a special yellow filter for the black separation. He then has four black-and-white sheets of film of the size the photograph will appear in the brochure.

If the printer is given a color print instead of a transparency, he must either photograph it using reflected light or make a color transparency. Whichever method he uses, there will be a substantial drop in quality.

The printer is like any other businessman. He is very interested in cutting costs, and where possible, passing those lower costs on to his customers in the form of attractive prices. To this end, he will try to shoot as many transparencies as possible on one sheet of film per color at the same time. In other words, he will try to "gang" the separations. But this too creates a problem. Because they are all shot on just four pieces of film instead of on four pieces of film for each transparency, they are all given the same exposure and processing time. This would be quite satisfactory if all the transparencies were of equal density and contrast and prefera-

bly on the same film-base material. But when the transparencies are of different color values, the printer must either sacrifice quality and hope that by ganging the transparencies he will be able to achieve a middle-of-the-road quality, or he must maintain his standards by making individual separations and increasing his costs.

If you are able to assist the printer by keeping all your transparencies to similar values, you will also be helping your client reduce his printing costs. One way of maintaining processing standards and also providing a guide for the printer is by including a color chart in your transparencies. If you are using roll film and all the shots are taken at the same time and under the same lighting conditions, it is sufficient to use the first shot on the roll to photograph a color chart. The color chart is simply a card printed with squares of the primary colors and black-and-white. The film processor is able to match his daily color test against your chart, and the printer is able to match the quality of his separations and his ink colors.

This careful matching of colors can be the difference between a successful mail-order catalog and one that is plagued with complaints from customers. If the color of the merchandise in a catalog is different from the merchandise received by the customer, the latter has good reason for complaint.

But all color in advertising photography does not have to be that accurate. In recent years, there has been a swing toward the bizarre—a move into the strange and unusual where women are pictured with green faces and horses with a tail at both ends.

The World of Fantasy

Sometimes just for a change of pace, a photographer will step out of his usual role and try something completely different. Perhaps the work of another photographer has struck a responsive chord, or perhaps an idea that has been simmering at the back of his mind suddenly blossoms into life. For whatever reason, a new world is explored, and many times it is the weird world of fantasy.

There is something about the weird and the unusual that is fascinating. And that is why science fiction books have a steady sale and flying saucer societies prosper in almost every country of the world. We like to be mystified, and providing we know it's really safe, we like to be frightened.

Several photographers have been able to cash in on the public's attraction to the mysterious. They have used photographs of strange and rare beauty to promote all kinds of products and services. The unexpected will always attract, and in this field, there are unlimited opportunities for the photographer with a really fertile imagination. So if you like the idea of building castles in the air and whimsey gives you pleasure, be prepared to enter the land of fantasy.

This is a world where cigarette men play football on pin legs and a roll of dough becomes a little roly-poly man in a chef's hat who advertises a cake mix. There have been bottles of beer that apparently play tennis; carpets that skim over the domed, minaret roofs of Arabian towns; and jet airliners that smile. Every magazine reader has seen a man floating down into the driver's seat of a moving car or been amused by the two loaves of bread that talk to each other. Fantasy is all around us, and a clever, original idea can be sold to almost any advertising agency.

These special effects are nearly always produced in the studio. They take several hours of careful thought and painstaking work, but unless it is a definite assignment, these interesting projects can be carried out in your spare time. When a few of your ideas have been published, you will find there is a steady demand for your services. The world of fantasy creators is not very heavily populated.

The place to start is the table top. Table-top photography has long been the general heading under which is grouped all those pictures of scenes in miniature taken indoors. The scenes may be clever reproductions that fool viewers into thinking they are looking at real mountains, authentic undersea action, or even a Tibetan monastery by moonlight. The mountains may be piles of salt; the under-sea photographs simply taken through the side of an aquarium with a photograph as background; and the monastery nothing but a framework of paper and cardboard photographed through a blue filter. But the person looking at the pictures could easily be persuaded into thinking that they are looking at the real thing.

The principles of table-top photography can be applied to produce pictures that are really cartoons made with a camera. The materials used are those found around the house or in the studio, and while almost any sturdy table can be used as a working surface, an old table-tennis table is ideal. It is a comfortable working height but not too high to permit overhead shots; and if the table is divided in the center, one half is usually large enough for most projects, with the second half available for larger sets.

Modeling clay, paper, cardboard, pins, glue, and paint are some of the materials you may need, although if you start out with a firm idea of what you intend to accomplish, the type of materials you will need is already partially determined. Apart from the materials mentioned, you will also find that a large sheet of glass can be useful. Small pieces of cloth, balsa wood, and aluminum are almost indispensable.

The figures used in table-top photography have no need to be three dimensional; they may simply be cutout figures, with the lighting so arranged as to make them appear more solid. If you, or one of your associates, have the skill to model small figures in modeling clay, this talent can be used to good effect. But if the ability to make small, lifelike figures is definitely not one of your more advanced specialties, there is no need to be discouraged. The figures may be completely unreal, peculiar products of your imagination, such as robots, dragons, elves, gnomes, and argonauts. Small figures may be shown climbing tiny ladders to operate kitchen or household gadgets; weird witches can zoom through the air on vacuum cleaners; and for insurance companies, model houses can catch fire without any trouble. Need further examples? Snap, Crackle, and Pop were three small caricatures who helped to publicize a well-known brand of breakfast cereal; the Jolly Green Giant uses table-top figures to promote sales; and Chicken of the Sea has a tuna fish that plays chess, reads music, and generally acts as a human "with good taste"!

Table-top photography gives you a chance to build Utopia or Hades. Beautiful sparkling streams made with cast resin can flow through mountain-ringed forests fabricated from moss and plastic trees. Dinosaurs can battle and pirate galleons can set sail, all in the name of advertising photography, and all constructed on a 4′ × 4′ table top.

When you have successfully created this world of fantasy—where photographs of earthquakes or rockets soaring skyward can be taken on any day of the week—it is a natural step to carry those photographs into the darkroom and work on them with some of those techniques which can transform them into startling advertising photographs that will put cash into your bank account and a great deal of pleasure into your working day.

There are other projects that are outside the sphere of an advertising photographer's usual day-to-day work. They are projects that cannot always be termed advertising in the strict sense of the word, but they are avenues well worth exploring, and they can certainly be very profitable.

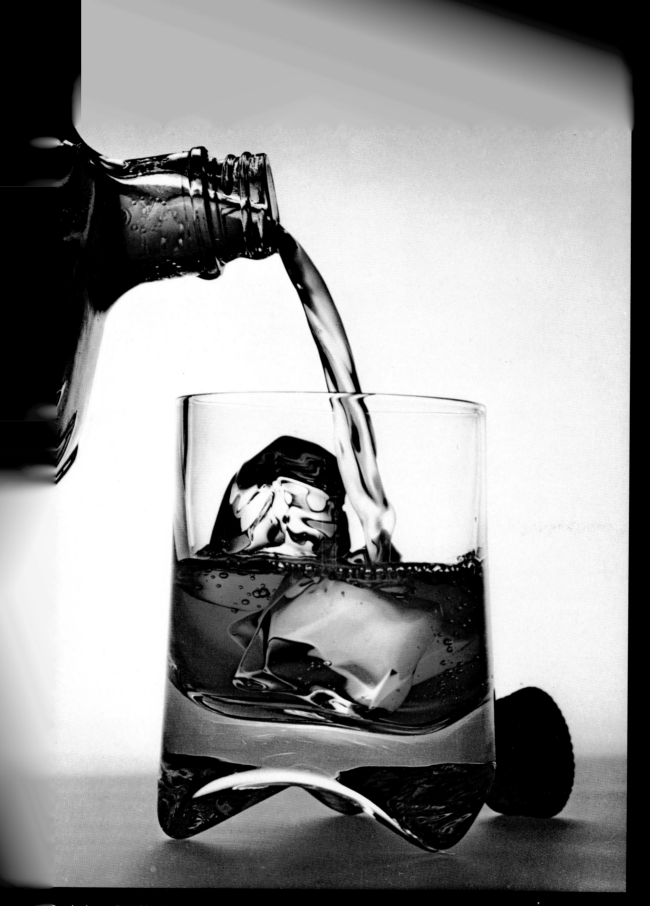

Rarely does a liquid look as wet as this one. Photo by courtesy of The Alderman Company.

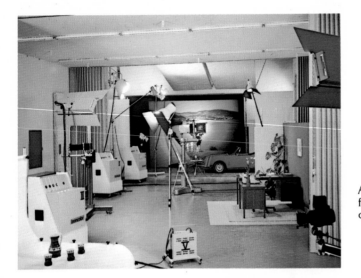

An ultra-modern studio able to handle anything from table-top items to trucks. Photo by courtesy of The Alderman Company.

Deliberate distortion can often be used very effectively. There are no rules in creative photography. Photo by courtesy of Los Angeles Art Center College of Design.

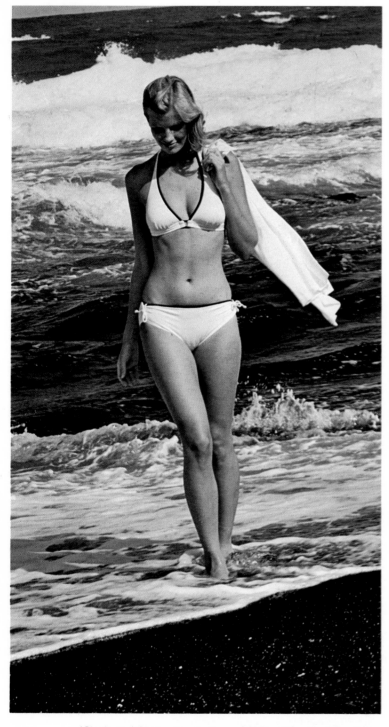

(Clockwise) Photos by courtesy of: Hall and Levine Advertising Agency for Catalina, Inc.; Peter H. Fürst for Biodroga Cosmetics, Germany; Peter H. Fürst for Lovable, Holland, Netherlands; Harry R. Becker.

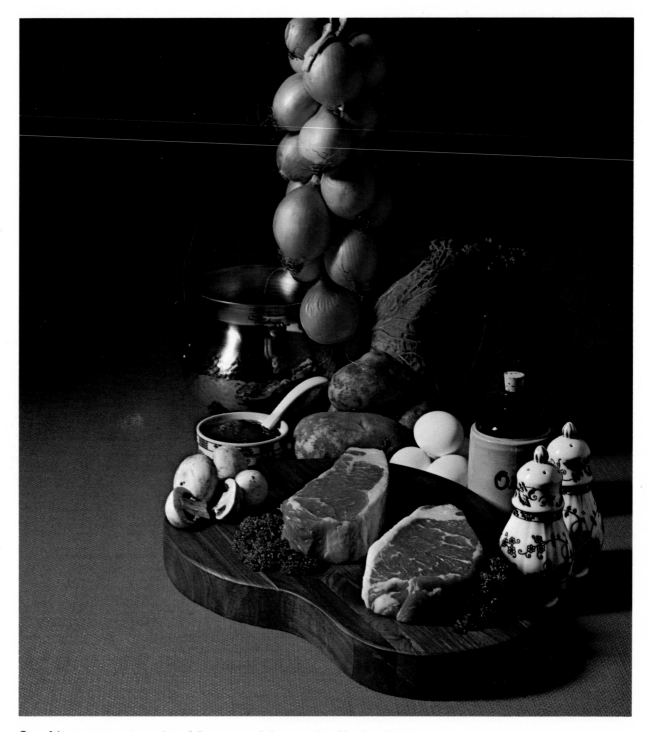

One of the most attractive and carefully composed photographs of food you'll ever see.

How to
Find Gold
With Off-Beat Subjects

11

Public Services
Illustrated Articles
Building a Transparency
Library
Unusual Photographic Material

Advertising photographers, as a whole, seem to follow well-trodden paths. While their work may be original and highly individualistic, their approach to earning money is a common one. The work they undertake is either given to them by an advertising agency or a manufacturer. They may have obtained their assignments by going out and actively seeking them, or the work may have come in quite unexpectedly through a recommendation. But generally speaking, very few advertising photographers look upon themselves as free-lancers. They direct the output from their studios into a fairly narrow channel; yet if they were to look around them, they would notice a great number of targets at which they could aim. Many of those targets can provide a very hefty income.

Public Services

Any advertising photographer, if he so wishes, could find work with people who organize special services for the public. This category includes environmental protection groups, civic bodies, service clubs, information bureaus, and many others. Some of these groups, many of whom are financed by donation, are always pressed for cash and are unwilling to spend more money on advertising or publicity than the absolute minimum. But there are others, also financed by donation, who are willing to spend staggering amounts on advertising. They have discovered that this brings a tremendous financial return. Sometimes the entire aim of these particular groups is to disseminate a special message.

As an advertising photographer looking into the various aspects of off-beat subjects, you will quickly discover which organizations are prepared to pay well for your services and which ones believe you should think the way they do and contribute your time and talent gratis. The photography you may decide to undertake for this latter group has three forms of remuneration, which may persuade you to provide a service. (1) The photography will provide practice. (2) Those photographs may be noticed by an interested advertising agency executive or manufacturer, and they could bring work of a more substantial nature. (3) These hard-pressed public service organizations can sometimes do with a little help, and you

129

may be rewarded by a great deal of satisfaction.

But advertising photographers have to eat; they also have to pay their overheads. So it becomes necessary to offer your services to an organization which it pleases you to assist and which will also pay you well for your efforts.

There are many types of projects for you to consider, but first, as with politics, you have to make up your mind whether you are for or against. Every organization that is pledged to some form of public service has its opponents, and sometimes those opponents will pay as much as the organizations they are opposing. So from the beginning, your advertising photograph must also bring you personal satisfaction.

One of the largest groups of organized public-minded people is formed by the conservationists. They may, at any time, have a specific program in hand. They may be fighting to prevent the beaches being spoiled by oil spillage or waging a battle against strip mining, and there are those who are opposed to the construction of further atomic-generating stations.

On the first issue, you may be in full agreement with their endeavors to bring before the public the tragedy of oil on the beaches. You may feel compelled to take photographs of injured seabirds, dead fish, or dying ocean plants. Alternatively, your approach may be to reach those who are more concerned about the effect on their checkbook, and your photographs could show the once-filled beaches now devoid of people, the closed concession stands, and the empty parking lots. A good advertising photographer can turn his camera into a powerful weapon, and he can aim it with devastating effect. But as with any weapon, the person wielding it must do so with a steady conscience and a sure knowledge of the consequences.

Catalog photographs can be static and unimaginative, or as this one illustrates, they can be a true work of art produced by a master craftsman. Photo by courtesy of Gerald William Hoos, International Photo-Art Service.

The industrialists who are seeking coal by open-face mining may be accused of destroying the appearance of the land; but there are those who would argue that the needs of the people must come before satisfying a concern that is purely aesthetic. It becomes your personal decision, and so you throw the power of your camera on the side that carries your convictions. Your camera can show either the terrible scars on the landscape, or it can show the desperate, national need for fuel. The same would apply to the question of building more nuclear power stations. You make your decision, and you offer your services to the side with which you agree.

The people concerned with the environment make up several powerful groups. They are worried about the effects of air pollution, noise pollution, and refuse disposal. They would like to see unpolluted, fish-filled rivers and litter-free streets. They have a deep love of nature and resent every move by authority to destroy any part of the environment.

People concerned with public services wage war on a different battlefield. They try to focus public attention on such issues as prevention of cruelty to children or animals; they show tremendous concern about care of the aged; they try to direct publicity on the need of returning veterans for offers of sound employment; and they press for anti-drug programs. There are bodies of public-spirited people who are worried about the rising crime rate, and there are other equally civic-minded people who would like to be sure that people in prison are given every assistance toward a better way of life.

If you can hear the cry of battle and would like to add your strength to a cause in which you believe, you have the means close at hand. All you have to do is to produce a few photographs that will present your side of the controversy—searing, powerful pictures that will say everything better than any words. Then send your photographs, as samples, to the director of the campaign in which you are interested. If your pictures have sufficient punch and convey the right message, your fee will be negotiated without any difficulty.

There are many other opportunities for turning your advertising photographic skills into cash. They surround you in the city, and they abound in the scenic beauty outside the towns. Although these types of pictures may not be advertising photographs in the strict sense of the words, they lend themselves to publicity, and they pay well enough to become a major source of income.

Cities need photographs. They need photographs to attract tourists; photographs to raise money for civic projects; and photographs as historical record. Libraries use a considerable number of photographs and are also very willing to display a local photographer's prints as a one-man exhibition.

The best way to obtain these civic assignments is to make a study of the type of photographs being used and then prepare your own samples for presentation to the person responsible for publicity at City Hall. Although it is unlikely your samples will be exactly what is required for future programs, if you make a good impression, it is probable that you will be approached when the next project comes to hand.

In the city, two more opportunities await the advertising photographer who is prepared to go out and seek work. These are the needs of hospitals and shopping centers for eye-catching publicity pictures.

Hospitals do a considerable amount of subtle and not so subtle publicity. For instance, those hospitals which present each mother with a photograph of her newborn child are engaging in public relations. In addition, there are the well-illustrated newsletters that are circulated to local doctors; the annual "open house," with a photographic display in the lounge intended to show "a typical working day

11

The opportunities to photograph a scene such as this are rare, but when the chance is offered to a skilled photographer, the result must be an outstanding photograph. Photo by courtesy of Studio Guy Marché.

at the hospital''; and all carefully planned publicity programs. If you are interested in this type of work, make an appointment to meet with the hospital administrator or public-relations officer. Tell him of your interest and show some samples of the photography you could offer.

Shopping centers are always in need of publicity. Apart from the occasional photographic exhibition or competition, advertising photography is frequently used to keep the shopping center in front of the local public. Photographs of various attractions and promotions appear in newspapers with steady regularity, and the larger centers work with advertising agencies to produce radio and television commercials.

The special type of newspaper publicity used by shopping centers will often offer extra cash opportunities to the photographer who can add a few words to his pictures. The photograph with a short, snappy caption will sometimes be accepted by a newspaper or magazine, whereas a photograph on its own would be rejected. The skill required for writing a few words that will help sell your photographs is not too difficult to acquire, and it is but a short step from this to photojournalism.

Illustrated Articles

All advertising photographers write copy, even if only in their minds. They take a photograph of a man examining his chin after a shave with a new, "super-close" blade and almost instinctively they find themselves thinking, "Smooth as a

Creative imagination, clever technique, and humor result in a photograph that will appeal to everyone. Photo by courtesy of Los Angeles Art Center College of Design.

11

baby's . . . " Or perhaps the photograph illustrates a new waterproof material. As the photographer watches as a stream of water is repelled, leaving the material perfectly dry, the chances are very strong that he will think to himself, "Like water off a duck's back." There's nothing very original in these thoughts; they are clichés that drop easily into the mind. But it is almost impossible to take a creative advertising photograph without a descriptive sentence coming to mind.

Sometimes photographs are taken to illustrate a new slogan. Suppose, for instance, that you were asked to photograph a new type of ball pen and illustrate the phrase, "Lighter than a feather." Perhaps the first thought that comes to mind is a chemical balance with the pen on one side being outweighed by a feather on the other side. But you know that this is not really what the slogan intends. To illustrate it correctly, you will have to show that the **touch** of the pen is lighter than a feather's touch. This proves to be slightly more difficult, but you eventually devise a photograph that shows the ball pen writing smoothly on wet tissue paper alongside the same paper being torn by a feather.

In advertising, the words and the picture go together to provide an imaginative message that is hard to forget. There are, of course, photographs full of meaning that require no words, and there are catch phrases that will conjure up images in people's minds without the need of pictures. But pictures and words go well together, and if you can put the two together in a way that interests publishers, you can turn this skill into a considerable income.

Once again, you begin by taking stock of your hobbies and interests. These are the things about which you have accumulated knowledge, and they are pleasures you can describe visually and verbally to other people. Along the way, you will have read many magazines connected with your hobbies; these will become your starting point. If you intend to be successful in photojournalism, you must know your markets almost as well as you know your subject.

Perhaps at this point you are thinking, "Well, I know a fair amount about photography, and I'm interested in ceramics. I could certainly provide illustrations, but writing an article would be out of the question."

You are being held back by fear of ridicule. If you can hold an intelligent conversation about a subject that interests you, then you can also write about it. True, your first attempts may be stilted and stumbling, and this is often enough to convince some people they should quit. But with practice, the words begin to flow, and phrases start putting themselves into your head, ready for committing to paper.

Try a short experiment. Carry a notebook and pencil with you. The next time you see something that interests you, take a photograph, or a series of photographs, and then before you leave the scene, take out your notebook and write the words Who, What, Where, When, and Why at the top of five pages. Then proceed to gather as much information as you can under those headings. Sometimes you will find that gathering the answers to those questions will lead to your taking more pictures.

Some time ago, a young advertising photographer was asked to take photographs of the propellers of some old fishing boats. The propellers had been treated with a special anti-corrosion coating, and the idea was to obtain some "Before and After" pictures. The photographs were to be taken at a small fishing village in the South of England, and the designated boats had been pulled out of the water, ready for the photographer.

After he had taken his pictures, the photographer spent an hour or so wandering around the small harbor, taking photographs for his own pleasure. He stumbled across a scene that completely fascinated him.

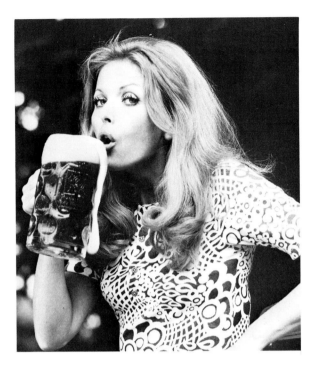

An advertising photograph that gives the impression of being completely spontaneous. Photo by courtesy of Harry R. Becker.

A short way from the harbor, behind some fish-packing sheds, a large bonfire was burning debris that had come in with the nets. A few bucketfuls of fish cuttings had been thrown on top of the blaze, and the photographer stood watching, astounded by the actions of the seagulls that screeched overhead. They formed a line above the fire, taking it in turn to dive down into the flames to pick up morsels of fish. The photographer started taking pictures, catching the birds as they wheeled and dipped into the flames.

After a while, he turned to a blue-jerseyed fisherman who was watching him take the pictures. "Do they always do this?" he asked.

The man smiled. "All the time," he replied.

"But don't they ever get burned?"

"Oh, I expect they get their wings singed now and then, but they seem to think the fish is worth it."

The photographer shook his head in amazement. "But why don't they go and get the cuttings before they're thrown on the fire?"

The fisherman jerked his head toward the packing sheds. "Just look at them over there. Dozens of 'em. We try to keep them out of the sheds, but they always seem to find a way of getting in. The girls encourage them by throwing them bits of fish."

The young photographer took pictures until he ran out of film. He took photographs of the girls working in the packing sheds, the fishing nets being repaired, the boats arriving back to harbor at dusk, and the fisherman gathered together in a nearby bar at the end of the day. In every shot, the gulls were prominent, even to the stuffed one that stood on the bar where the men were drinking.

When he returned home, the photographer wrote a short 500-word story, telling in simple words how the seagulls and the fishermen accepted each other. He tried to explain how the birds were cussed and loved at the same time. But it was

11

the photographs that sold the story, and the national magazine that bought it ran the photograph of the gulls diving through the flames as its cover. In this instance, the payment made by the magazine was almost double the fee for the advertising photographs for the original assignment.

If you want to sell illustrated articles to magazines, first read at least a dozen copies of the magazines that interest you and for which you think you could write. With this as your background, you then need a theme or a hook on which to hang your article.

There's nothing to be gained in contemplating the writing of an article that is similar to one which has recently been published, but your theme should follow the pattern established by the magazine. If it publishes articles about camping, then that's the type of article for which they are looking; it would be no good sending an article on baby care to a motorcycle magazine. But let your ideas sparkle with originality. Look beneath the surface and you'll probably find an angle that hasn't been previously tackled.

When you've decided on the type of article you're going to write and have settled on a theme, the next step is to send a letter to the editor of the magazine for which you would like to write, describing **briefly** the article you have in mind. Briefly means a page or less. Never send a proposal with more than two pages. In your letter, simply state that you have an idea for an article, which you think may prove acceptable. Quickly outline the idea and the type of illustrations you would be able to supply, and then sit back and wait for a "yes" or "no." If it's a "no," don't be too disappointed; the editor doesn't yet know you or your work. Examine the possible reasons for the negative reply and then set up another magazine as a target for that article and try again. A refusal could mean that the editor is overstocked or that he has a similar article already in hand. Perhaps he just didn't like your idea. Go ahead and try it on someone else.

If you get a "yes," get started immediately. The editor may not be so interested six months from now. Make your article about the same length as those

(Right) Automobiles, like fashions, change every year. Each new model has to be photographed and publicized. Photo by courtesy of Studio Guy Marché. (Far right) A mood picture created by a master photographer. Photo by courtesy of Gerald William Hoos, International Photo-Art Service.

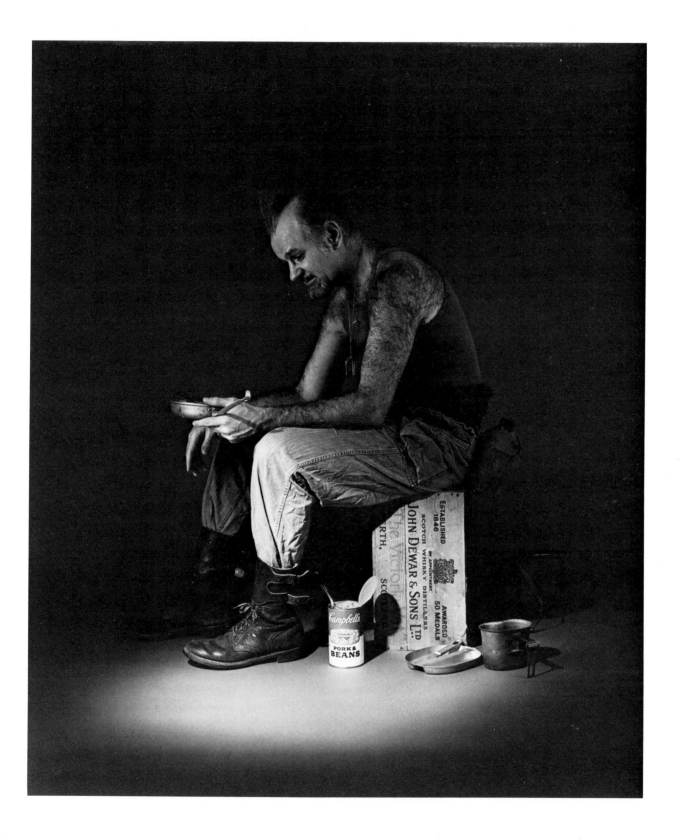

regularly published by the magazine, and enclose more photographs than are usually printed so as to give the editor a choice of those he may wish to use.

The proposal is one of the advantages the writer of nonfiction has over the person who writes fiction. For an editor to accept a story, or a work of fiction, he really has to read it first. The writer of nonfiction is able to test his market and get a tentative approval before he even starts writing. This means a tremendous saving of time and effort.

The photographer who is able to add a short article to his pictures has a tremendous market before him. Almost every magazine published uses photographs—week after week, month after month. Someone has to write them and take the photographs, and that someone might just as well be you. There are a couple of tips worth knowing, which will add to your chances of success. First, if you are writing for a gardening magazine, write about gardening. In other words, write on a subject you know will interest the readers of the magazine. Second, when you are taking photographs for a magazine, know precisely which magazine is going to be interested before you press the shutter release. To take a series of disconnected pictures and attempt to pull them together into an interesting article by means of a few words is to beg for a rejection slip.

There is another kind of photograph from which you can make money individually and without even the need of a caption. They are photographs you can take at any time and any place, while taking a vacation or between shots for an assignment. These photographs may be taken by the most experienced professional or the raw beginner, and they have the potential of becoming a full-time, well-paying business.

Building a Transparency Library

A transparency library can be big business. Like the stock-picture library, it sets out to provide photographs for photographers, printers, publishers, and advertising agencies. But unlike the stock-picture library, this service supplies only color transparencies.

The people who use transparency libraries are frequently unable to take the type of photographs they need, perhaps because they are not photographers, or maybe because time is too short. They turn to the library to obtain photographs of foreign countries, unusual photographs, or photographs to be used simply as cover pictures. They seek photographs which, in turn, will earn them money.

As your advertising photography business grows, you will gradually accumulate a collection of transparencies that can either stay hidden in a filing cabinet or be put to work paying your salary. To develop a successful and profitable transparency library, you need the answer to four questions: Who would use your pictures? How would they use them? What type of pictures would they need? and How do you sell your service?

Although your clients would include the same type of people who would use a stock library of pictures, there are one or two other outlets for color transparencies that would be well worth pursuing. These outlets include photographers who have front- or rear-projection equipment. They have constant need for a wide variety of color transparencies in 2¼″ × 2¼″ or 35mm format, depending on the type of projector they are using. The transparencies they require could vary from the inside of a Chinese Temple to a view from the San Francisco Bridge. Their needs are determined by the clients for whom they are taking the photographs, and while perhaps the majority of these are fashion designers, anyone with projection

Catalog pictures can be simple illustrations, or as in this carefully composed photograph, they can be minor masterpieces that enhance the product. Photo by courtesy of Gerald William Hoos, International Photo-Art Service.

equipment will want to use it whenever possible, if only to make the most of a large investment. Consequently, the transparencies required for projection may be of any type. They could be the type of transparency suitable as a background for a jewelry or automobile advertisement, or they could be patterns of color formed by whirling lights or smudged paint pallets—patterns that could be used as a background for almost any product.

Transparencies of a different kind are required by industry. Many large corporations use audio-visual equipment for instruction. Complex electrical wiring is photographed and the wiring operation explained in a classroom by means of a projector. Driving instruction is given with the aid of photographs projected on a screen in front of the student driver, and transparency projection has been used for tuition in many parts of the space program. It is extremely unlikely that your transparency library would be able to offer pictures suitable for training in a space program, but producing transparencies for tuition in almost any industry would be well within your capabilities.

The type of transparencies requested from your library would be determined by the clients you service. Printers and publishers may need transparencies of landscapes, suitable for reproduction as calendars, action shots for book covers, or glamorous starlets for magazine fillers. Advertising agencies may require general-purpose pictures, very much like those they would obtain from the stock-picture library.

To sell your transparency-library service, you would need illustrated brochures for mailing to potential clients and an illustrated catalog of all the transparencies you have available. The catalog should be flexible to accept pages offering new additions to the library as they become available. The income from your transparency library can be greatly increased if, in your mailings, you mention that you are able to offer some of the new photographic materials that are proving so useful for promotional and publicity purposes.

Unusual Photographic Material

People in the arts and advertising fields are constantly on the watch for new ideas. Eye-catching innovations are their lifeblood. To fill this need, manufacturers are

11

constantly introducing new materials and new uses for old materials. The photographic trade is well served by manufacturers, and there is a steady flow of new equipment and materials. New accessories regularly appear on the shelves of photographic stores, and the trade magazines have sections devoted to a review of the latest introductions.

The majority of experienced professional advertising photographers prefer to stay with a tried and trusted equipment. They have well-established routines; they know the characteristics of their film; and they are usually reluctant to introduce new materials or systems that could upset the tested procedures.

But as in every profession, there are the more adventurous workers—the innovators. These alert men and women not only welcome the opportunity to try new ideas, they dream up new devices and original approaches. Then, when these ideas prove successful, they are happily accepted and used by the entire profession. But it is the people first in the field with a new product who have the greatest financial opportunity.

If you would like to see an immediate rise in profits, keep your eye on the new-product pages of the trade magazines. A few years ago, a special photolinen made its appearance. At first, few photographers showed any appreciable interest, but one man saw in this unusual material a way to enormous success. He ordered a small quantity and made a few tests. When these seemed to prove satisfactory, he wrote to the manufacturers and asked them for the specifications of the material and the maximum sizes in which it was manufactured.

He was told that the material could be treated like bromide paper and that once it was processed, he would have a photographic enlargement on a base material similar to sailcloth. It was washable; could be colored with stains or oils; and although it was stiff like artist's canvas, treatment with a solution of glycerine would render it sufficiently flexible to allow it to be made into coats and dresses.

Magazines and manufacturers frequently request photographs of interior decor. It takes superb skill to present them with this kind of flair and imagination. Photo by courtesy of Studio Guy Marché.

This photograph could have resulted in a confusing mass of detail. Instead, experience and true professionalism have produced a photograph that is truly eye-catching. Photo by courtesy of Studio Guy Marché.

Within six months, the photographer had prepared samples and showed them to a large number of the top industries. The orders rolled in. A major film company supplied its own negatives and asked that a series of photographs of one of its top stars be made on the photolinen. These photographs were to measure 4′ × 9′, be oil painted and framed, then used as props in an old manor featured in one of the year's most acclaimed films.

A string of restaurants ordered 20 wall murals measuring 20′ × 8′. Each wanted photographs depicting scenes from some of the world's capital cities.

A manufacturer of small yachts ordered a large number of panels featuring pin-up photographs, which he then sewed into sails.

Several manufacturers ordered giant enlargements, up to 30′ long, to be used as photographic backgrounds for their booths at trade shows.

A manufacturer of photo albums ordered immense quantities of the linen with photographs depicting wedding scenes, and made them into covers for wedding albums.

A plastics corporation ordered the linen and requested that it be printed with photographs of kitchen appliances. The linen was then laminated between sheets of plastic and used as counter tops.

The uses seemed inexhaustible. Gradually, other photographers became aware of the possibilities of this special material and entered the market with their own ideas. But the man who was first in the field had already become firmly established and was on his way to a fortune.

It is an inescapable fact that the newest and best ideas are eventually copied and sometimes run to destruction, but at first they enjoy an exclusive and highly profitable popularity. It was that way with sepia toning, color film, photography in

11

packaging, and high-speed photography; the old ideas are rediscovered, current methods seem to be the ultimate, and then new products make their appearance to demand attention.

Cibachrome promises to be one more of the great strides that color photography has been taking over the past few years. We have been given high-speed color film and film in which the color fidelity is almost incredible. Now Ciba-Geigy of Switzerland has produced a film that offers several significant advantages over the films we have begun to take for granted.

Briefly, Cibachrome is a color film with remarkable stability to light, brilliant and highly saturated color coupled with extreme image sharpness. In the normal way, photographic color development processes have two serious drawbacks. First, the dyes used have poor lightfast properties. Second, because undesirable colored by-products form during processing, there is a certain degradation of colors. The image on conventional color film is produced by color-coupling; in other words, the color is built up to form the image.

With Cibachrome, the image is produced on a background that is uniformly dyed. During processing, the dye is destroyed where it is not required for the image, providing a transparency with extraordinary sharpness and acutance. The dyes used have been developed by Ciba after many years of research, and as a result, color enlargements may, for the first time, be used for shop-window displays, interior decoration, and even outdoor advertising over long periods, with little effect on the color stability.

Another photographic material with strange properties is Agfacontour Professional film. This unusual film is not a pictorial, or taking, film in the accepted way; instead, it is more a black-and-white film used for copying a negative or transparency that has already been taken. The controllable results are remarkable.

Agfacontour film has the ability to select areas of equal density and isolate them in reproduction. The effect is something like the contour maps that record areas of equal height. But there is one significant difference. With Agfacontour, the photographer is able to select, by means of controlled exposure during copying, the contours, or areas of similar density, he wants recorded. This opens the way to some very unusual photographic effects.

Let us suppose you have a color transparency of a vase of chrysanthemums. This is contact-copied onto, say, four sheets of Agfacontour film and given four different exposures, resulting in four black-and-white negatives on which appear only certain areas of the original transparency. These are, in turn, contact-printed in exact register onto color transparency material using different colored light sources. The resulting transparency is a dramatic color-tone separation.

In a similar way, if the original is an aerial photograph and subsequent copies are made on Agfacontour to produce sets of equal-density negatives, these can be enlarged and processed in chromogenic developer and then viewed or copied in register.

Although Agfacontour film is being used in medical, industrial, archaeological, and oceanographic photography, very little has yet been done with it in pictorial and advertising photography. The opportunities are always waiting for someone with an alert mind.

With all the new materials and all the new techniques made known to the photographic profession, the advertising photographer still has to follow some well-established routines if he is to have a successful advertising business. He has to build his business on a firm foundation if he is going to make his photographic knowledge pay full dividends. And so he finds himself involved in a world of facts and figures, a region of Profits and Percentages.

Build
A Substantial Business
In Advertising Photography

Correct Costing
Simple Accounting
The Economic Way to Buy
Materials
Foolproof Record Keeping
Saves Money
The Way to Success

People with a strong artistic or creative streak are, by reputation, notoriously poor at conducting business. It almost seems as if they hide behind their artistic ability to escape from the need to organize an efficient business system. Yet a well-run and profitable business offers returns far beyond the effort required.

An efficient, business-control system can mean even greater profits; it can also mean more clients providing the type of work you prefer, projects that flow smoothly through the studio without snags and hitches, extended opportunities to expand, and extended leisure time. These are rewards that are surely worth the small amount of time necessary to get a good system started. Once the business is rolling in the right direction, the plan you have initiated will almost take care of itself.

Correct Costing

The man who owns a grocery store is in a similar position to the man who owns a shoe store or a department store; he is able to calculate his selling price based on the amount he has to pay for his merchandise, his profit, and his overheads, which would include rent, labor, and utilities. In actual practice, it is, of course, never quite so cut and dried. There are other factors that affect the profit a businessman would like to make: he is affected by his competition; he suffers losses through theft and accident; goods that just sit on a shelf represent a loss. There are quite a number of reasons why those profits which look so attractive on paper are never quite so substantial in reality.

But the advertising photographer has to work by a different set of rules. True, he has the cost of materials to take into consideration; he has to make allowances for rent and utilities; he suffers deterioration of equipment; and he is likewise affected by his competition. But the selling price of his photographs and service would seem to bear no relation to his costs and overheads. Why should the grocer be prepared to accept a modest profit when the advertising photographer makes a profit of several hundred percent?

The answer is, of course, that the advertising photographer, like other professionals such as doctors and lawyers, charges more

for what he knows than for what he does. The higher he has climbed up the ladder of fame, the more he can be expected to charge.

To the person just entering the profession of advertising photography, this can be very confusing. How much can be charged for any assignment, and on what are those charges based?

Various photographic associations have prepared charts of fees, which professional advertising photographers may follow. But while these are reliable guides, they can't be expected to take into account the personal worth or financial liability of each practicing photographer. So the individual must set his own standards and charge his own fees, basing them on the charges made by local, established competitors. Perhaps competitors is the wrong word, because happily, in the profession of advertising photography, studios do not actively compete with each other. They seek business on a merit basis, and as there is always sufficient work for all, the situation is fortunately a very congenial one.

But to the advertising photographer getting started, there is always the fear of charging too much or too little. When a client offers him an assignment and wants to know how much it will cost, the newcomer is placed in a difficult position. He can't go across town to ask another studio. To do so may be particularly embarrassing, especially if that studio has just lost that account. He can't take a rough guess either, as that would be too risky. The newcomer is forced to try and estimate the work involved, the materials needed, and from that give his potential client a figure he hopes will be agreeable, while still allowing a fair profit.

As a general rule, the new advertising photographer must be guided by factors of which he is aware and estimate those of which he is not so sure. He knows, at the outset, what it is the client requires. We will say that in this instance he wants three dresses photographed against different backgrounds and requires four different transparencies of each, plus ten 8″ × 10″ color prints of each transparency.

The photographer now knows that he must allow for the cost of 12 sheets of transparency film, 120 sheets of color print paper, plus processing costs. Those are known material costs. To them he must add other costs of which he is not so sure. In his inexperience, he does not know how many sheets of film or paper will actually be required, so to be on the safe side, he doubles the known amount. Now he is uncertain as to how long it is going to take to change backgrounds, change film, and allow time for the models to change. He is also uncertain as to how much it is going to cost to build the backgrounds, and he doesn't know the total shooting time.

The simple request for an estimate has suddenly become a major difficulty. But the approach is correct. Those estimates of the time involved must be translated into cash, the profit added, and an estimate prepared. It is in the profit factor that a beginner makes his largest mistakes. Although the profit made must be fair to the client, it must also be fair to the photographer. Too small a profit will prevent him from progressing as he should, but even more important is that too small a profit does not allow sufficient margin for the correction of mistakes.

Correct costing comes with experience, and until that experience has been obtained, it is necessary to safeguard the business by allowing a sufficient margin of profit. You will lose a certain amount of work because of your price structure, but not very much, especially if your work has that special quality only you can supply. As your experience grows, you will be able to adjust your charges to suit all possible assignments and to know that you are requesting fees that are both fair and equitable.

Versatility and imagination are essential qualities for any set designer. Photo by courtesy of The Alderman Company.

Simple Accounting

According to figures issued by the United States Department of Commerce over the past ten years, more than twice as many photographic businesses failed through sheer incompetence than for any other reason.

Although there are many factors that contribute to a successful business—for example, individual inclinations, personality, initiative, skill, business location, competition, cash resources, business volume, and overheads—these factors can either work against or for you. In most instances, you are the person who decides which way these considerations will apply.

To some people, the cold, hard logic of facts and figures is very hard to accept. They mentally rebel against sitting down with pencil and paper to discover whether they are winning or losing. Perhaps they suspect they are losing and prefer to ignore the fact. Even if they think they are winning, they have no desire to discover the rate of progress. Such knowledge may prove a sad blow to their ego, so the facts and figures are left to drift.

But let's look at it in a businesslike way. You already know the rewards are worth working for and that advertising photography is a profession in which you wish to succeed. So if facts and figures are your pet hate, struggle along for a little while, and you may find that it's not so bad after all. First of all, let's look at the **Balance Sheet.**

A typical model's dressing room in a busy fashion studio. Photo by courtesy of Studio Guy Marché.

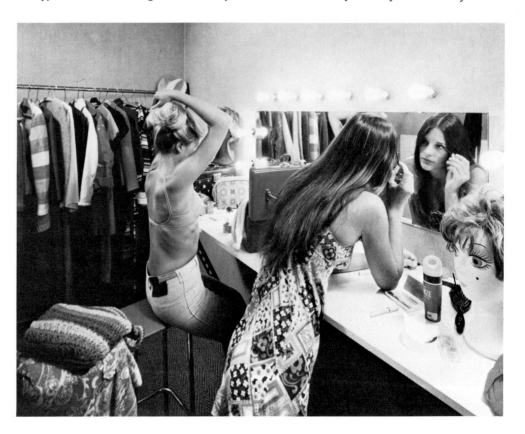

Here art directors deliberate over some of their studio's assignments. Photo by courtesy of The Alderman Company.

A Balance Sheet is simply a piece of paper divided down the middle. On one side are your winnings, or assets, and on the other your losses, or liabilities. The Balance Sheet on its own really doesn't mean very much, but when prepared at regular intervals, it will give you a very good idea of the direction in which you are heading and the speed at which you are getting there.

Some people measure the success of their business by the amount of cash they have in the bank. This is not too accurate a gauge. You could have little cash in the bank yet carry immense quantities of materials in the storeroom; in other words, you have been ploughing the profits back into the business. The reverse is equally true. A large bank balance may give you a feeling of importance, but it doesn't mean very much if you owe the greater portion of it.

Here's how you can prepare a simple Balance Sheet. Take a sheet of paper and divide it down the middle, lengthwise; write at the top of the left column, "Assets," and the top of the right column, "Liabilities." Under the Assets heading, list the amount of cash you have in the bank, the amount you have on hand, the amount of cash owed to you, the net value of your materials, and the investments or shares your business owns. These are your current assets, and you can run a total on them. But you have other assets to take into consideration. Continue this list with your **Fixed Assets**, i.e., furniture and fixtures, cameras, equipment, land, buildings. Again you can run a total and add the two totals together to arrive at your **Total Assets**.

12

Now in the right column, start listing the amounts you owe, i.e., trade accounts, other accounts payable, taxes, and notes payable. Total these amounts. Then list your further liabilities, which include mortgages and all other liabilities. The total of these, added to the previous total, will tell you exactly how much you owe. All you have to do now is to take the totals from each side, subtract one from the other, and you will know precisely where you stand financially. But remember, taken on its own, this grand summation means very little. It can fluctuate considerably during the year, or even during the month, but it does provide an indication of your progress.

Of more immediate value is the **Profit and Loss Statement**. This will provide information showing the profitability of all sections of the business. While the Balance Sheet will show the position of the business at the time the balance is drawn, the Profit and Loss Statement will show the overall structure of the business. To obtain an accurate Profit and Loss Statement, you will have to obtain three sets of figures: (1) the actual cash flow into the business; (2) the cost of obtaining that cash flow; and (3) the expenses involved in obtaining that cash flow. Let's take them one at a time and see how we can arrive at the figures.

1. The actual cash flow. This is very much what it says. It is the amount of money earned by the business after all discounts or other allowances have been taken into account.

2. The cost of obtaining that cash flow. You first need the cash value of your inventory at the beginning of the period over which you are taking the Profit and Loss Statement, let us say, the first of the year. The second figure you will need is the value of the goods bought during that period. The third figure will be your present inventory which, with subtraction, will give you the value of the inventory used in that period. To that figure you must add an amount for the depreciation of your equipment. This will give you a total of the cost of obtaining that cash flow, or in other words, the **Gross Profit**.

3. Now you will have to subtract your operating expenses in order to arrive at a **Net Profit** (or Loss) figure for the year. Your operating expenses will include all salaries, not forgetting your own, the rent of your premises, taxes, bad debts, travel, telephone, utilities, advertising, stationery and office supplies, including postage and freight, subscriptions, dues and membership fees, insurance, automobile and office equipment depreciation, and all other expenses. This will give you a total of all your administrative expenses, and by deducting this total from your **Gross Profit** total (or vice versa), you will arrive at a **Net Profit** (or Loss). To this figure add the income from any other business, subtract your taxes, and the remaining figure is your **Net Income**.

If you run these figures out in neat lines, the way an accountant would, several facts quickly become apparent. When you take the amount of money the business has earned and deduct the amount of money that it has cost you to earn that money, you obtain a very accurate idea of the efficiency of that part of your business. By expressing your profit as a percentage of your total earnings, you are presented with a figure that may give you satisfaction or cause you to seek ways to improve your position. There are ways by which you can increase your profit percentage, and we will come to those in a few moments. In the meantime, take another look at those administrative expenses.

Administrative expenses represent your overheads, and it is these costs which can make or break a business. Take, for example, the question of salary as it refers to your own or members of your family who may be working with you. It is so easy to say, "Well, I only take a very small piece out of the business," or "My two sons work for me, and they help me cut down on labor costs."

This really is a mistake. You should always base your salary figures on the amount of money you, or members of your family, would expect to receive if you were working for someone else. Perhaps the money actually taken in cash is quite low, but in calculating the worth and efficiency of your business, the salaries must be reasonable, even if the money not actually taken in salary can be shown as a loan or investment in the business.

To paint an attractive picture of the worth of your business by cheating on the figures is always self-defeating. If the reason for impressive figures is that you intend to sell the business, the potential buyer's accountant could see through such camouflage in a second. It is exactly for this type of trickery that they would be looking. If the intention is simply to make you feel that your business is more successful than it really is, such self-deception will stop you from taking the steps that would make your business what you would wish it to be.

Figures from the Profit and Loss Statement, taken together with figures from the Balance Sheet, can provide you with some very valuable insights as to the way in which various areas of your business are progressing. For example, if you want to know how efficiently your working capital is being used to make profit, simply divide your **Net Profit** by your **Net Working Capital** and multiply by 100. The result is a percentage figure. The higher the percentage, the more efficiently your capital is being used.

Publicity pictures surround us all times. An advertising-minded photographer never neglects the opportunity to take pictures that can be used at a later date. Photo by courtesy of Studio Guy Marché.

12

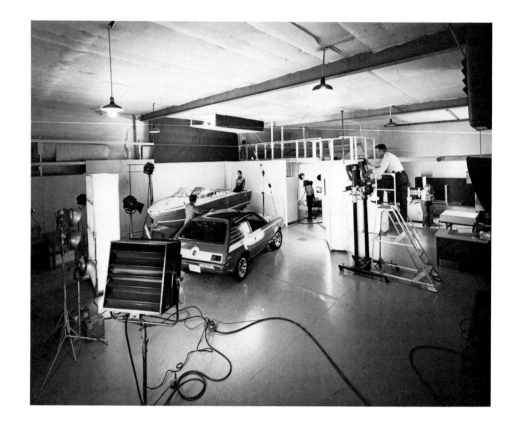

A typical, highly efficient advertising photography studio. Photo by courtesy of Harper Leiper Studios, Inc.

Another calculation worth noting is that which will tell you how much of the business you own and how much is owned by your creditors. To obtain this percentage figure, divide your **Total Debt** by your **Tangible Net Worth** and multiply by 100. The lower the figure, the greater your holdings.

These figures, or accounting ratios, are obtained from well-established formulas that may be found in any standard accounting textbook. With their use, it is possible to calculate how much of your investment is returned in cash every month or every year; how efficient the darkroom side of your business is compared with the cash received from clients; and how many days are needed to collect on your credit accounts.

This latter information can be quite vital, because the longer it takes to collect the money owed to you, the more capital you must have to tide you over until your receivables are paid. Many small businesses have been lost because they ignored this inescapable fact. No matter how much work you are doing or how many big clients you have, if you encounter difficulty in getting the money owed to you, your business can be closed by your creditors.

There are several reasons why businesses fail, among them, inefficiency, lack of skill, insufficient capital, laziness, and lack of initiative. Most of these pitfalls can be avoided with just a little forethought and determination. But just as there are reasons why a business can fail, so there are reasons why an advertising photography business can succeed. Hard work, inventiveness, creativity, careful spending, willingness to learn, and a diligent application of the ways to increase profit are all

ingredients for a successful advertising photography business. Although it may be satisfying to see orders pouring in and a great flow of work going through the studio, it is possible to discover at the end of the year that you have in fact made very little profit.

To work hard and have little to show for your efforts is completely frustrating, and it's not an uncommon occurrence. The major cause of this situation is that the margin of profit between what it costs you to produce your pictures and the price at which you sell them is too small. There are only two solutions: either you increase the price of your work, or you lower the cost of producing it.

The fee you charge is largely determined by your standing, the type of work involved, the clients for whom you work, and your own evaluation of what you are worth. These factors can only be evaluated by you and the decisions you make, based on the current situation. Lowering the cost of producing your work is a much more difficult problem to tackle, as new equipment sometimes become essential, overheads continue to rise, and interest rates are beyond your control. But there is one area in which it is often possible to conserve, and that is in your purchase of materials.

The Economic Way to Buy Materials

Advertising photographers who are well established and financially sound will give you good advice. They will tell you to be creative in your picture-taking, to keep your overheads low, and to buy reputable equipment and materials.

Rapport between photographer, staff, and models is essential for the production of first-class advertising photographs. Photo by courtesy of Peter H. Fürst.

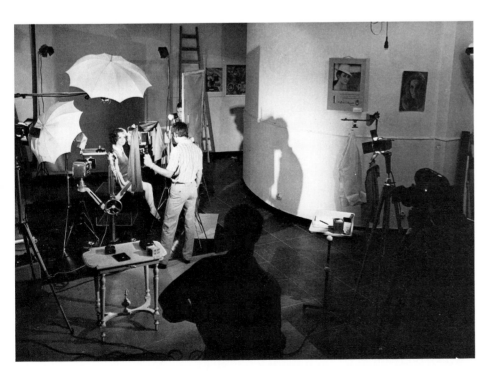

There can be no argument with such sound recommendations, but the newcomer struggling to become established sees his creativity as his strongest suit. His overheads and his material costs are outside his control. Or so he thinks. In fact, both his overheads and the cost of his equipment and materials can probably be lowered far more than he imagines.

Overheads can best be tackled by examining your day-to-day working procedures and eliminating all those unnecessary frills that cost money, such as expensive telephone systems where a simple one would really do just as well, the destruction of studio sets when they could be saved and used with a few changes at a later date, the collection of expensive lenses that are rarely used, and the hiring of extra staff when you know that with a little more effort you could handle those jobs yourself.

These overheads, which signify a certain amount of luxury, are easily pinpointed and dealt with. There are others, not quite so obvious, that you will come across as you take a closer look at your working procedures. But it is in the purchase of materials that you can make the greatest savings.

The real answer to saving money in the purchase of material is bulk buying. This presents two immediate problems: Where can the small business find the money for bulk buying, and who wants, let's say, a couple of hundred gallons of hypo?

Let's take the first question first. Bulk buying is only a true savings when the material bought is going to be used within a reasonable period of time, and when the money used to make the purchase could not have been used to make even more money in another type of investment. So to answer the first question, the money to be used for bulk buying can be diverted to that purpose from other investments which are not quite so profitable. Money can also be borrowed either from banks or privately, if the rate of interest is well below that which can be saved by the investment in materials.

The decisions of what to buy and when to buy are governed largely by the average demands of the studio. If, for example, a roll of background paper costs $20 and lasts you for six months, there would be little advantage in buying 100 rolls, even if you could buy them for $10 each. Although you may save $20 on the first year, it will not be until 50 years later that you would fully realize on your investment. But if you were using a roll of paper every week, in two years you would have saved $1,000.

Sensitive materials, such as film and paper, can be bought in bulk at considerable savings, and efficient inventory control will tell you at a glance how many sheets of film or paper you get through in an average month. If you buy this type of material in quantity, it is essential that your storage conditions are such that the material will not deteriorate. Color film is particularly sensitive in this respect and requires that you have a refrigerator large enough to accommodate all the film you may buy. But you will have to remember to discount some of your bulk-buying profit against the cost of running the refrigerator.

Who wants a couple of hundred gallons of hypo? It could be you, if you are going to use that amount in a reasonable period of time and if you have somewhere to store it. Processing chemicals are an expense that can be eased by bulk buying. Even in the very small sizes, the advantages of buying in larger quantities is very obvious. To buy one quart of a compounded developer could cost, say, $2; one gallon of the same developer, $6; and five gallons, $20. Buying in still larger quantities will show even greater savings until the quantities reach a stage where the prices level off. Even these savings can be improved upon. If, instead of buying liquid developer, you buy compounded dry chemicals, there is a savings on water

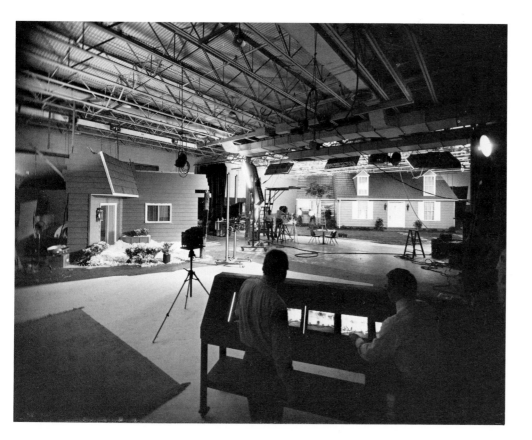

A spacious, well-equipped studio is the dream of every photographer entering the profession. It is there, waiting for those who make the grade. Photo by courtesy of The Alderman Company.

and bottles, which is reflected in lower prices. But you can still take one further step. By compounding your own processing solution from raw chemicals, the savings are enormous, even taking into account the cost of the labor involved.

There are many ways of cutting costs by buying in bulk. The materials you buy and the money you spend are determined by the studio operation. As the business grows and becomes more complex, the profit from bulk buying will decrease in some areas and become more attractive in others. Most photographic dealers have a special scale of prices for professional photographers who are truly full-time professionals. Even manufacturers will frequently supply direct in bulk on a cash basis.

Although bulk buying does help to reduce costs, never fall into the trap of buying materials with which you are unfamiliar. A bad buy is expensive at any price. Stick to name brands or materials you have pretested. Make every step you take a calculated move toward success. Watch for opportunities as they occur around you. Take advantage of photographic businesses that fail and auction their equipment and materials. Visit trade shows and keep an eye open for new products. Most new items are introduced at an attractive price to stimulate sales. Later, when the products have proved successful, there is a tendency for prices to climb.

Apart from saving money for materials and equipment, there are other ways to increase the profit ratio, ways that can be applied to any business, large or small. It's all a matter of figures.

12

A room interior that really tests the skill of the photographer. Note the faithful rendering of even the finest detail, the high-accent lighting, and the overall tone balance. Photo by courtesy of The Alderman Company for D'Arcy, MacManus & Masius, New York, and their client Henredon.

154

Foolproof Record Keeping Saves Money

An efficient filing system is a major part of a successful advertising photography business. To be able to locate a client's work sheet several years later should be a matter of routine. Every assignment you undertake, all credit transactions, all photographs, proofs, transparencies, and negatives you ever take should be recorded and the information quickly recoverable.

If you start an efficient filing system from the moment you begin business, your dollar value will increase steadily over the years. Not only is there extra profit in being able to pull a negative and run extra prints at a later date, but it is useful to be able to refer back to previous work for a new account.

The best filing systems are always the simplest. You need to know the name, address, and business of your clients, and this information should be on the front of each file folder. Inside the folder should be copies of the client's instructions, duplicate prints or approved proofs of work completed, a costing sheet showing the fee charged and how you arrived at that figure, orders for reprints completed, and color filtration factors for any color enlargements ordered.

As the studio becomes established, you will find it a savings in time to have large envelopes or folders printed with all the required data questions, so that you need only to jot down the necessary information. In this way, there is less chance of neglecting to make a note of facts that may be important at a later date.

This file folder should also contain information on any special equipment that was required, detailed construction notes regarding any sets that had to be built, the names and addresses of any models used, and the time taken to complete the assignment. Always provide yourself with as much information as possible, perhaps even to the extent of noting how you arrived at any creative ideas for any particular job. Not that you are necessarily going to repeat those ideas on other assignments, but in writing them down, they become recorded in your mind and will frequently help to inspire other ideas at another time.

Most professional photographers retain possession of all the negatives they take, although the copyright and the right to reproduce belong to the client who ordered the photographs taken. The usual procedure for filing negatives is to number them consecutively as they are taken and then file them numerically. A separate card file should accompany the negative file, and in this your clients should be filed alphabetically, with the negative number relating to that client documented on his file card.

When a stock-picture file or color-transparency library is being maintained, it is a good idea to contact-print each negative and transparency and file those contact prints under a subject-matter heading. One of the easiest ways to arrange this visual reference file is in the form of a three-ring binder. If the negatives are contact-printed onto sheets of 8″ × 10″ paper (four 4″ × 5″ negatives to a sheet, twelve 2¼″ × 2¼″ negatives, and six strips of six 35mm exposures) and holes punched in the sheets, it becomes a simple matter to separate them with index sheets under the various subject headings.

The keeping of accurate records is essential in every business, regardless of size. The negatives and work records are an important part of every advertising photography business, but no more so than the daily work schedules, the follow-up on delinquent credit accounts, and the day-to-day correspondence.

To assist in getting through the day with a minimum of wasted time, you will find a weekly schedule chalkboard invaluable. Fixed to the wall in your office, it will tell at a glance who should be doing what, at any hour of the day. This visible reminder helps to organize each week, prevents overlapping of operations, and

guides you into each assignment smoothly. Schedules can be changed efficiently, and if the board is properly maintained, it will be a constant reminder of preparations to be made for shooting sessions, days or weeks ahead.

The following-up of delinquent accounts is an unpleasant chore that can mean the difference between your business limping along or striding ahead. Any business handicapped by lack of finance is constantly fighting an uphill battle. The situation is even more aggravating when money is owed to you, and due to collection difficulties, you are unable to afford a special piece of equipment essential for a new or profit-paying account. Bad debts and slow payers can jeopardize your business.

To eliminate this problem as much as possible, it is essential that your statements be sent out promptly and regularly. Very few advertising photographers receive payment in less than 30 days, unless they request special attention. The businesses to whom they provide service are accustomed to paying their bills on a 30-day account, and unfortunately, some of the larger businesses take advantage of their size and extend payment into 60 or even 90 days. This is very convenient for them, as they are able to use your money and that of other creditors for as long as it takes them to pay. When those creditors are numbered in the hundreds, the interest alone on the withheld funds would provide your salary for many years.

The Versatile 2¼″ × 2¼″ camera will tackle almost any subject and is a worthwhile investment.

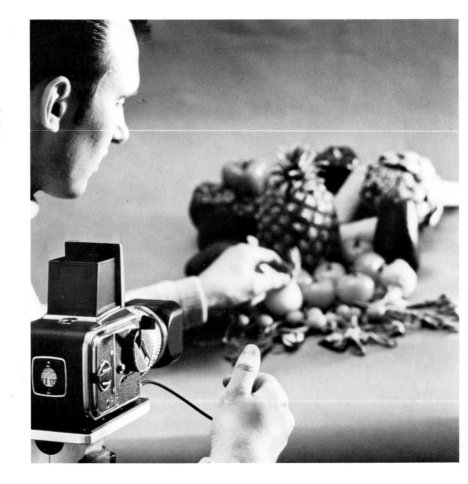

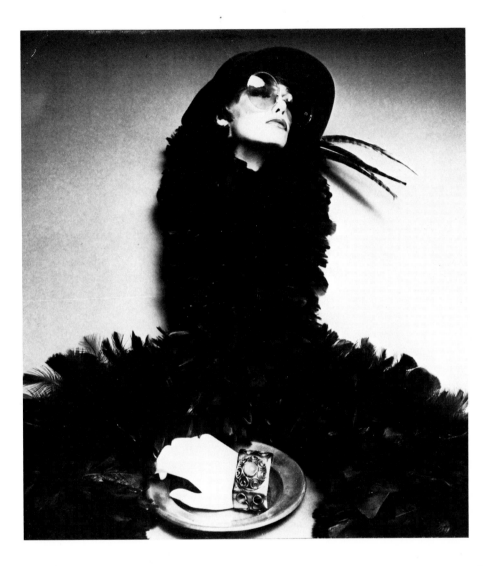

An advertising photograph that slams home with the force of a pile driver. Photo by courtesy of Los Angeles Art Center College of Design.

By billing regularly and sending out a reminder as soon as an account begins to get delinquent, you help to alleviate any difficulties. If clients discover that you are very indifferent about being paid for the work you have done, you can hardly blame them if they form the opinion that you prefer to work for free.

There are two generally accepted methods of ensuring prompt payment. The first is in agreeing to a discount for prompt payment. It could be 5% discount if paid within 7 days, 2½% within 30 days, and net for anytime thereafter. The second method is really a step on from the first. All accounts not paid after 30 days become subject to interest charged at current bank loan rates. This puts the delinquent account in the same position as having borrowed from a bank, and the majority of clients will pay your account promptly rather than increase their indebtedness.

Although these two methods will usually produce results without alienating the client, prompt and regular billing dates are your most expedient course.

Promptness signifies efficiency, and it applies as much to your correspondence as it does to your billings. If a client has taken the time and trouble to write to you, the least he can expect is a swift reply. If, for any reason, you are unable to supply requested information, write back and tell him, promising that the information will be forwarded as soon as it becomes available.

Keep a special file for all correspondence, indexing alphabetically under the correspondent's name. When one of your correspondents is also one of your regular clients and his letters also contain instructions on a project, you may wish to file the letters with the project file. But this would mean that any time you wished to refer back to a letter, you would be looking in two places. To cover this eventuality and to speed your search through previous correspondence, you may consider it worthwhile to make a duplicate of the letters and keep a copy in each file.

All these systems and methods of organization will assist in keeping the studio running smoothly, with a steady flow of work and satisfactory profits. But with all the help electronic calculators and filing systems can provide, and with all the most up-to-date photographic equipment and materials, the success of your business depends on you—on your ability to be successful.

The Way to Success

It is almost impossible to mistake a successful businessman—the president of an oil corporation, the owner of a string of supermarkets, or even the self-made man who pumps gas into your car. Such men have an air about them that has nothing to do with the way they dress or the house in which they live. Every successful businessman does not belong to an exclusive club or own a yacht, yet they all have one thing in common—the inner confidence of knowing they are successful.

It shows itself in courtesy, friendliness, and a serene calmness. No businessman ever climbed to the top by being unreasonable or constantly flustered. A recent survey showed that almost all successful businesses are built on a thorough knowledge of the product, efficient but friendly service, a readiness to correct mistakes, and the willingness to extend oneself on behalf of the customer.

As a successful advertising photographer, you will learn to deal with emergencies and last-minute assignments with good humor and steady efficiency. Even a last-minute assignment is better than no assignment, and that client probably came to you because he knew he could rely on you to handle it.

As a successful advertising photographer, you will accept opportunities to expand and diversify without overreaching yourself. You will keep abreast of current trends in advertising techniques and seize the chance to learn something new whenever the opportunity occurs. As your prestige and skill grow, you will try to help those that are climbing the ladder behind you, remembering all the time the difficulties and hardships you once had to endure.

There will come a time, in the near future, when you will be handling big-name accounts. Your studio will be filled with the highest-quality equipment, and top-flight models will be facing your cameras. Perhaps you will find time to pause and look back—to remember how tough it was at times and to recall how you worried about gaining new accounts and lost sleep thinking about the problems you had to face the following day. But in looking back, you'll remember that you never lost sight of the target, and how, when things refused to go right, you still had the secret contentment of knowing that you were entering one of the most exciting and rewarding professions in the world. You were on your way to becoming an Advertising Photographer.

INDEX

Accidental model, 30, 103-105, 106
Accounting, 14, 146-151
Advertising, 9-11 passim
 campaigns, 32, 59, 90, 91
 concepts, 55-56
Advertising agencies, 12, 21, 59-62, 87
 Blue Book, 51
 Hall & Levine Advertising, 90
Advertising photography
 applications, 18
 authenticity, 13, 18
 business of, 143-159
 creativity, 65
 organization, 87-96, 155-158
 originality, 65
 success in, 13, 19, 158
 trends, 62, 64
Agfacontour Professional Film, 142
Alderman Studios, 108
Assignments, 32, 47-64, 108-111
Atmosphere, 73, 80-82

Backgrounds, 21, 41-42, 91-94
Back projection, 41, 46, 138-139
Book illustration, 30-32, 58
Breaking rules, 74
Bryant, Clinton, 12-13
Bulk buying, 151-153
Business, advertising, 143-158

Cameras, 33-37
 accessories, 34-37
 advantages, 34, 36-37
 disadvantages, 34, 36-37
 larger format, 37
 roll-film, 34-37
 selecting, 33
 35mm, 33-34
 used, 37
Campaigns, 32, 59, 90, 91
Catalogs, 24, 126
Cibachrome, 142
Ciba-Geigy, 142
Client, 84-85, 124 (see also Manufacturers)
Close-up photography, 78

Color, 125-127
 "ganging," 126
 reproduction, 125-127
 separation, 126
Combination printing, 117-118
Commercial photography, 19, 24
Committee, the, 124
Contact printing, 121, 123, 142
Copying, 118, 121, 142
Covers, 30-32, 58
 organizing, 31
 selling, 31

Darkroom, 40, 117-128
 equipment, 14, 40
 setting up, 40
Darkroom techniques
 combination printing, 117-118
 contact printing, 121, 123, 142
 copying, 118, 121, 142
 distortion, 121
 grids, 118
 photograms, 123
 processing, 117
 reticulation, 123
 screens, 118
 solarization, 118
 special effects, 121
 superimposition, 118
 textures, 118
 tone separation, 121
Deadlines, 95-96
Direct stimulation, 74-76
Distortion, 38, 67, 121
Dream session, 68-73
Duplicate negatives, 118, 121

Education, 16
Equipment, 14, 33-46, 108
 camera, 33-38
 darkroom, 14, 40
 special effects, 44
 studio, 14, 39-44, 108
 used, 37

Estimates, 51-52, 63, 64, 143-144
Experimentation, 73-74

Fantasy, 127-128
 darkroom, 128
 materials, 127-128
 special effects, 127
Fashion photography, 19-23
 designers, 21
 equipment, 21, 42
 houses, 23
Film, passim
 processing, 39-40
Financial status, 13, 14
Front projection, 21, 40, 41-42, 46,
 138-139

"Ganging," 126
Grids, 118

Hall & Levine Advertising, 90
Hitchcock, Alfred, 86
Hobbies, 9, 16-18

Illustrated articles, 133-138
Illustrations
 book, 30-32, 58
 catalog, 58
 manuals, 58
Imaginative power, 65-76
Industrial photography, 19, 23-24
Invasion of privacy, 105

Knowles, Eileen, 18

Large format camera, 37
Layouts, 87-91
Lenses, 37-38
 interchangeable, 34, 37
 wide-angle, 37, 76
 telephoto, 37
 zoom, 34
Libel, 106
Libraries
 stock picture, 26-28
 transparency, 138-139
Lighting, 41, 78, 82
Light tent, 46
Loans, 15
Locations, 90-95, 100
 equipment, 91
 finder's fee, 94

Mail-order houses, 24
Magic, 18
Manufacturers, 52-56, 65-67, 82,
 139-140

Thomas Register of American
 Manufacturers, 54
Merchandising, 14, 77-86
Model agencies, 98-100, 102
Models, 21, 56, 78, 82, 97-106
 accidental, 30, 103-105, 106
 amateurs, 98-102
 law and, 105-106
 libel, 106
 payment, 101-103
 professional, 98-102
 releases, 106
 rights, 100
Money markets, 19-32
Mood, 80-82

Off-beat subjects, 78-79, 129-142
Organization, 87-96, 155-158
 profits, 91, 143
 success, 87, 143

Photograms, 123
Photographs, advertising
 action, 71
 "before and after," 67, 76, 134
 bizarre, 79, 127
 close-up, 78
 creative, 65-67
 humorous, 79
 location, 36-37, 90-95, 100
 political, 32
 propaganda, 80
Photolinen, 140-141
Photojournalism, 133-138
Polaroid shots, 84, 94-95, 124
Political photography, 32
Presentations, 50-52, 54, 67, 124
Printers, 58, 125-127
Processing, 39-40
Profits, 64, 143-158
Proofs, 123-125
Props, 21, 44-46
 choosing, 46
 finding, 46
Public services
 cities, 131
 conservationists, 130
 hospitals, 131-133
 shopping centers, 133
Publishers, 58-59

Quotations, 51-52, 63, 64

"Rag trade," 21
Rear projection (see Back projection)
Record keeping, 155-158 (see also
 Organization)
Recreational interests, 16-18
Reflectors, 42
Releases, model, 106
Research, 50, 51, 90, 113-115, 142

Reticulation, 123
Retouching, 18
Roll-film camera, 34-37

Sabattier effect, 118
Samples, 14, 23, 46, 47-52, 54, 55, 58, 59,
 84, 111, 131
Schedules, 91, 95-96, 155-156
Screens, 118
"Seconds," 50
Self-advertisement, 28, 111-113
Self-evaluation, 14-16
Selling pictures, 14, 28, 77-86, 139
Showmanship, 86
Shutter release, 42
"Snob cycles," 62
Solarization, 67
Special effects, 44, 121
 equipment, 44
Specialization, 16, 19, 58, 62, 107-116
 areas, 13, 18, 19, 58, 107-111
 payment, 58, 62, 108
Stock picture library, 26-28
 markets, 26-28
 organizing, 28
Studio equipment, 14, 39-40, 41, 42-44,
 108
 lighting, 41
 special equipment, 41-44
Studios, 39, 40-41, 65, 87, 116
 Alderman Studios, 108
Style, 86, 115-116
Superimposition, 32, 118

Table-top photography, 32, 42, 128
Tape recorder, 46, 82
Technical ability, 13-14
Telephoto lenses, 37
Test shots, 84, 94-95, 124
Textures, 118
35mm camera, 33-34
Thomas Register of American
 Manufacturers, 54
Tie-in technique, 56
Timing, 13-14
Tone separation, 121
Training, 15
Transparency library, 138-139
 markets, 138-139
 organizing, 138-139

Unusual materials
 Agfacontour Professional Film, 142
 Cibachrome, 142
 photolinen, 140-141

Wide-angle lenses, 37, 67

Zoom lenses, 34